REFLECTIONS ON BAROQUE

REFLECTIONS ON BAROQUE

ROBERT HARBISON

The University of Chicago Press

ROBERT HARBISON is professor of architecture and interior design at the University of North London. He is the author of *Eccentric Spaces* (1977) and *Thirteen Ways: Theoretical Investigations in Architecture* (1997).

For Craig and Sherrill

The University of Chicago Press, Chicago 60637
Reaktion Books Ltd, London, EC1M 3JU

09 08 07 06 05 04 03 02 01 00 1 2 3 4 5
ISBN 0-226-31600-9 (cloth)
ISBN 0-226-31601-7 (paperback)

Library of Congress Cataloging-in-Publication Data

Harbison, Robert.
 Reflections on Baroque / Robert Harbison.
 p. cm.
 ISBN 0–226–31600–9 (cloth : alk. paper) — ISBN 0–226–31601–7 (pbk. : alk. paper)
 1. Arts, Baroque. 2. Civilization, Baroque. I. Title.

NX451.5.B3 H37 2000
900.9′032–dc21
 00–060726

This book is printed on acid-free paper.

CONTENTS

FOREWORD vii

I THE CASE FOR DISRUPTION I

Bernini, Borromini, Mattia Preti, Milton, St Ignatius, Monteverdi,
Fischer von Erlach, Costanzo Michela, Juvarra, thoroughfares, staircases,
Sacred Mounts, St Teresa, plague columns, ceilings (Pozzo, Maulbertsch,
Tiepolo), Marvell, Crashaw

II TORMENTED VISION 33

Maulbertsch, Handel, Rubens, Sacred Mounts, the sketch, Clérisseau,
Soane, Sterne, Vittone, Borromini, convents, saints,
the Sacred Heart, Messerschmidt, the cult of sensibility

III THE VIEW FROM ABOVE 60

Wren, Ragusa, Palermo, Rubens, Milton, Dryden, Vanbrugh,
Jesuit expansion, Defoe, Querétaro, Noto, Blandford Forum,
Turin, Versailles, Schönbrunn, Bucharest, Pope

IV THE END OF HEROISM 78

Mozart and opera (*Idomeneo*, *Così fan tutte*, *La finta giardiniera*), Asam brothers
(Rohr, Weltenburg, Freising), Serpotta, Watteau

V THE WORLD AS SCENERY 102

Congreve, Pope, the Bibiena family, Piranesi, Soane, the Gothic
novel, Venice as scenery, Canaletto, Guardi, Longhena, Vanbrugh

VI BAROQUE NATURE 127

Isola Bella, Giardino Buonacorsi, Versailles, Nymphenburg, Amalienburg,
Veitshöchheim, graveyards, English landscape gardens, Die Wies,
Vierzehnheiligen, new and exotic species, scientific drawings, encyclopedias,
the Academy of Lynxes, Rameau, Waldsassen, Pianta, Hogarth,
Messerschmidt, Handel, Goya

CONTENTS

VII COLONIAL BAROQUE 164

Ocotlán, tile façades, backwaters, Sagrario Mexico City, Hindu temples, Goan Baroque, St Francis Xavier, Bolivian Jesuit sacred opera, *Sant' Alessio*, *Santa Rosalia or The Wounded Dove*, Stradella's *oratorio erotico*, Tepotzotlán, Salamanca, Querétaro

VIII NEO AND PSEUDO BAROQUE 192

Russian Baroque, Turkish Baroque, Persian Rococo, Edwardian Baroque, Linderhof, porcelain knick-knacks, '50s American cars, Jeff Koons, Richard Strauss, Beardsley, Guimard, the National Trust, Bellotto and Warsaw, Baroque pearls, Japanese Baroque, Gothic Baroque, Chinese Baroque, Hellenistic Baroque, Wölfflin, Deleuze

IX BAROQUE IN THE TWENTIETH CENTURY 222

Czech Cubists, Santini, T. S. Eliot, Gehry, Coop Himmelblau, Russian Constructivists, Scharoun, Ludwig Leo, Miralles

NOTES 241

ACKNOWLEDGEMENTS 253

PHOTOGRAPHIC ACKNOWLEDGEMENTS 254

INDEX 255

FOREWORD

THE BAROQUE can be viewed as an episode in the history of art, or of religion, or of absolutist politics or of consciousness more generally. In art it begins in Rome with work which owes a lot to Michelangelo's impatient deformations of Renaissance prototypes and quickly progresses to something more extrovert and untrammelled on scales seldom seen before. In religion it is tied to Counter-Reformation reassertions of Catholic orthodoxy against Protestant incursions, but shows individualist traces suspiciously similar to Protestantism, at least to untrained eyes. In politics it corresponds to the increasing centralization of power in the monarch and the vigorous ritual displays which accompany it. To define the significance of the Baroque for consciousness generally is more difficult. What may have begun as intimidating declamation can become a celebration of turbulence for its own sake, the equivalent in art of white water rafting, and such exuberance does not always remain within the bounds of art.

It is a mode which begins in Italy and eventually encompasses all of Catholic Europe, with distinct local forms in Spain and Portugal, Austria, southern Germany and Bohemia, Sicily, Piedmont and France. Northern Protestant variants are more problematic – debates still continue over whether there is an English Baroque at all – but it is safe to say that no European art or thought of the seventeenth and eighteenth century remained immune to the influence of the Baroque, which was also carried by Spanish and Portuguese colonizers to the Americas and India.

In some places the mode lasted a hundred and fifty years from the early seventeenth to the late eighteenth century, until replaced by sterner classical revivals. There are many transitional figures and monuments. The Bavarian architect Balthasar Neumann was either lucky or unlucky depending on your preferences: he came late enough for his Baroque spaces in several instances to be fitted out with cooler neoclassical trimmings.

A mode which prevails over such a wide territory for such an extended

period will accommodate many variations, but the Baroque is consistently remarkable for the value it places on subjective response, aiming to stir the spectator's emotions actively. The consequences of this approach are profound and work against the tendency of some Baroque products to intimidate the undefended individual. What begins as an authoritarian mode comes in course of time to accommodate desires for human-scaled comfort and relaxed subject matter. So the gargantuan boasts of Baroque evolve towards the gentler Rococo, sometimes without a clear break. In Bavaria particularly, large architectural carcasses are embellished with a charming filigree of plaster ornament which turns whole church interiors into groves and bowers.

Rococo takes a considerable share of this book because metamorphosis is one of the fundamental processes of the Baroque and the transition to Rococo is the most important upheaval within it. With practice anyone will learn to tell when Baroque has become Rococo. Everything is lighter, more sinuous, more playful and thoroughly secular. Shepherds, pastel colours, brief forms and small spaces – exquisite rather than grand effects characterize Rococo, which one would not expect to find before the second decade of the eighteenth century even in France, its land of origin. This tendency spreads east more readily than it does south: Italian Rococo is a rarity.

This book applies a few Baroque principles in treating its subject. The first is a mixing of genres. In the seventeenth century borders between genres cease to be strictly observed and become blurred in forms like opera, which combines architecture and perishable sculpture-type effects with music and literary texts. The most elaborate interiors of the period also aim at phantasmagoric mergings of architecture, painting and sculpture, deliberately confusing the borders between them, the goal a single overpowering effect. So it seemed less appropriate than ever to segregate architecture from painting, epic poetry, gardens or opera in this book. Instead, I have tried to show how similar intentions are differently realized in different mediums, believing that such comparisons sharpen our perception of both halves.

More debatable perhaps is the book's handling of chronology. While I accept that examples should be presented in chronological order unless there is a compelling reason to violate it, there are many such reasons in the field before us. Time does not run forward smoothly and uniformly in all human activities across the whole world. Music is generally agreed to be out of sync with most other arts in the eighteenth

century. Bach doesn't seem Rococo, nor Mozart Romantic, at least not primarily. Geographical discontinuities are also legion: Sicilian Baroque lags perhaps twenty years behind Roman, for example. But we cannot leave it at that: in some senses the two are not comparable and what is most special in Sicilian forms cannot be translated, bound up as it is with the isolation and peculiar past of the island.

Chronology is only one ordering system, and there are others, mainly thematic, which seem more suitable to the present subject. Likewise geography – there is no attempt here to give a complete picture of any part of the territory. A few omissions I regret and cannot entirely account for, Prague and Guarini in particular, both of which, the place and the designer, were central to my idea of the Baroque, but somehow found no place here. Otherwise, the geographical range is as wide as my experience allows and the examples are chosen because they are the most powerful of their kind, the most striking works of their author who is the most compelling worker in his medium in his time and place. Sometimes I have chosen less well-known works which deserve wider circulation. Often I have been drawn to oddities, like the Sicilian stuccoist Serpotta, the Sacred Mounts of Piedmont or the Dutch tulip craze. Part of the justification for this emphasis is that the Baroque (none of the three is exactly standard Baroque of course) tends to extremes, having little interest in quiet, well-behaved works.

I realize, though, that I am pushing even further into odd corners, towards the edge where artistic production becomes simply freakish. I heard the other day of someone living in one room in Chicago who wrote the longest fiction yet known (called 'In the Realm of the Unreal') and apparently showed it to no one. I do not know how his name is spelled, and I suppose it is revealing that I find him such a key instance. My version of the Baroque is that of an unreconstructed individualist who thinks crucial stages of large historical processes are sometimes illustrated best by exceptions. This book therefore contains a high quotient of the extraordinary, the unrepeatable, the one-off, which is not there for itself alone but because it illuminates much else, perhaps just by stepping outside it.

It will come as no surprise that the book is organized thematically rather than chronologically or geographically, until its latter parts, where it departs from the central territory to trace transmutations of Baroque material far afield in both time and space.

The first chapter introduces the most distinctive feature of Baroque

art, its striving after simulations of energetic movement. The second chapter treats Baroque subjectivity, beginning with the strange angles of approach promulgated by Baroque artists who present their subjects obscurely lit, seen from beneath, or sketched so negligently that the spectator struggles to decipher them. To this, the next chapter forms an antithesis, normative not eccentric. This is the conventional Baroque of rulers and of ambitious rational plans for new capitals or towns. Chapters IV and V treat the central Baroque theme of theatre, at first literally, then as a motif which spreads outward until it encompasses most of experience. Science and the natural world, the subject of the sixth chapter, forms an antithesis to the preceding theatrical artifice and carries the argument beyond the bounds of art. The last three chapters are devoted to the surprising afterlife of Baroque beyond its natural boundaries, first in Latin America where it remains a nominally Catholic style, though most interesting of all are native subversions of the Spanish model, which tend to obliterate doctrinal content under decorative exuberance. The next chapter ranges further, into non-Catholic, non-Christian and finally vulgarized derivatives, from Russia to Turkey, to Edwardian Britain, nineteenth-century Germany and present-day America. The last chapter looks in twentieth-century architecture for parallels to the Baroque, especially tricky because of orthodox Modernism's profound hostility to decoration. Where we find a conscious relation, in the Czech Cubists for example, it goes together with a strong desire to detoxify and delocalize the model, that is, to salvage Baroque movement without finding an equivalent to Baroque imagery or doctrine. In fact the most interesting later parallels are of this abstract kind – Frank Gehry and Coop Himmelblau resemble Baroque in their fixation on movement and spatial illusions and their need to subvert conventional forms.

Like all modes the Baroque is liable in weak moments to become formulaic, a kind of empty bluster; but in the most adventurous manifestations of this style lurks the first hint of what is to become the Romantic exploration of the furthest recesses of the self. What began as formal dissatisfactions with Renaissance harmony had before long brought a revolution in consciousness, and by preferring dramatic expression above all else unleashed a flood. Cultural consensus has never been the same since.

REFLECTIONS ON BAROQUE

I

THE CASE FOR
DISRUPTION

THE BAROQUE IS SET APART from what precedes it by an interest in movement above all, movement which is a frank exhibition of energy and escape from classical restraint. The psychological and social meanings of such disruptive impulses are diverse but it is obvious from the start that the style is not just a formal exercise but signals a transformation of human consciousness. In fact the Baroque is one of the necessary ancestors of Romanticism. This is not to say that this mode is primarily interesting for what it leads to, but rather that the Baroque is no dead end or herald of spiritual exhaustion.

The Baroque desire to suggest movement in static works of art meets its severest challenge in architecture. Baroque buildings have never ceased to annoy purists because they strive after the impossible, aiming to suggest to viewers that they are watching an unfolding process rather than a fixed and finished composition. Such effects are hardest to obtain on very large scales but this does not deter an overweening Baroque artist like Bernini. He has shaped the empty space in front of St Peter's into the archetypal Baroque work, which although the masses of colossal Tuscan columns in rows four deep are enormous, remains more empty than full, a sketch of something even grander, a great oval room that upstages as well as introducing the building which lies at its far end. Bernini also had plans to provide such a setting for his favourite classical monument, the Pantheon. For him, it was a way of extending the building's aura into its surroundings, and thus enlarging the effect of architecture.

He likened the two arms to the embrace of a protective female, the Church, which shows that he anticipated a subjective reading. The arms are not a cool display of classical proprieties but an impinging appeal, a

large gesture which sweeps the spectator along in its wake. Like other Baroque artists, Bernini saw the physical materials of art as means of working on spectators' emotions, a headlong pursuit which can seem vulgar or unscrupulous to modern eyes.

The oval plan is often met in the Baroque and this is not the only time Bernini employs it crosswise, with the short dimension used as the axis of entry. But of course one of the beauties of urban squares in contradistinction to buildings is their porousness to entry from different sides. Only in Mussolini's time did Bernini's Piazza acquire the appearance of a single way in, when he drove the via della Conciliazione through from the river to a point opposite the church façade: in planning terms not a conciliatory gesture – Bernini meant the oval to burst upon the visitor emerging from narrow surrounding streets, not announce itself from a mile away. The effect he wanted can still be approximated by coming at the oval from the side rather than the front. In this way the Colonnade is met as an obstacle thrown across the street, on a different, triumphal scale and slippery in its unwonted curve. Once inside, you watch the space expand around you, its 'walls' individualized by the columns into something like a promenading throng.

Bernini and Borromini, the two great architects of the Roman Baroque, are antithetical figures. At St Peter's Bernini worked with huge spaces and lavish budgets, a master of extravagance. Borromini by contrast is a master of parsimony who obtained some of his best effects in moulded plaster, which he preferred not to dress up in colour and gilt, disguises obscuring the essential forms.

But if Borromini is severe, at the same time he is disturbingly licentious, taking unequalled liberties with classical system. He seems to thrive in awkward situations, cramming monumental façades into narrow streets. Like Bernini orchestrating his vast plain, Borromini also aims at dramatic effects of movement, through compression not expansion. One of his earliest works is an optical joke in the form of a little passage leading off a courtyard in a nobleman's palace, the Palazzo Spada in Rome. Borromini's corridor is lined with columns and closed by a statue in the open air at the far end. The trick is that the space between us and the statue is illusory. The columns shrink precipitately and thus conceal the fact that the distance is shorter and the statue much smaller than we suppose. Lured into the passage, we find ourselves ducking, as walls and ceiling close in.

For the rest of his career Borromini went on repeating this joke in

subtler forms, creating false recessions in his façades and interiors, which multiply, and you could say theorize, the space we are looking at. One of the goals of Borromini's departures from classical norms must always have been to make the user think, but for anyone who enters into the experience, his architecture is powerfully visceral as well.

Probably his least known major work is the Collegio di Propaganda Fide (illus. 1) in an unimportant street near the Piazza di Spagna. Here he had the pleasure of demolishing an earlier chapel by Bernini to make a larger church. Bernini's was a slippery oval and so Borromini's replacement is a staid rectangle. But interior and exterior are disjunct: on the street Borromini executes one of the great Baroque tours de force, imparting a sensation of violent movement to what is underneath it all a flat façade. He does this by tricks not far from those of theatrical scenery, hollowing out the wall a little and then exaggerating this concavity with a gigantic protruding cornice which follows the curve. Under the cornice is a series of seven niches, each containing a large window, but each also acting as a little architectural stage, developing steep receding space in its own ingenious way.

Taken altogether and seen from underneath the whole thing can cause a mild vertigo or at least make you think you are seeing things, as sizes and distances melt and change before your eyes, jutting ledges

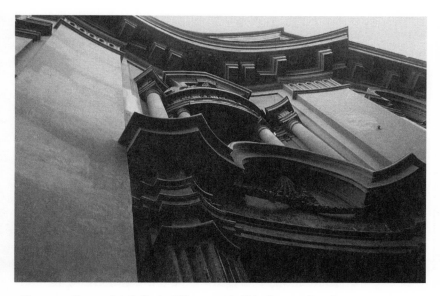

1 Francesco Borromini, Collegio di Propaganda Fide, Rome, 1647–65.

leading straight on to others you know to be far above them or breaking off and leading nowhere. As a spatial landscape the façade is phantasmagoric, echoing the unexpected clumping and disjoining of events in dreams. And yet every detail is hard edged, and every distortion of classical normality is measurable.

One could link instability and contradiction in Borromini's forms to general spiritual crisis in the seventeenth century, or one could say that the Baroque preference for dynamic effects corresponded neatly with Borromini's restless temperament. He remains a striking case of someone working in a traditional vocabulary and manipulating imagery he does not invent, who nonetheless produces results which seem to issue from the deepest recesses of his personality.

What began by seeming a limitation of the architect's power, the narrow space available for experiencing his work, is converted at Propaganda Fide to a spur to mental and visual investigation. Two-dimensional forms like paintings do not usually permit varied angles of approach as buildings do. Except for anamorphic freaks, which work only from the side not head on, more exciting in a long corridor (as at Trinità del Monte) than in a cabinet, no one to speak of before Monet had exploited the spectator's mobility in front of pictures.

But there are earlier equivalents in painting of Borromini's sideways composition in a narrow street – radically diagonal presentation of the picture space, as in Mattia Preti's *Wedding at Cana* (illus. 2) in the National Gallery. Here the image feels incomplete, as if there is a missing foreground over the edge of the frame, and so the movement into the picture becomes so powerful that it devalues features met along the way. Though most of the actors are seated, the strong diagonal thrust makes the situation feel precarious and temporary. And the weather does not inspire confidence. It is not night-time but extremely dark, suggesting storm. Details are hard to pick out and getting harder; faces are buried or veiled in shadow, and the Biblical story deceives us with its reassuring outcome, for this is a picture about losing one's individuality in a spatial matrix too powerful to resist.

The kinship between various arts in the Baroque, though extremely marked, can be hard to pin down. It is often argued that Baroque architecture becomes painterly, seeking fluidity and indistinctness much more feasible in flickering brushwork than solid stone. Painters like Preti conceive spatial ambitions which would be more at home in architecture, and one finds poets treating language as a plastic medium, which

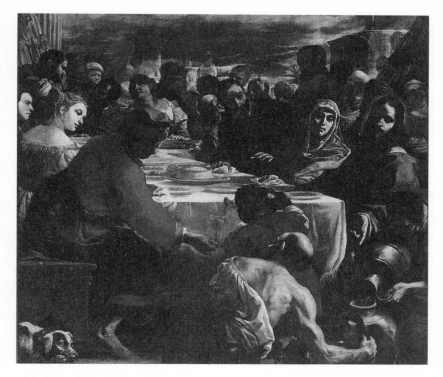

2 Mattia Preti, *The Wedding at Cana*, *c.* 1665.

makes its appeal as a shifting physical mass as well as, or even instead of, an intelligible verbal construct.

It will seem odd to press the blind poet Milton into this role, for in the most obvious sense of the word he is an un-visual writer. *Paradise Lost* was written from within darkness in some sense: Milton went blind ten years before he began it. The earliest scenes in the poem occur on a darkened stage where the characters flounder locating themselves in an unfamiliar place. But this groping in the dark is also a powerful immersion. If not visual, *Paradise Lost* is a very plastic work, in which language has a physical presence like a sculptor's material or like the coloured marble and gold of a Baroque church.

It was a strange, Baroque decision to begin the poem in Hell, a literary equivalent of Preti's diagonal entry into the picture space. Space in Milton's poem is not compact and orderly like Dante's in the *Divine Comedy*. Not that Dante's journey through his hierarchical world is at all straightforward – you must go down in order to ascend – but Milton's

poem jumps about, using tricks of perspective to suggest the vastness of his scene. This vastness is presented from the start as relative and historical, indicated partly by our mental distance from the states the poem describes.

If the hunch is correct that Milton the lover of Italy meant St Peter's as the model for the devils' hall in Pandemonium, there is a powerful irony in the comparison. However corrupt, any human construction must be inadequate to the task and simply indicate that our perceptions are only approximations at best. In the poem these disparities cause less gloom than this may suggest, and work like a continual play of wit.

Darkness and dynamic movement are exhibited at an intimate level by Milton's impressionistic grammar, so fertile in spreading confusion or at least uncertainty about whether the word at the end of the line is a noun or a verb, about when the suspended or hovering sense will be allowed to find temporary rest or final closure. So it is a fabric in molten if not fluid state whose proportions and massing undergo change as we move through it.

The involving, even entangling movement of *Paradise Lost* reshapes the reader's perceptions in an almost kinetic way. Milton, it is often said, writes English as if it were another language, as if it had inflected endings or unheard-of connectives which could be willed into being in their absence.

A famous nineteenth-century physicist credited Milton's involuted language with inspiring in him a fascination with physical space. This is to read the poem as Baroque architecture, placing its elements vividly in space, or introducing them in sequences like optical illusions, which a few lines further on show you how to reorder near and far more appropriately. He is the most perspectival of writers, like Borromini a magician of scale. His choice of subject has guaranteed that from the beginning no single vantage point will answer to all its ranges. Even his invocation of the Muse shifts restlessly from place to place and finally to no place, the Holy Ghost brooding over the waters, covering them with wings of enormous extent, but suggesting the most confined figure as well, a prosaic bird, emphatically a creature of limited dimension.

When Satan's position in the universe is being defined we come up against abrupt lurches of size and profundity, mechanisms which work like jokes or displacements. Satan's shield is cast behind him like a shadow or like the moon, the moon that an astronomer at evening on a Tuscan hill views through his telescope. So something large, seen from

a certain point, is small and surrounded by vast empty distances, and Satan swims into focus and out again.

Then his spear is introduced, bigger than a pine on a mountain, like the mountains the astronomer on his hill finds on the moon. So the spear is irrationally relocated to the mountain within the moon, the moon which is the shield. All the while we are told how big this spear is, but feel that it is nowhere near the right order of magnitude to match its mate, by which it has just been swallowed. In dissolving frames the moon is replaced by the observer on his mount, on which a pine is growing, which becomes a wand waking the locusts which are Satan's army, which a minute ago were leaves shed by trees in Vallombrosa, a valley no longer shady when they have fallen, or the broken remnants of Pharaoh's chariots floating on the Red Sea, a later phase in the story than the locusts who formerly threatened the same Egyptian enemy.

Such rich confusions seem to breed faster in Hell. Temporal and spatial contradictions are among Milton's means of describing evil. But they are also built into our perception of God and our relation to Adam. The poet has chosen an impossible subject in the sense that all the narrative expedients he invents for rendering the unearthly and invisible are misleading in one way or another and need to be dispelled before they get too deeply lodged in consciousness.

Ingeniously, Milton identifies the fallen angels with specific historical figures, the pagan gods of whom we have distant but circumstantial accounts, like anthropologists' records of tribal practices which shade into legend which is a kind of poetry, and therefore dangerous for Milton. Can one love the names of Astoreth, Thammuz and Rimmon, as Milton clearly does, while hating what they stand for? Can the pagan gods be safely contained by locating them in Hell? Will all this learning lie down meekly and let itself be negated? It is a question met before in the *Hymn on the Morning of Christ's Nativity* and answered paradoxically by allowing paganism a long farewell appearance.

Other Baroque works have their own versions of paganism, the Other or Contrary which the ruling doctrine professes not to admit, whose presence is nonetheless strongly felt, creating an unacknowledged tension which powers the work – a tension which subsists for example in Hawksmoor's conflation of the temple and the church. Cultural ambivalence runs deep in his work and his interest in centrally planned buildings feels more intransigent than Wren's, even though more veiled. Fervently Catholic designers also exploit such contradiction,

using worldly interests to describe spirituality, or sexual passion as a model for ecstatic union with God, as in Bernini's St Teresa pierced by the angel's fiery dart executed in chaste white marble.

This was not an aberration of seventeenth-century piety – a similar ambiguity is observable in the spiritual techniques devised by St Ignatius, not himself a Baroque figure but founder of a movement which took off in that period, and the inventor of some of the seventeenth century's most telling psychic economies. One of the most powerful is 'composition of place', whereby the devotee sees in imagination the physical setting of the spiritual event: the road Christ travelled on, the room He ate in, or in the most famous meditation of all, Hell with all its horrors. This vivid imagining is only the beginning. One goes back over it in further sessions, concentrating on the consolations, desolations and moments of spiritual relish it offered on the previous occasion. Sensuous detail is not the final goal, and Loyola's systematizing of the act of contemplation leads in the end to its contrary: an inflamed love of God. The programme of the *Spiritual Exercises*: four 'Weeks', each with its overarching subject, each of whose days is broken into five exercises or contemplations, each lasting an hour, beginning at midnight and continuing on first waking, sounds rigid but is in fact hypnotic.

The *Exercises* are an important source for many overheated Baroque works. Among the most unexpected candidates is *Paradise Lost*: the fourth day of Week Two gives an unmistakable recipe for the poem's opening. St Ignatius authorizes lurid visual imagination, which the possessor uses like a chastising whip, urging himself on and then countering the effect. The *Exercises* introduce their denials of ordinary reality by means of a wallowing in the senses, and therefore lead one to the truth dynamically, by contraries. In a parallel way, Ignatius unites in his own person unearthly purity with contamination by the world. No advocate of innocence, he conducts dangerous flirtations with power from which he does not always emerge intact. Perhaps the dangers are crucial to the triumphs and the structure of his world is binary or divided, so that he seeks not peace and quiet by itself but islands of quiet in an urban sea.

Opera might provide an opportunity to realize such agitated structures as literal movement in space. One would need to know more about the staging of the earliest operas to know whether all the internal oppositions and changes of course exhibited by the voice were ever replicated in movement on stage. Monteverdi stands out from his

contemporaries in how deeply he internalizes the idea of opposition inherent in musical drama. In one of his late works, *The Return of Ulysses*, it is present in the contrast between gods and men, in the distance between rustics and rulers and in such techniques as alternate lines spoken by a pair undergoing strong emotion, a format which sounds hopelessly artificial but in Monteverdi's hands proves a way of screwing emotional intensity up to a high pitch.

The plot of *The Return of Ulysses* is in a way the simplest possible, someone coming back after an absence to those who should have given up expecting him, but haven't. Scenes are relatively short and the action is dispersed not concentrated; in fact agitation or fickleness seems a trademark of the drama as Monteverdi has decided to present it. There are amazing examples of obliquity or cross-grained movement, the luxuries of a composer dealing with a well-known story. Thus the hero is introduced mute: he sleeps through a whole scene. He is first *heard* waking up (several scenes later), musing about sleep, a surprisingly inward way of introducing a hero. In another major indirection, Monteverdi first relates the slaughter of the suitors through the eyes of the glutton Iro, who takes an entirely different view of the affair from ours.

And of all twisted movements Penelope's is the most perverse and interesting. She seems thoroughly dug into her dead end, and yet finds in despair a potent sexual charge. It is strangely plausible that she cannot let herself emerge from this partly self-constructed prison, so that even when Ulysses stands in front of her, she continues to deny that it can be he. Self-denial is a kind of safety; releasing oneself, one cannot be sure what might happen.

Underneath are deeply divided feelings about pleasure. Offered the chance of fulfilment, Penelope's instinct is to draw back. Uncertain prospects of pleasure only deepen her discontent. The Baroque taste for the unconcluded moment or work takes different forms in different hands, but this early phase can be roughly distinguished from those which precede and follow by its enthusiasm for dynamic suspension or interrupted movement which represents energy as yet unspent. The idea of Return on which the opera is built is at one level an idea about the function of time in music, about recurrence (over larger spans) or repetition (in smaller). On the one hand there is the (relatively) thought-less cycle, represented by the dance forms which carry a strong negative moral charge for Penelope; on the other Monteverdi's kind of reitera-tion, setting texts word by word and fastening on syllables which obsess

the speaker, like *mai* (never) or *torna* (return). More often than not, Monteverdi's reiterations are still looking for the meaning, not clinching it, as happens in the return to the first verses in da capo arias in Handel. His dramas retain surprising life for modern listeners in part because they remain unresolved, or at least leave us feeling that not everything has been said about the emotional state in question.

Opera spatializes music or ties it to the literal spaces of the stage. Stage productions are presumably always exploring spatial equivalents for the music while operating under severe physical limitations. Because of these, reading Shakespeare or visualizing Monteverdi at home will always be superior in certain ways to public performance – not a point of view that Baroque stage designers would have much time for, with their enthusiasm for mechanical devices which simulated storms at sea, heroes raised or gods lowered from heaven in firework-like explosions, or real fires and floods. Bernini, himself a writer of plays, was one of the cleverest contrivers of such expensive and startling ephemera. But at the same time as these materialist illusions unfolded, the music allowed listeners to map the spaces, draw them large or small, empty or full, bustling or motionless.

The centrality of the *plan* in Baroque architecture and urbanism is often nothing more than another manifestation of the enthusiasm for scenery, that is of heightened dramatic presentation of the need for order: hence the Baroque partiality for bird's-eye perspective which makes a plan look like a view, and subjectivizes it as if from a real though unobtainable vantage point, not just thinking about it with some quasi-mathematical part of the brain.

The bird's-eye and the worm's-eye view are hard to assimilate to each other. Perhaps just because Baroque buildings are often so befuddling, making powerful effects without letting us see how they make them, we need to consult plans afterwards in order to master the experience. Sometimes the study of such plans is the only way of keeping a fluent concatenation of curves and ovals in place.

Bernini experimented more than once with the expansive format of encircling arms extended from a circular or ovoid structure, the curved void attached to the curved solid, both elements aiming to evade the finite, bounded tendency of buildings. Although his church of Sant' Andrea al Quirinale looks reasonably logical in plan, one is caught off guard upon actually entering, to find the church positioned sideways, with its main dimension lying across one's path. Materials here are also

surprising: two different shades of soft red marble coat almost every inch below the cornice. One's attention rotates slowly in a space with no very strong emphases, though the main altar possesses a lantern of its own, with putti drifting up into the opening. Beneath it, a painting in an enormous frame tilts towards us like a picture hung on the wall of a drawing room. Sideways presentation works as a powerful relaxant of focus and of feelings of duty or urgency, allowing us to luxuriate in the space, sybarites rather than devotees.

Misleading, even deceitful first impressions often go hand in hand with such spaces. Like Bernini's Sant' Andrea, the Karlskirche in Vienna (illus. 3) begins with a forepart disjunct from what lies behind it. The experience within is impossible to anticipate from its façade which consists of a stretched gallery verging only lightly on the main body, as if Bernini's arms had retreated and stiffened themselves laterally like a pair of flimsy wings – except that they are lively composite affairs with open pavilions at the ends ('Chinese pagodas'), and a couple of 'Trajan's columns' jammed against the non-functioning portico.

Fischer von Erlach, the architect, was a serious amateur archaeologist who intended an ambitious fusion of cultural flavours and of sacred and secular motifs such as many civilizations have managed – like the distant and exotic ones he refers to, but not the eighteenth century which he happens to inhabit. In spite of its unquestionable learning and

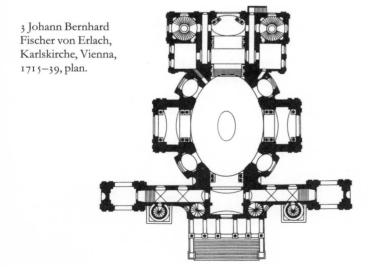

3 Johann Bernhard
Fischer von Erlach,
Karlskirche, Vienna,
1715–39, plan.

assurance this seems an attractively home-made production. It is a wonder that the medley of forms and motifs makes any kind of whole at all.

After the crazy preface we enter deviously through one of the Chinese pavilions to find the internal vessel relatively tranquil, except that again we are wrong footed: the building wide on the outside is long within. In plan it looks like an oval trying to be a Latin cross, different styles of organization at war. Like Bernini, Fischer von Erlach orchestrates two shades of red in this interior, faded liverish rose and browny pink, a colour scheme indulgent and secular, muting the intellectual rigours suggested by the plan.

When built, this church which remains out of scale with its surroundings was on the edge of the city. Another oval design, Hildebrandt's Peterskirche, contrariwise engorges a tight inner city square like an ornament too big for its tabletop. Here the oval is experienced initially as a force pushing against the walls of the surrounding houses. It seems a space secreted by a larger body or carved from a solid. So the two leading Viennese architects of the early eighteenth century employ oval plans in antithetical situations. Fischer von Erlach is building the world from scratch, and Hildebrandt relishes the crushing force of the pre-existing city, setting himself against it and thriving on the dynamic tensions of the contest.

The whole class of ovoid plans descends from centralized conceptions of the Renaissance, that perfect form which architects from Brunelleschi to Wren longed to build. This Baroque flattening of the ideal sphere, which seems perverse distortion to some, is welcomed as humanizing adjustment by others. Central spaces are grasped at once, whereas Baroque ovals encourage a succession of viewpoints.

Later phases of the style often wandered far from such relatively simple and compact forms, emerging as multi-layered ovals reminiscent of Gothic nave and aisles like Steinhausen in southern Germany, or absolute curvaceousness like Costanzo Michela's parish church Santa Marta at Agliè, a small town in Piedmont (illus. 4). This has a plan so eccentric it has been likened to a woman in eighteenth-century dress with a bulging skirt, a whimsical reading which makes sense of the strange stair passages at the sides – they become arms – but leaves you with a Dalek-sized head, the raised choir. Indeed the plan only brings into relief the inability of flat forms like plans to represent multi-layered spatial compositions which expand and contract in rhythms easier to model than draw.

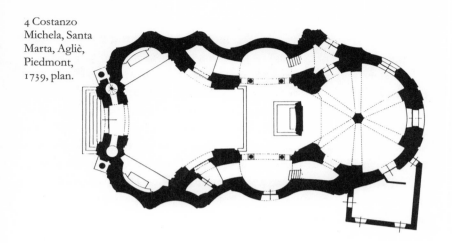

4 Costanzo
Michela, Santa
Marta, Agliè,
Piedmont,
1739, plan.

The building at Agliè sits on uneven ground and its left-hand flank, rising from a lower starting point, is one of the most wayward stretches of wall in Europe, a flexible skin which sucks in and blows out like irregular breathing. The main mass has absorbed a triangular tower which juts out above but is continuous below with the rest of the ridged and melted substance, semi-liquefied and intermittently stiffened. One looks at the plan and sees an irrational variation in the thickness of the wall, until one reads the thickenings as rational buttresses disguised as momentary ripples in a surface, a conjunction not to be met again for a century and a half in Gaudí.

Other works by this very local architect, of which there aren't many, have none of this building's exuberance. Where did it come from? A priest or patron of adventurous disposition? Nowadays the brick fabric is exposed, unusual in Piedmontese churches of this type, which conveys a misleading suggestion of a modern interest in expressive materials. A few seventeenth-century precedents exist: when Borromini built in brick at the Oratory of the Filippini attached to the Chiesa Nuova in Rome, he tried to make it look like a single piece of sculpted clay, and his follower Guarini in Turin (nearer home for our architect in Agliè) revelled in the material's sculptural potential. Even so, Agliè remains a freakish outburst. But often the freaks of disparate styles share more with each other than with their literal kin, and there are whole modes tending naturally to freakishness. Late Gothic is one and Baroque is another. Late Baroque architects like Bernardo Vittone and Cosmas Damian Asam are among the prize eccentrics of Europe.

There is at least one other important class of destabilized plan, based on raying diagonals, of which the most startling is the hunting lodge at Stupinigi near Turin (illus. 5). In plan it seems clear if megalomaniac, and neither Juvarra the designer nor someone who wants to illustrate it knows where to stop. It replicates itself like a runaway molecule, adding arms in every direction, mirroring a hemicycle of stables with another and then further wings at forty-five degrees, which spread the infection over further acres and may fill up with functions or perhaps only connect one set of princely apartments with lots of others. One could almost imagine its goal was to transfer the hunt indoors. Horses would make sense as a means of traversing its great intervening passageways. Oddly enough, much of Juvarra's spatial ingenuity collects at the termini where, instead of trailing off, peculiar spaces multiply – bedchambers at different angles joined by hallways and boudoirs which practically no one is allowed to enter.

Stupinigi's plan is scenographic in unpredictable ways. From subsidiary wings thrown out diagonally by the main body one gets raking views back to the palace and unobstructed glimpses of the park as well, so that every seat in this theatre can turn towards the centre, unlike plans

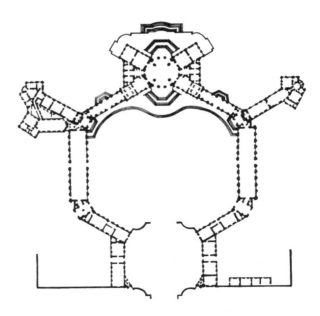

5 Filippo Juvarra, Hunting lodge at Stupinigi, near Turin, 1729–33, plan.

like Versailles where one simply becomes further and further removed from the centre. But Juvarra's sense of scale has run away with him: corridors which give painless entertainment in plan are boring in reality. Still, he never produces anything as dull as the long straight file of Versailles with its stranded ends.

Especially his grandest projects replicate theatrical scenery – the unfinished palace at Venaria (another hunting preserve on the other side of Turin) even more than Stupinigi. Here the scale is so huge he doesn't even pretend to complete the plan but appears ready to build only half of a hypothetical whole – as in that eighteenth-century convention where only one of the matching sides of a symmetrical façade is actually shown. So here the plan is content to sketch the whole by materializing one of a bilateral pair. The result is like the irregular diagonals of the Katsura villa in Kyoto, in every superficial way the work farthest from Juvarra's giant folly, so impossibly large it cannot reasonably be kept in repair all at once, a conception dynamic like a one-legged man who makes walking painfully dramatic.

Juvarra probably comes nearer than any other architect to realizing the principle of the vista in a single structure, the principle that is of extending the ordered control of the plan to whole landscapes. A favourite form is the goose foot which is much easier to grasp in a park where raying paths are routes one could walk or ride but can survey clearly without taking a step.

In urban settings social activity always half obliterates the geometry of such schemes. One of the most extensive seventeenth-century im-provements to Rome was a goose foot or trident of three diverging avenues starting in the Piazza del Popolo and heading for the centre. The middle one or Corso became the busiest street in the city. Partly for that reason, no one ever saw all the possibilities of this plan at once except when looking at the map. The setting was always too big and congested for anyone to fit converging and diverging views into a single outing.

It is even possible to study the map and be so distracted by other features that one misses this gigantic regularity. Undoubtedly when they were new the straightness of these streets was more startling, but perhaps the scale was always too grand and the vistas too long and unclosed for easy grasp. The via del Po in Turin has more chance of being noticed, a single diagonal in the grid fabric. Where it reaches the river it runs into a gigantic new square, and at the other end its path is blocked by a major monument. Even so, you can imagine an inhabitant

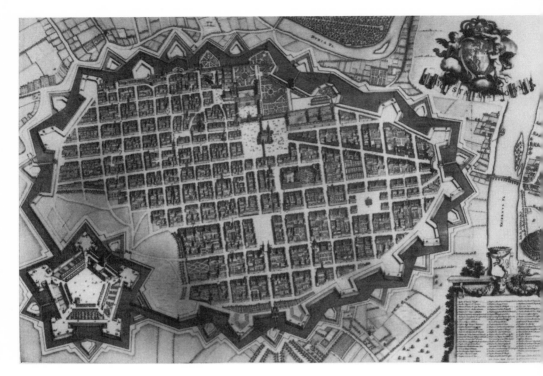

6 Gian Tommaso Borgonio, Idealized view-plan of Turin, from *Theatrum Statuum Sabaudiae...*
(Amsterdam, 1682).

who has never seen a plan missing entirely the sense of power flexing
itself in this diagonal which cuts through the inertia of the grid (illus. 6).

If it doesn't strike you on one occasion perhaps it will on another.
Juvarra's largest gestures of this kind can seem the purest wishful thinking,
and yet, there they remain in a ring around Turin, above all Superga on
its perch, a votive church on a steep hillock seven kilometres from the
city centre. A web has been drawn of all the royal emplacements which
ring the city in which the furthest vista, between the palace at Rivoli
and the church and monastery at Superga, is nineteen kilometres, said
(erroneously) to be the limit of unaided human vision.

Although Juvarra conceived plans on the largest scale of any
Baroque designer and built some of the heaviest of all Baroque struc-
tures, the final goal of all the masonry is an optical effect. He never
outgrew or renounced the perspective of the stage designer who
creates dramatic spectacles that interpose as many layers as possible
between the viewer and the endpoint. The straight line from Rivoli to

Superga is in some sense a conceptual distance, because no one can make the journey along the shortest route.

But links between the various palaces around Turin are not simply elements of a static pattern. The power of the rulers shows itself most starkly in their easy command of these distances. Their scattered seats give a prospectus of their control of territory, an impression strengthened by finding that the intervening journeys are quite a slog for ordinary folk. The ruler is not compelled to make the trip: for him it is always a triumphal progress because the place where many other people want to be is moving as he moves.

The ruler's triumphal progress, a classical form resurrected in the Renaissance, came into its own in the seventeenth century. New routes which cut through medieval tangles like famous examples in Palermo or Rome could give the idea a kind of permanence in generalized form, but basically such processions were extravagant eruptions leaving barely a trace behind. The city became a stage enhanced by flimsy scenery, its meanings expressed in fleeting grandiloquent gestures.

If such events could ever be calcified or captured it might be in showy fountains, but for the most part it would have to be indoors. One of the great Baroque forms where actual and implied movements meet is the ceremonial stair hall, found in semi-outdoor form in Naples and indoors in Austria and southern Germany. Opportunities for spatial extravagance in the form are enormous. It calls into being a double or triple height space through which we move at once laterally and vertically.

The stair is normally a useful device but in the ceremonial version becomes at least as much an instrument of delay as of progress. The building is elaborately introduced so we hover on the threshold bringing with us sensations of the outdoors, of freedom and an open sky above, glimpsed as the flight turns back on itself in Naples, depicted overhead in Germany by magicians like Tiepolo.

So a represented movement is added to the actual one of climbing: above climbing there is flying. In a few Viennese examples our path is also framed by muscular stone figures heaving slabs of stair powerfully upward. Such dramatization blurs the edge of the building by allowing natural wildness to enter living spaces, as if keeping alive the idea of the building site or showing how rooms were carved out of cave-like material. Outdoors, an exterior stair sometimes extends the building's influence in complex ripples or rings. So Baroque staircases

soften or strengthen the building's relation to its context, making it more active and dynamic by stretching out the moment of transition between inside and outside.

Military defences often have a strange afterlife in this role. Outlying bastions converted into gardens became an enlarged equivalent of stair-transitions. In Marvell's *Upon Appleton House* Fairfax builds a mock fort with five bastions for the five senses. Ramparts have become flower beds, because the general has taken up gardening: in mollified land-use we trace the progress of civilization.

How conscious is Sterne of reversing this process when he shows Uncle Toby disrupting the rural peace of his garden in *Tristram Shandy* by importing memories of the battle of Namur, and rebuilding, if only in miniature, the artificial land-forms which accompanied that carnage? Perhaps the writer relished turning this particular curve back on itself. His mind could move in surprisingly emblematic ways, as in the famous squiggle page (illus. 7), which purports to show the shape of his narrative, a parody of Rococo curves at their most irresponsible. This prankish

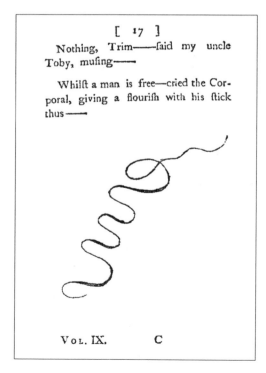

7 Laurence Sterne, 'Squiggle page', from *The Life and Opinions of Tristram Shandy* (London, 1759–67).

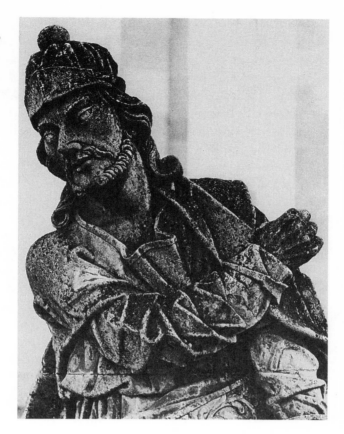

8 Aleijadinho, *Ezekiel*, Santuário do Bom Jesus de Matozinhos, Congonhas do Campo, Brazil, 1800–1805.

attempt to draw a picture of the plot throws him back a century earlier to George Herbert's poems in the shape of angels' wings, altars or the divine name.

One of the most striking examples of a transition between art and landscape as an emblem field are the extensive bastions populated by statues at Congonhas do Campo in Brazil. They are the culmination of a shrine strung out along a slope. Lower down, six chapels contain scenes from Christ's Passion; at the top the balustrades of the terrace support Aleijadinho's twelve Old Testament prophets, who have broken free of confinement in buildings to confront the surrounding landscape. Aleijadinho, reputedly a dark-skinned dwarf, has infused the exaggerated outdoor scale of gesture familiar in hundreds of Baroque garden figures with an indoor level of intensity: his Prophets exhibit a heart-rending individuality (illus. 8).

The Sacred Mounts from which Aleijadinho's congery derives are usually larger in scale and more elaborate in their programme. Coming to them now, we can hardly help thinking of Disneyland. They always consist of a set of separate pavilions widely spaced in a woodland landscape. Each pavilion contains a lurid scene in the life of Christ or the Virgin or St Francis, scenes made up of painted terracotta figures in lifelike poses set in intricate spaces which you view through wrought iron grilles or fictitious 'windows' (illus. 9).

This studied fictional quality brings Disney to mind, as does the unashamed sincerity of depiction. But there lies the root of the difference as well. For the Sacred Mounts are a passionate propaganda from which nothing is allowed to distract. There is no selling here, no importuning, except for the quaint seventeenth-century collecting boxes built into the screens between you and the drama.

By Disney standards the capacity of a territory to support amusements is not well exploited, for at least as memorable as the pavilions with their lifelike fictions are the in-between spaces. A Sacred Mount is an allegorical journey which makes doctrinal points real by putting physical spaces between them and thus making them into places you can visit. Like Ignatius's *Exercises* they manage to impart an idea of internal distance to concepts or states formerly not seen as spatial at all. The best Sacred Mounts are in favoured spots and a visit to them is like a woodland walk.

You are given a plan which plots all the stops, though you could manage without it, for they are usually all numbered – at Orta with a hand painted on the wall of the previous shrine, pointing the way to the next goal. One of the best features of the whole experience is this sensation of distinct goals. If only one's everyday life were numbered and labelled and stretched ahead with easy flower-strewn climbs between each stage of one's progress.

An acquaintance with the saint's life gained from a source like Sassetta's pictures in the National Gallery would equip the visitor with more incidents than can be shown at Orta. In between the episodes – an interval which expands as much as one lets it, being one's subjective commentary on one's reading, like the pages left blank and headed 'Notes' at the end of badly planned books – one may think about the 'other' scenes, those which are not illustrated. These intervals make the composition Baroque over all if not always, strictly speaking, in detail. As wholes, Sacred Mounts are mixed, unruly, asymmetrical, and this in

9 *St Francis Naked in the Streets of Assisi*, Sacro Monte, Orta, Piedmont, second half of the 17th century.

spite of adorning a landscape with perfect little Renaissance temples.

Of all the tableaux, crowd scenes are among the most compelling, partly through the contrast between their commotion and the general peacefulness of the setting. The spectator moves around the scene viewing it from different angles, guided by the peepholes to consider now one and now another character's emotions. After a while it becomes a slightly formulaic procedure, a kind of Spiritual Exercise which uses all the dramatic ramifications of a situation to keep one thinking about it for an unusually long time.

Bernini apparently followed St Ignatius's *Exercises* in his own devotions, *Exercises* which among other things encourage the practitioner to cultivate a vivid sense of place and to fill in as many of the original sensations as possible to bring to life the idea of Hell or Christ's suffering. Dissecting experience in this way expands it by subdividing it and creates space and movement where previously there was none. In order to extract the maximum meaning from each part, Ignatius advises the

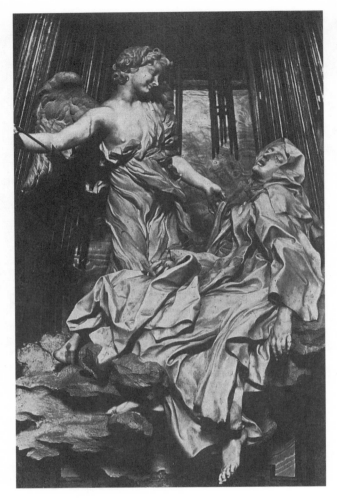

10 Gianlorenzo Bernini, *St Teresa in Ecstasy*, Cornaro Chapel, Santa Maria della Vittoria, Rome, 1645–52.

devotee to work through the five senses one by one. Placing them against each other in almost adversarial fashion can have unexpected results, pushing each to overheated excess, encouraging histrionic over-development.

Bernini's *St Teresa in Ecstasy* (illus. 10) shows signs of this, being built on a set of dynamic contrasts strong to the verge of paradox. It describes visionary experience through intense sensuality, an alert childish male set against a swooning mature female, an image of care-free pleasure against preoccupied pain. In her autobiography the saint depicts these two incompatible sensation-emotions following immediately on each other's heels in her single consciousness.

It is an astonishing passage that the post-Freudian reader cannot help sniggering at – doesn't the nun realize she is describing mainly sexual longings? Indeed, a few lines later she recognizes that it is like bodily seduction, but only as an opening or avenue for another kind of experience. Human sexuality or even the senses cannot have the primacy for Teresa or Bernini which they do for us. The shocking reciprocal movement which grabs our attention so forcibly is not intended as sensational; it aims to jar us into another place entirely.

Recently the whole Cornaro chapel along with Bernini's sculpture has been returned to what was presumably its contemporary gaudiness. Now more than ever it is a prime example of earthly riches as the path to spiritual truth. Saint and angel are no longer a standoffish white but a buttery cream which makes them luscious, almost edible. The symphony of coloured marbles around them inescapably suggests confectionery, for ochre marble is iced with white clouds and angels which are clearly laid on. The hyperactive gestures of the Cornaro notables (mostly dead a hundred years when sculpted) are more stagy than before, *pace* Wittkower, Blunt and all the others who want to make this vulgar and distracting luxury into thoughtful aids in a long spiritual ascent.

It has even been proposed that the ancestors are thinking, though not seeing, the vision, making them essential generators of the whole scene. Those who find the subsidiary actors' devotion unconvincing should concentrate on the central tableau, for here Bernini has outdone himself in imparting movement to the marble on the most intimate scale. In fact it is one of the first examples of figure sculpture as abstract energy, present more extensively and powerfully in drapery than in faces, hands or feet, a shift of focus later carried to the most extreme heights in central Europe.

In the Teresa group there are two kinds of drapery, the angel's aspiring upward like tiny flames which wrap a body as they are consuming it, and Teresa's more torpid sort sagging back to earth like an infinitely complex impediment. If it is a war between these two beings and these two forces, it is also a depiction of the soul in the form of the angel leaving the body in the form of the saint. Both figures are shown in ambiguous motion, drawn to and repelled from each other. If one tracks Baroque movement to its smallest units, psychological or physical, the gesturing arm, the fold of drapery or curl of plaster, one finds sentiment and material interfused, gestures become abstract,

froth of stucco become instinct with emotion, both vehicles of similarly elemental energy.

This work spawned a series of expiring or ecstatic female saints in Roman churches, but the influence of its centrifugal conception of sculpture was more widely and diffusely felt. One of the more formally gratuitous manifestations of Baroque figure composition as matter become hysterical (Deleuze's phrase), of its energy as almost a disorganizing force, is the plague column which sprang up all over eastern Europe with the plagues of the 1690s and the next two decades. They commemorate delivery from it rather than the infection itself, of course, but nonetheless it is odd to find something which one might prefer to forget so gorgeously remembered.

The specific ancestry of these columns is classical as filtered through the exorbitant piety of Naples, where the first plague column was begun in the 1630s. Next came Bernini's embellishments of Egyptian obelisks in Rome, one stuck on top of a rocky tree-girt mount from which water gushes to make a fountain in the Piazza Navona, and another, fake this time, placed on the back of a baby elephant, a relatively Egyptian kind of animal.

By the time we arrive at the plague column on the Graben in Vienna, perched on Fischer von Erlach's two-storeyed, three-sided base with concave railings, the obelisk has disappeared into the pillar of cloud, the sign sent to Moses in the desert (illus. 11). But this cloud is heavily populated with putti who convey the idea of ceaseless activity and of earthly forms converted to heavenly. Like the similar eruptions round the masts of the barque in Watteau's *Embarkation for Cythera*, the putti represent a desire to obscure the skeleton underneath. Pillows of cloud and fat babies are more likely to evoke bedrooms and assignations than spiritual flights, intimating that the healing force which descends is in some way transgressive, part of a disobedient Baroque desire to overspill boundaries.

Besides plague columns and saints in ecstasy, who may be supposed existing in a realm between earth and sky, there is another form of supernatural vision brought within reach of earthly senses in the Baroque, the painted heaven found on church and palace ceilings. Such ceilings are among the strongest Baroque protests against the boundaries and closures of architecture, which are all founded on the fiction that the roof does not exist, allowing the space we are in to extend upward out of sight. We have come inside only to find our view widened

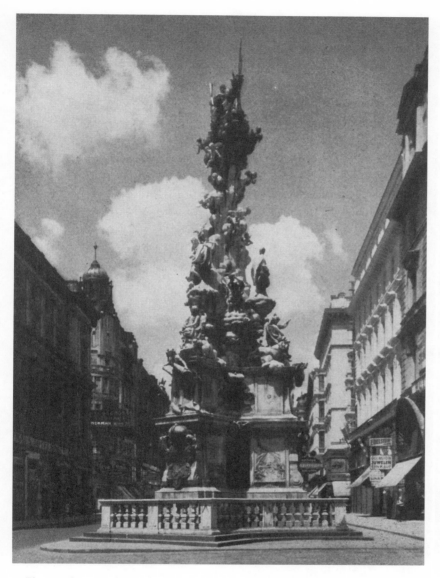

11 Plague column on the Graben, Vienna, 1682–6 (base by Johann Bernhard Fischer von Erlach).

not enclosed, and range on range of a superior realm revealed. Or rather that is one form; but there are at least two different types of Baroque ceiling-vision, the more intellectual of which was perfected by the Jesuit Fra Andrea Pozzo who worked in Rome and northern Italy before ending in Vienna.

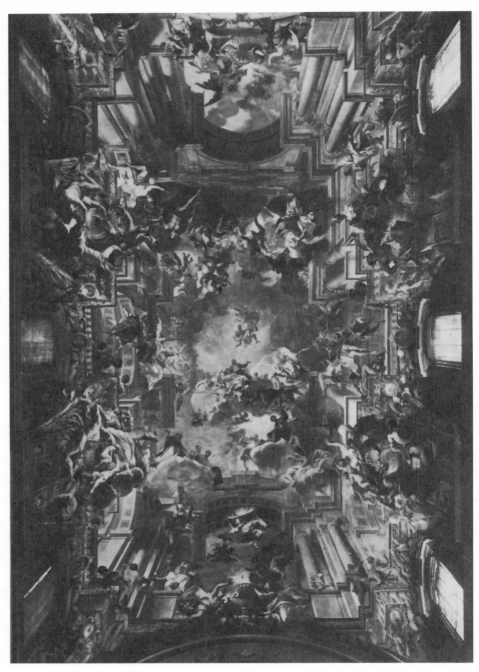

12 Fra Andrea Pozzo, *Allegory of the Missionary Work of the Jesuits*, ceiling fresco, Sant' Ignazio, Rome, 1685–94.

The typical Pozzo ceiling, exemplified by Sant' Ignazio in Rome (illus. 12), shows figures in steep flight viewed through a screen or fringe of painted architecture. Often the fringe steals much of the show. The stonework, of appalling heaviness, would be monstrous if built, but because it is painted, our admiration increases the more improbably these balconies, balustrades and vaults loom and block the painted light. The painting makes the architecture levitate, as if it too along with the foreshortened figures flees towards the vanishing point in the centre of the space.

Pozzo is sometimes faulted for creating visions which only work perfectly from a single spot, when you are centred under the axis of the vanishing point. Elaborate diagrams in his publications, revealing the secrets of these illusions, might lead one to believe in ideal angles like best seats in a theatre, but actual experience of his visionary spaces belies this. In Sant' Ignazio the whole vessel of space above, mirroring the body of the church below, tilts as one moves, like a ship strongly buffeted by waves, swaying from side to side. It is hard to stop playing the game of changing your position and seeing the space overhead shifting in time with your movement. Like some of Loyola's practical recommendations, Pozzo's ingenious machines do not fit conventional notions of the spiritual. Such visions are hard edged and rational, starting in stony pomp where our attention is snagged on the interesting props, which we ought to use simply as a telescope for looking into the realm beyond. Bernini, for one, expressed disapproval of the genre, though contrariety between one's goal and the medium one uses, between ensnaring earthly forms and the ultimate heavenly aim, is exactly what we keep finding in his own work.

The other less intellectual kind of ceiling gives less space to an earthly prologue and is less common in Italy than further north. In the great examples, like Franz Maulbertsch's frescoes of 1752–3 in the Piaristenkirche, Vienna, a set of different spaces unfurl continuously in series. From further away it almost looks like abstract painting and individual figures dissolve unless one makes a determined effort to bring them into focus.

Whereas Pozzo's ceilings give you a comprehensive underview, allowing you to survey the scene by peering through a frame which just happens to be overhead, the other kind sweeps you along in a careening movement, so you no longer inhabit a stable grounded place but move freely through an enlarged universe. If you look hard enough, you will

find bits of fictional architecture in Maulbertsch, continuing a world of built form beyond the closure of the vault. But the colours blur this solidity, and stucco ornament suggests a lower horizon than the cornice, as if more of the world has been converted to sky than the space of the vault alone. Perhaps the predominant white of Rococo interiors is indeed to be read as cloud-substance and the plaster frills round niches as a stylization of the mist.

One could imagine an ideal marriage between Bavarian Rococo architects and Tiepolo, the painter of the most compelling sky effects: a meeting which indeed took place in several rooms of the Bishop's Palace in Würzburg. But the results are disquieting. Tiepolo renders the most exciting turbulence in all of Western painting before Kandinsky. Why then is it not enough to be given this coruscating substance, full of solid bodies which refuse to hold still? Why do we ask for more, instead of savouring the startling combination of overpopulation with the evacuation of meaning? Tiepolo is so obviously an anti-profound painter that it seems perverse to quiz his saints who often resemble bored foot-men on duty for hours in a draughty hall where nothing is happening. Sometimes it seems that the price of his escape from gravity is a complete absence of expression, as if Tiepolo's facility of movement, both of hand and motif, is only possible beyond the sphere of individual differences.

Even in a Decapitation he diverts our attention to the sheen of satin; people's clothes are regularly more interesting than their expressions. Not that he hasn't made a conscious study of human moods – it is simply that he so often elects to portray boredom, distraction or inattention. His saints in ecstasy thus make a telling contrast with those of the earlier pietistic Baroque and his skill is mainly employed on the beautiful distracting clutter which surrounds the putative centre. In the second-rate ceiling painters of Bavarian Rococo this metaphysical emptiness in spite of physical crowding is no problem, but Tiepolo makes us uneasy because he is so good *and* so shallow, deploying such painterly intelligence in denial of thought.

Unlike many other Rococo painters he does not shy away from subjects of extreme violence. Though not afraid to depict pain or cruelty, he refuses to enter them. Skill in defining forms has come apart from any troubled human understanding of what is painted. It is an inversion of Cézanne's imbuing any object however trivial with the same overriding significance – Tiepolo imbues everything with the

same meaninglessness. Unlike his contemporary Watteau he conveys no unease in this quandary, but to us the props which fill his skies seem the mental goods one rushes out and acquires in job lots to fill up a vast emptiness, to protect oneself from the chill of a pervasive draught sweeping through the old pre-scientific universe. So the tumult in this painted heaven hides a dearth, and even Tiepolo, in some way the most justifiably confident of painters, is, though not at the level of paint, a typical case of Baroque overconfidence.

The ceilings are doubly out of reach, in what they depict and in where they are, but their remoteness is a large part of their message. More surprisingly, Tiepolo often feigns something similar in the seemingly more grounded altarpieces, like a splendid picture of martyrdom by stabbing in Bergamo. Here something which looks like an angel's raised wings is the white surplice of an expiring saint with outstretched arms. The lacy ends of the sleeves attenuate to spidery hands. A gilded cope slips from him in complex curves. His executioner's face is so cleverly foreshortened we can see only the bridge of the nose peeking from beneath the brow, whereas the saint viewed contrastingly from beneath shows impossibly prominent nostrils. As usual our attention is distracted on to liveliness of presentation, like a magic trick in which reality is conjured into something else, as in beheadings dominated by a silvery sheen, where colour harmonies supplant any inkling of distress. Perhaps an agitated surface conveys a transformative vision, a transversal of values in which hideous realities are reversed by a movement more like extravagant wit than spiritual discovery.

The literary equivalent of a Tiepolo ceiling is a work like Marvell's *Upon Appleton House*, another engine driven by unnerving wit, a wandering poem of Rococo brittleness and Gargantuan, hence truly Baroque, ambition which becomes intermittently uncertain about its own dimensions. It is by far Marvell's longest poem, highly individual in character yet conforming to a recognizable type of country house poem, which runs from Ben Jonson's *Penshurst* to Pope's *Epistle to Burlington*. They typically combine Virgilian advocacy of rural life with a proto-romantic enthusiasm for landscape and quasi-patriotic praise of a patron. Unlike many authors of such poems Marvell spent several years living in the house and landscape he writes about, as tutor to the daughter of Fairfax the Puritan general (who incidentally spared the medieval glass of his local cathedral at York).

As Tiepolo converts ugly martyrdoms to dazzling refractions of

paint, so Marvell makes of his prosaic subject an unpredictable mental journey. One of the most surprising and exquisite sections for instance gets over the ticklish problem of how a nunnery became a private dwelling. After his philosophical and historical introduction it seems Marvell will descend into an ordinary present. But in crossing a field he is reminded of ancient Egyptians and mythical events like the Deluge. He domesticates the emblematic mode of Biblical interpretation, turning it loose on ordinary experience with profound consequences. Bernini enlivens the sacred with secular energies; Marvell produces similar conflations in the other direction, a sanctification of the everyday. In some ways he is the most shockingly mundane writer, training impressive machinery on to trivial subjects. But in Marvell philosophy means turning the world upside down and finding the gigantic in the minute.

The poem opens with exhilarating confusions of inside and outside, which prepare one for the vast mental distances one will be asked to cross within the confines of a line or a stanza which masquerade as tiny. Marvell runs through an elaborate gamut of sizes and out the other end. Human scales from ordinary to sublime are set against the larger rhythms and concerns of nature, which reach their conceptual apogee in the idea of the bee's cell, significant as only a room or integer in a vast sum, yet linked to Romulus' hut, the generator or seed of the largest empire ever conceived.

This slipperiest of writers is at his most elusive in *Upon Appleton House*, for which he has devised a structure which mirrors his subject. Like a landscape this poem looks different at different moments, travels at different speeds in its different parts, mixes nature and culture, subsuming opposites partly as a means of escape from entrapment in any single attitude or intellectual standpoint. Like other Baroque works it believes in evading fixity as an end in itself, a fluidity compatible with the most gem-like summations of perception.

The poem's perfections are mostly fleeting. The longest, oddly, is the nuns' defence of the cloister, in which Marvell gives full rein to virulently anti-Catholic feeling. This section is deeply paradoxical, for Marvell gets some of his most exciting effects from the subject he professes to despise. Like the nymph in his *Nymph Complaining of the Death of Her Faun*, Marvell's nuns are silly creatures in touch with a seductive myth, this time a sensuous but purified universe peopled entirely by women. He is preternaturally alert to this world's potential corruption, a complication which

multiplies its allure. Catholicism seems all the more interesting by virtue of the moral contradictions inherent in it.

Reading satire in an opposite sense, as if the writer seeks a way to enjoy the presence and even the mental habits of the enemy, seems a dubious practice. But in Marvell our suspicions arise because his devices for describing the Catholic enemy come so near the favourite methods of that arch-Catholic Richard Crashaw, who has always been considered the most Baroque of English writers.

Crashaw's father was a moderate Puritan cleric, and the poet converted to Catholicism while at Oxford in a climate where this was a decidedly unpolitic thing to do – or perhaps one should say, in a polarized world, where extreme positions became more easily thinkable. Crashaw is a fascinating cultural (if not also psychological) case, with the convert's infallible nose for the least Protestant features of his new faith. Nowhere else can one find such concentrates of martyrdom and blind adoration of symbolic trappings like Names, tears, hearts, wounds. Intensely literal and physical entities become abstract in this obsessive focus. Talking so persistently about Christ's Blood or His Name, Crashaw makes us think that he must mean something else, that his emblems must be substitutes.

He combines in the most unexpected way dramatic violence and narrative inertia, lurid ideas lined up in agglomerative, monotonous series. In spite of his overwhelming enthusiasm it remains an outsider's view, Catholicism seen and embraced from an indelibly Protestant perspective, forced to contemplate the purest quintessence of the not-Self. A comparison between Bernini's and Crashaw's St Teresa, though a tired cliché of criticism, is revealing. More Italianate than any real Italian, Crashaw is an embodiment of pseudo-Catholic, pseudo-Baroque, driven to a more hectic form of motion than the more leisurely rhythms of Baroque in its homeland.

In some matching way Marvell is a pseudo-Puritan, who enjoys the forbidden Catholic material too much for comfort, to whom it represents a bolt-hole for powerful sensuality licensing inappropriate marriages – between the spiritual and the military, for example (defending themselves the nuns fire off the chain shot of their beads) and between religion and fiction (the nuns are gypsies or denizens of one of the haunted castles of romance).

Thrilling violence of thought occurs more easily in alien territory. Marvell compresses wild movement into spaces in some sense confined

– the obscure history of an insignificant English house, short lines and demure stanzas. But the abruptness of his thought constantly opens abysses beneath our feet, like miniaturized caricatures of those grandiloquent Baroque gestures, which while reversing direction startle the spectator into an outpouring of tears or loquacity. By a law of contraries the Baroque, an arch-Catholic mode, is sometimes embodied best by Protestants hankering after Catholicism or converts to it, who are preternaturally alert to those tensions and anxieties, that absence of repose which gave birth to the Baroque.

II

TORMENTED VISION

THERE IS A STRANGE PAINTING in Vienna which shows an old saint wafted aloft by an angel and a putto. His robes are a mass of flickering patches, like shafts of light through clouds. Most obscurely illuminated is his head: because the twists of his robe make the body hard to locate underneath, we cannot be sure which way his head is turned (illus. 13). Here the excitement of unusually mobile paint makes it urgent to understand what is happening. But the spectator's first mistaken impression that the saint's glance is following the movement of the whole composition, looking upward and left, never really goes away. It reminds us that vision is tricky and that often we do not comprehend what we are looking at.

Maulbertsch's picture is an extreme instance of the eccentricity of Baroque vision, which delights in strange angles of approach, as if to suggest that oddity is a kind of norm and that we are usually standing in a place which gives us only a partial glimpse of the world. When such angles of vision are reproduced in art they show us that interpretation is a necessity, not a luxury. By this means an insistence on our limits can point towards our ability to transcend them.

Distortions caused by individual perspective are not fixed prisons but points on a continuum, and the twists and turns of Baroque substance refer not to eternal verities but to unpredictable coruscations of highly individualized matter. Instead of a permanent spiritual fact, Maulbertsch's saint represents a reality predominantly unstable and about to leave the present state behind never to return.

The saint in this picture cannot be positively identified. An earlier theory that he represents St Narcissus is now judged more precise than the evidence warrants. A mitre and a sword identify only a bishop-martyr,

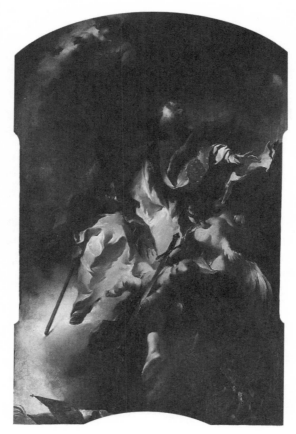

13 Franz Anton
Maulbertsch, *A Bishop-
Saint* (? *St Narcissus*),
c. 1754.

and there are plenty of those. Nonetheless we detect a generic individu-
ality here, defined partly by our own relation to the phenomenon we are
looking at. Something which can only be apprehended sideways works
in a peculiar way. We don't have the succession of angles we have with
Hamlet or other truly complex characters, and so it remains a lopsided
particularity like that of characters in opera.

The ritualized arias in Handel's Italian operas, which come in three
parts, provide the equivalent of intense peephole views on to character,
characters who thrash about within a single moment of emotion, as if
providing a detailed explication of the sideways vantage of one of
Maulbertsch's saints. In Handel the odd perspective is seized and then
given a prolonged shake; thus what seemed preposterous at first is
now firmly established. Unbelievable motives or unlikely projects have

become part of the furniture, so the next sally can be launched from the new beachhead.

To talk about the individuality of these characters and procedures still seems perverse. In Maulbertsch the focus on extreme emotions or internal plights flamboyantly exhibited for an unacknowledged audience (saints don't have their ecstasies just for us) begins to call something out in the viewer which may be the earliest inkling of what will later appear as Romantic subjectivism.

The format of Handel's operas puts one human integer after another under the sort of microscope that no stage-works had yet employed. Handel's texts are hypnotically reiterative. Their simplicity, which might seem inanity without the music, creates just the right interference with the autonomy of the music to define inner states. But it remains a mystery that this gregarious genre, notoriously at the beck and call of the egos of performers, should have become the testing ground for radical experiments in self-inspection, with results which are for long stretches deeply introverted in spite of being paraded for all to see.

An earlier stage in the conversion of Baroque extrovert expressiveness to Romantic inwardness is found in Rubens. One of his key ideas, that of seeing from below, is suggested in the first place by a commission to do thirty-nine ceiling panels for the great Jesuit church in Antwerp, among the most significant projects of his entire career. Ripples caused by this necessity spread through his later work, influencing his vision in crucial ways.

It is generally agreed that Rubens himself executed only the small models for these panels, which were then used by his assistants, including Van Dyck, to produce full-size versions. From the beginning therefore Rubens was obliged to conceptualize the problem of seeing from beneath. Nothing he himself produced was going to be seen that way, unless he constructed experiments in which he placed his reduced models a short distance overhead to simulate their location inside the church, studying in this way the effect of some of his proposed distortions. Just as likely, once focused on this set of problems, Rubens could have rigged up a means of viewing live models from directly beneath, or high overhead, in his very large studio.

The surviving *modelli* show the immediate fruit of any such experiments which may have taken place. Rubens has been stimulated to find new spatial possibilities in the vertiginous approach, until figures in palatial settings move like mountain goats, striding across chasms or

14 Peter Paul Rubens, *Modello* of *Esther before Ahasuerus* for the Jesuit church, Antwerp, 1620–21.

leaning eerily over the empty space beneath them (illus. 14). He thus makes the void between them and us active, or brings into being the space in front of the picture.

It would need careful study to specify the full effect of these exercises on Rubens's later vision. In the first place more than a third of his *modelli* are lost and all the full-size mock-ups perished in a fire in 1718. Nonetheless it is clear that these radical studies of the effect of vantage point on the way we understand the world had energizing repercussions on his approach to figure composition ever after. The most obvious is perhaps the incorporation of multiple viewpoints in a single frame, brought about by such devices as locating some of the figures on plinths or at the top of stairs, allowing him to depict them looming over us.

These platforms can be so low as to be almost notional, as in the one from which Decius Mus addresses his troops (in an oil sketch in Washington), but they still allow Rubens to practise the set of tricks which leaves us reeling under the leaning figure. Or figures can be shown flying overhead. The circumstantial justification is that they are angels or other spiritually privileged beings. But this seems misleading in our effort to understand what these elements contribute.

They energize parts of the space which would otherwise be taken up with inert architectural members or empty sky and give the sensation that it is a continuous fluid medium or force-field across which complex muscular spasms operate. It is a vision where none of reality keeps still and the universe expands centrifugally. Earlier in his career Rubens had created a sense of sprawling energy by letting the composition overspill the frame, like the huge limbs of Samson thrusting diagonally towards the edge in London. Later the system of powerful asymmetrical forces is less overtly rambunctious, no longer posing such threat to the edge of the picture space. But the later work encapsulates a more profound restiveness with gravity and the sense of a top and bottom it imposes on any view.

For a later painter more deeply infected by the tilted vision of illusionistic ceilings (as opposed to conventionally viewed scenes pasted on to ceilings, as in Michelangelo and the Carracci), consider Tiepolo who pushes into the grotesque, depriving an expiring saint of all facial features except his upturned nostrils and reducing the upper part of his executioner's face to a concealing brow. Here not recognizing what we are seeing licenses us to feel little or nothing, taking a technical interest in exactly what slope of the body is required to produce such absences. So one destination of Baroque interest in expressive gesture seems to be clinical study of certain inclinations of the body.

Much more literal experiments with angles of vision occur in the Sacred Mounts of northern Italy, though of course the aim is the opposite of detachment. It had long been the practice to tell sacred stories as series of distinct episodes, the reverse side of Duccio's *Maestà* being one of the most elaborate instances. But it was a relatively new idea to break the separate scenes apart and then to make actual and enterable the intervening spaces, replacing a painting with a landscape dotted with art objects, which the spectator could infiltrate and dramatize with a new intensity.

This Counter-Reformation institution, of devotional circuits with

intermittent physical reminders, shares to a surprising degree Protestant focus on the workings of the individual psyche and conscience. Though the lurid cues in the form of life-size sculptural tableaux were a late, more exuberant flowering of the image-world which Protestantism swept away, their cultivation of peculiar psychologies of belief would have been perfectly at home among Bunyan's Baptists or Pascal's Jansenists. And the Sacred Mounts had at least this in common with Disneyland, that they were meant to appeal to ordinary unlearned folk, not to settle fine points of theological debate, but to awaken emotion in response to the human import of sacred narrative. At Varallo in particular the drama heats up towards the end, as Christ is shown abused in a variety of settings, spatially but not doctrinally distinct. The main difference between the two separate tribunals of Pilate and Herod in which Christ is successively arraigned, is that the first is shown sideways and the second head on, and that the first is a vestibule or antechamber and the second a throne room or audience hall. At this point in the sequence most of the tableaux are crowd scenes, to express the wider attention Christ's doings have attracted at this stage of his life and also to awe the viewer with the pomp and magnitude of it all. It is a worldly conception of this great spiritual progress which finds fulfilment in the noise and tumult of crowds, not the quiet moments of Christ alone with one or two.

Likewise the story of Francis as told at Orta focuses inordinately on papal audiences or councils, even on such things as papal visits to the saint's tomb. The whole series culminates in the conclave of cardinals agreeing to canonize Francis, a strange deformation of the life of one of the most inward and pomp-shunning of its children, into a celebration of the lumbering administrative machinery of the Church.

Yet one could say that in a strange way the story has been democratized, the brooding saint and his ideas brought into the life of society. Inwardness has its limits at Orta and Varallo. You are encouraged to ponder the various webs Francis or Christ has got tangled in, rather than to plumb the depths of their inner worlds. For that individualized style of devotion Bernini's single or paired figures are more effective vehicles. Although the Sacred Mounts give new, invigorating scope to the spectator's wandering, they keep a sharp check on what he or she is likely to find among the rocks and trees.

But how tight can this control really be? Who can be sure what a particular viewer will fasten on in these scenes? And whether one

becomes conscious of it or not, the drama is to a striking and under-mining degree about oneself, undermining, that is, of any simple form of piety. Never before in art has the viewer been so conscious of being off to one side of the main event, as in the scene of the Three Kings at Varallo, or above it looking down as in the nearby Nativity. Breaking this episode into three almost adjacent parts – Kings, Nativity, Shepherds – is one of the most revealing decisions in the whole complex, for it makes each feel drastically contingent; they are all dependent parts of larger wholes. Or likewise, *not* part, and hence markedly incomplete. If we could see round the corner or take in two segments in the same glance, then we would be at peace. But we cannot, and it is a short step from there to becoming interested in the limits of our vision. So it seems the most engaging feature of the world as we know it that at any moment so much of it is hidden and about to unfold.

Once one has passed any of these stopping places, turning back to get a fuller view seems a little perverse. What is gone is gone; in some sense it ceased to exist when you left it behind for something else. Nowadays you can buy the guidebook and study the stages, and you were always free to stray within the sequence, making whatever re-capitulations you liked, but in some sense the lesson of Varallo is the irrecoverability of past perspectives. It is the most anti-eternal of loca-tions, which makes the off-centre focus of the contingent individual absolutely central.

Perhaps the initial inspiration is not remote from Ignatius's method-ical compartmentalizing of explosive spiritual material, in order, the onlooker sometimes feels, not to miss any chance to stimulate under-developed spiritual nerve sets, by inventing a series of locations in which one can stop and look round. They are a way of keeping a straying attention fixed for longer than it initially thought possible, while giving it an illusory sense of a diversity of objects.

At Orta in the tableau of St Francis's first mass the saint is not accorded an especially prominent position. The scene stretches later-ally, distending itself across our field of view. The saint is found far to the left, near the outer edge of this panorama, at first unnoticed, except that there is a peephole beamed on him. Spatially this is an unremark-able point of vantage, or remarkable in being so far out of the way. Perhaps this is exactly what we are meant to grasp, that Francis's way of taking part in the main events of his life is to stand aside from them. So to look through this peephole is to take a particular view of things, a

view which makes no personal demands and finds a place for itself to one side. A paradox looms threateningly here: Francis takes off his clothes or steps out of the limelight and at that moment realizes his specialness in its purest form. Humbling himself he becomes a world-famous figure.

Still, in Baroque representations of this saint the dilemma is poignantly preserved: a vacated self serves as a stimulus to self-inspection for centuries to come. The idea of a saint is inevitably a means of individualizing religious content, for a biographical approach, however ritualized or iconic, posits a world in which the separate self is the basic unit of value.

A parallel movement towards individuation occurs in painting, where the idea of the sketch becomes in the seventeenth century a significant means of individualizing an artist's work. Occasionally one can move from visible evidence of technique, movements of the hand separately distinguishable, to ideas of the psyche or personality laid bare. In seeing the acts of the artist so minutely recorded we come near the inner self which directs the flickers of the brush, capturing momentary tremors passing through the recording apparatus.

Certainly the sketch ceases to be purely or mainly instrumental, and then its speed and nonchalance, no longer signs of its unimportance, come to mean something else. We begin to see artists like Rubens importing the sketch into unlikely mediums – oil, for instance – where he overcomes extra resistance in pursuit of permanence, which contradicts the very idea of the sketch and gives a wayward impulse durable form. Rubens is a pioneer also in presenting some of his most un-intimate works in this intimate form. The most exorbitant of this kind is the bravura sketch on a single panel of the entire Banqueting House scheme, the central oval, the corner insets, and the linking friezes (illus. 15). As finally executed, these elements are a set of rather tame and bounded inlays. In the miniature version (less than a metre high) it is a world gone molten or cyclonic, with compressed figures flying in every direction, their limbs sometimes forming bristling composite machines like many-armed sea creatures or Leonardo's more exotic instruments of war.

Rubens must have seen this stage as an opportunity to impart the very qualities the final work would not have, of momentary vitality and unpredictable motion. Though it is less formulaic in this form, it must be said that the individual actors in the drama are even less distinct than in the final version. We know from his letters that Rubens took

15 Peter Paul Rubens, Sketch for the ceiling of the Banqueting House, London, 1629–30.

his allegories seriously and felt impelled to correct interpreters who mistook personifications of cities for Cybele the earth goddess (both of whom wear towers on their heads), but the truth is that all these ladies are interchangeable and, according to what they are carrying, can be either Monastic Virtues or Military Outcomes. It is sometimes interesting to have them explained and sometimes not: it does not matter to us whether Victory or Peace is crowning James I in Whitehall, but it is significant that the experts cannot agree which it should be.

For the paint to be individualized the subject must be obscured. We cannot be sure of the nature, orientation or even number of the figures, but we can make out individual brush strokes very nicely. The level at which the painting operates has shifted radically downward and now the brush stroke has the assertive personality which has been taken from the figures. It is a world fragmented into egotistical atoms, where all kinds of new entity are claiming their own separate identity, lines, flourishes, briefest applications of the brush.

Baroque gestures appear first in the subject matter and then finally in the material substance of the work, when paint itself becomes gestural, calling attention to its own variable thickness, its way of doubling back on itself. Rubens introduces some of the qualities of the sketch into works of totally un-sketchlike scale and elaborateness. Certain events and substances, like storms and eruptions of water, lend themselves more naturally to sketchy treatment, and there are canvases which exhibit sketchy bits in an un-sketchy setting. But Rubens also found ways to simulate sketchiness in places where it must have seemed quite unlikely. One of his methods of transferring the texture of the sketch to larger scales is a deliberate loosening of technique which prevents individual marks from blending at a distance, which they will normally do even when easily distinguishable close up. There will of course usually be a distance at which this sort of detail is lost, but in Rubens's case (as not in Velásquez's) his most individual works are not meant to lose their identities at a whole range of viewing distances.

You have to lose one sort of definition in order to gain another. The parts are winning at the expense of the whole, and the primary sensation is deliberate loss of control in the interest of energy. Sketches in architecture mean something different, more unmistakable holiday or licence. Rubens can decide he wants the sketch to survive in the finished work, but this is not easy for the architect. Juvarra, one of the most prolific and enthusiastic of architectural sketchers, may have

discovered this inclination through his early training in metalwork and his sideline in stage design, the one encouraging sheet-sized intricacy, the other fleeting fancies.

In any case Juvarra's albums are treasure troves of irresponsible spatial experiment, in which stones shift as in some drug-induced dream (illus. 16). Flipping through his collected theatre sketches we can imagine him undaunted at the prospect of a two-hundred-room palace, for each one of whose spaces he must find a special form. Designing on the vast scales to which he was accustomed required a kind of irresponsibility like Tiepolo's: the bigger the space the faster he could fill it, and in a practical way the more sketchy he needed to become.

So Juvarra's characteristic style of decoration, oversized and intricate, but spread over wall and ceiling with sketch-like aplomb, may derive from an improvisatory way of working which jots down its first thoughts and rushes on. In any case, some of his most grandiose work

16 Filippo Juvarra, 'Atrio con vedute di Giardino Reale', sketch for scene 3 of *Teodosio il Giovane*, c. 1711.

may accurately be labelled sketchy. The basilica at Superga is huge but also picturesque, a piece of hollow scenery designed to read well from the back of the hall, that is from the floor of the valley, where its disparate, strangely joined elements add up to a lively clump.

Later eighteenth-century followers of the scenographic approach to architecture, like Piranesi and Clérisseau, built less. Besides Clérisseau's numerous sketches a single built work of particular interest survives. This is the Ruin Room he devised for a couple of French monks at Trinità del Monte in Rome (illus. 17). It is a fascinating intersection of sacred and secular, the insertion into a religious house of a battered Roman ruin in painted form with a few marble chunks as occasional furniture. There are painted ruptures in the walls and a painted sky overhead, where the original roof is supposed to have caved in. Sadly this conceit is more charming on the page than in the monastery, and the large mock-up cruder than the smaller drawing.

Should Clérisseau have 'built' it more seriously, with a glass roof where the sky could show through and more impinging lumps of ancient stone studding the walls? This is exactly what John Soane did a few decades later in his London house, a project which is not generally regarded as sketch-architecture, though there are grounds for seeing it this way. The texture is stronger than the structure, which is so loosely woven it lets in light through half-concealed slits at the edges. And all the gaps between Soane's different bits, the items in his collection, are like spaces between brush strokes. He has composed an *impression* of an antique world in ruins – not a dry scientific reconstruction but an airy fantasia whose interstices produce a liberating vagueness.

Recent parallels aren't so far to seek. Early works of Frank Gehry and Coop Himmelblau emphasize the part at the expense of the whole, even suggesting that the choice is still open for them not to form a whole. Coop Himmelblau hang on to suggestions in the initial sketch, notoriously done without looking at the paper, which it would be easier and saner to sacrifice, while Gehry gives materials like corrugated sheet metal and rough timber studding the function of shading or hatching in a drawing, another way of being sketchy.

For both of these practitioners spiritual disintegration leads to a new concentration on minutiae and fascination with sensations of the momentary. The built results are scenographic not in literal flimsiness, but in the way durable architecture can afford to be, by virtue of symbolic instability. So like Baroque it is an architecture founded on illusion.

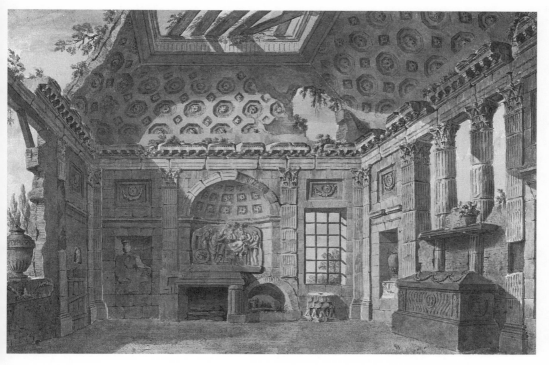

17 Charles-Louis Clérisseau, Design for the 'Ruin Room' at Santa Trinità del Monte, Rome, *c.* 1766.

Sensations of the momentary are more at home in temporal arts like literature and music than in architecture. For reasons of his own (he was forty-six and consumptive when he first succeeded as a writer) Laurence Sterne was preternaturally conscious of the passage of time. He set himself the task of making a whole structure of interstices, digressions and dropped stitches. His prankish novel *Tristram Shandy* can't rest quietly in the time books exist in, but keeps reaching out into the reader's present, trying to link it to the moment Sterne is describing or the one in which he is writing.

In *Tristram Shandy* conflation of different times or overlapping of different, but equally vivid presents is one of the strongest expressions of the personality which rules the work. In that book time is an active, unpredictable medium, not something which goes forward evenly or can be left to take care of itself. This is because the kind of time that counts is internal and often collides with external reality, with ludicrous results. In the powerful internal perspective of the book, forgetting is as real and important as remembering (different from its objective cousin, not-forgetting). Characters are regularly waylaid on their path through time, and because it too issues from a character, the book itself is similarly waylaid. So you get this idea of a world running chaotically to a host of private clocks which rarely remember to align themselves with any of the others. As a consequence two people can sit on two sides of the same room and inhabit totally different mental places, as they will learn when they try to have a conversation.

Although the hero's father and his Uncle Toby are brothers and bound by many ties, their relation consists mainly of forgiving each other for being miles away and incapable of understanding the other's concerns. Sterne's book finds a thousand ways to express this varying but ever-present disparity between inner and outer. The result is about equally silly and profound, dominated by an excruciating sensitivity to temporal incongruities which turn up in a multitude of forms. Sometimes it is the characters who are wrong-footed, sometimes us, sometimes both at once.

Sterne has a habit of addressing the reader, but addressing him in a particularized form as 'Madam', so that we, who are not this prudish or perhaps prurient Madam, are cast as intruders on someone else's intimacy. Or he will break off from an account of some kindness of Uncle Toby's to apostrophize himself, 'O let me never forget thee, Toby', and to promise that as long as his strength holds out he will keep the path clear and

mowed, not to Toby's grave, but to his bowling green or playground.

With a jolt the reader realizes that Toby must be dead, which is to say no more than a figment of the author's mind, and at the same moment he is reminded that the author won't last for ever either (soon he won't be able to mow the path, and then he will die, etc). So the ultimate point of all these diverse subjective perspectives is that they are perishable and that even something as reliable as Toby's military obsession or his kindness will end, has in fact already ended, except in the unreliable consciousness of the reader.

Sterne's way of making subjective consciousness the hero or at least the subject of the novel has maddened many readers. His method is an inordinate dependence on devices as fleeting and ephemeral as jokes. Time is always getting lost or left behind in the story, and then we are told that Tristram's father is still lying stretched on the bed in a tragic attitude like a figure in a Baroque painting. In a way Sterne is right – we left him there, not so long ago, but now he is the furthest thing from our minds, so the narrator yanks us back with something like a rebuke. Perhaps the real forgetter is the author – certainly we don't take his promises of not-forgetting too seriously: his assertions that he will say nothing now, but will develop subject X at greater length later on. From time to time he makes a tally of these deferred subjects and we see they are mounting out of control – there will never be time for all of them; will there be time for any? So we conclude that the amount of unfinished business will in the nature of things constantly increase until the whole idea becomes absurd, when the procrastinator dies.

All the incidental conundrums take place under the larger canopy, a story of someone's life which has started so far back (with conception roughly) that it will never reach his birth, leaving us with the infinitely silly spectacle of the hero waiting to be born.

In the end we are uncertain whether Tristram is totally defeated by time or whether his deferrals have worked and his transparent ruses held the future at bay for as long as anyone can, and, what is more, supplied us with a recipe for getting through time without either deciphering a purpose in it or giving in to despair. So there will be those who concede the book's frivolity but hold it to be brave and not trivial.

The nearest architectural equivalent of the multiple temporal per-spectives of *Tristram Shandy* are the small centralized spaces of Bernardo Antonio Vittone, a Piedmontese architect who performed the unlikely

feat of combining Guarini's geometric complexity with Juvarra's decorative extravagance (illus. 18). Like some Rococo designers further north, Vittone functions best with relatively small spaces, where a restless variety of shapes and forms can be apprehended in a single subjective moment, which easily lengthens into a brief reverie. Vittone's version of the centrally planned space is entirely different from the Renaissance type. He shows you an assorted, almost disconnected set of spaces at once, visible through openings and punctures which begin to suggest an unravelling of the single conception that hasn't quite happened yet. It is generally a space full of window- and door-like apertures, each closed a little further on by an unlikely domelet or a small window of novel shape in another layer of wall beyond. Beneath the collision of disparate forms is the suggestion of the building's substance being perforated, eaten and eventually consumed, leaving for the moment a residual webbing.

The geometry is more confused and less abstract than Guarini's and overlaid by crude plant motifs enlarged till they verge on folk art. These and the walls are unexpectedly coloured in faded pastel tones, like Rococo in other places deprived of some of its freshness. Like some other eighteenth-century practitioners including even Fragonard, Vittone evolves towards a disappointing bland classicism, and the spaces become larger, simpler and more monolithic, the colours even less fresh. Baroque heaviness is followed by Rococo lightness, and then by another less energetic heaviness.

It is a commonplace of criticism that Rococo neurotically banished darker tones and shadow, shadow which is the main vehicle of subjectivity in painters like Solimena, where the most conventional subjects become indeterminate through the heavy fringe of warm shadow which surrounds them. This darkness draws one in and creates an effect like figure–ground reversal. Investigating the shadows we sink into a reverie from which we may not get free.

The nearest that most Rococo will let itself come to such torpid states is seen in its enthusiasm for ruins, ruins which sometimes suggest recently vacated premises like still-warm beds – instead of remote eras, just barely departed presences. Even graveyards in this perspective need not leave one feeling too melancholy, for tombs are the building blocks of larger, fallen structures which one can imagine complete, so that even their dishevelled tilting stances can be read as signs of life or energy.

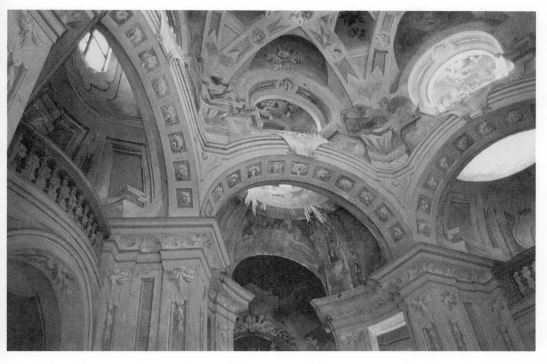

18 Bernardo Antonio Vittone, Church at Vallinotto, near Carignano, 1738–9.

Such love of sensations of the momentary has its peculiar treacheries, as consumptives like Watteau and Sterne knew too well. The freshness of the sketch carries the seeds of its own destruction: the viewer finally realizes that its immediacy, and the sensation of the maker's fleeting presence, cannot be literal. The act of drawing looks incomplete, but cannot be added to, and as if it has just happened, which it has not. The more hasty and impromptu the work manages to look, the harder it will come to a halt at the barrier of its fixed place in history, its momentum no realer than that of a just-stopped train.

Baroque subjectivism often looks like self-conscious cultivation of odd perspectives, more like a kind of science than true self-absorption. For that helpless and obsessional fall into inwardness Mannerism is a more natural locus than the Baroque. So Mannerist subjectivity will seem to many observers more urgent and authentic, less garrulous and theatrical than the Baroque versions we have examined. Mannerist art plumbs true if relatively specialized psychological depths, while in Baroque all responses are magnified not concentrated. For tortured knots and tangles, the Baroque substitutes a fluent emotionalism, like an autistic subject granted the gift of overflowing speech.

But one can find in Michelangelo's contorted poses and throttled extravagance premonitions of the Baroque, and affinities between Mannerism and a certain neurotic strain of the Baroque have often been noticed. The 'Mannerists *manqué*' – Borromini, Guarini, Santini and Hawksmoor – all fit somewhat uneasily in the Baroque. Of all modes it is one of the least hermetic, yet it accommodates these hermetic practitioners. In Borromini's case the unburned residues or unexpressed intensities appear as incongruities in the fabric, surprising eruptions which can never be satisfactorily accounted for, like the unnerving frieze of little severed heads which takes the place of egg and dart moulding along the cornice of Sant' Ivo's lantern (illus. 19).

In a place where you expect neutral decoration requiring no closer look, you find instead ghoulish creatures, older than putti though framed in immature little wings, who turn this way and that. Maybe they hark back to gargoyles of the Dark Ages, but their camouflage as ornament is entirely new. If such elements of the fabric can spring into such nervous life, what part of the building is safe from the invasions of overactive imagination? The lantern rises above them in spiralling tiers punctuated by bumps like a sea creature's shell, but somehow this inconspicuous border of heads is the madder element, more suggestive of inner disturbance.

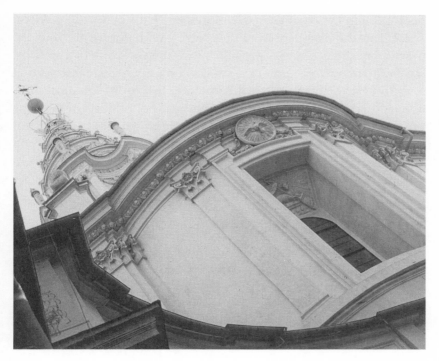

19 Francesco Borromini, Ghoulish heads on an exterior cornice, Sant' Ivo della Sapienza, Rome, 1642–60.

Borromini, the earliest, remains the most exorbitant of the group, but in all of them incongruity is deeply embedded, with its roots in unresolved tensions in the personality. When Santini puts Renaissance details in an overarching Gothic format, it isn't post-Modern prankishness freely combining the baggage of the past, but a seriously divided mind unable to give up the earlier phases, which his historical moment or his stage of life would ordinarily have relinquished. The earlier architecture stands for immature parts of the self insisting on forms of expression which will after some fashion represent them.

There is a religious institution, the convent, which embodies similar contradictions in peculiarly Baroque form. Both Borromini and Vittone designed such complexes, but for the most part these institutions did not call for or elicit remarkable works of architecture, though an anthropologist could extract a great deal from the spatial planning and daily routines of those prison-refuges.

Nowhere but in colonial Mexico or Peru was as large or as significant a part of cities and of the female population turned over to convents,

because both lives and city plans were harder to fill with meaningful content in the blank space of the New World. An insight into the Mexican religious orders is provided by a fantastic genre of paintings, which shows nuns on entry or at various jubilees of their incarceration as the brides of Christ, positively erupting in flowers like late, unseasonably blooming trees, becoming thus rich altars for sacrifice. At the same time they stare with a downward, world-evading gaze that makes them faintly corpse-like. These are portraits, badges of family pride, and generic extinctions of the personality at the same time. They express a throttled version of Bernini's St Teresa idea, digesting the contradiction between sensual arousal and denial. Denial becomes a continuing excitement.

The Mexican pictures put one in mind of the rich vein of fantasy literature these institutions have inspired – ranging from Marivaux, Walpole and Kleist to Balzac and Dostoevsky. With the exception of Dostoevsky who is writing about a monastery, these are all male writers looking into female precincts alternately fascinated and horrified by an intensity which they read variously as perverse abstention or deviant indulgence. The convent is also seen as an epicentre of hierarchical artifice, which with uncanny force transmogrifies turbulent human nature to an art form.

Baroque artists are often credited with lurid depiction of religious emotion, but the extremes of physical suffering common in medieval images of martyrdom are off limits to them. The most characteristic seventeenth-century contribution to devotional imagery is a class of scene allied to martyrdom but milder, the saint in prostration or ecstasy, a moment at once dynamic and passive. Like a martyrdom it is something the hero-subject *undergoes*, completely beyond his control though he has probably prepared for it, using methods like those Ignatius popularized, which are best carried out by a solitary sufferer. Ecstasies in this sense are mixtures of pain and pleasure.

To the innocent eye Bernini's St Teresa and his Blessed Ludovica, a late work, don't look so far apart. It is more lively and dramatic to have a materialized agent like the angel who appears to St Teresa, but this doesn't make the event social or gregarious. The later work (Ludovica in her terminal spasm) is doubtless more austere, but the distressed yet elevated state of the two women, one dying, the other 'dying', look more nearly identical than writers like Wittkower and Hibbard will allow. Attempts to find a radical difference between the two works

seem literal minded, for in Bernini's world someone on the verge of death and someone having an experience like death from which she will recover are in much the same plight.

We could add further examples of ecstatic saints from many Roman churches, for which large marble altar reliefs were a favourite format, perhaps because the stone could be lit from the side or above in a way that made it look unearthly. A variant on the ecstasy is the saint 'in glory', somewhat more staid but essentially another form of being carried away, all argument and reasoning swept aside. It is a difficult question whether this range of subjects has simply evaded earthly conflict or whether the motif is an essay in triumphalism at the expense of the Protestant enemy.

Certainly the playing field has been moved to a fairly impalpable place. But then saints' lives as managed by the Church are bound to fall into ritualized patterns. In the Jesuit model, you take young men of good family who died in their teens or early twenties, like Aloysius Gonzaga, and put them at the centre of a luxurious flutter of wings and clouds. Martyrs to grisly illness or foreign hardships now undergo their ordeals surrounded by precious materials, a combination which does not seem to be felt as paradoxical.

Francis Xavier, one of the great Jesuit saints, spent the last eleven years of his life in India, Indonesia and Japan, places of which he had little understanding and on which he made slight impact. To a jaded outsider the importance of Jesuit missionary work lies mainly in its reflected effect in Europe, where exaggerated reports of conversion rates were common. Only in the New World were there successful mass conversions, and the Jesuit reductions in Bolivia or Paraguay remain profoundly ambiguous constructions. But to see missionaries as cultural raiders, stripping natives of traditional spiritual protection while settlers subjugated them physically, would not come easily to Francis Xavier and his contemporaries. Fanaticism is required of saints, whatever biographers may sometimes say of their moderation and tolerance. And how much more so in foreign parts, where European moorings could so easily come untied?

The recurring motifs in saints' lives are early seriousness, devotion to the poor, administrative ability, submission to authority, resentment from those in the immediate vicinity; at some point in many such lives it is touch and go whether they will be welcomed or excluded by the Church in the end. Lives of the favourite Baroque saints make fascinating reading, but one would also like to have Lives of Notable Heretics and Lives of

Failed Saints, or almost-saints. Though there is tremendous variety among those who make it into the record, powerful forces are levelling and shaping the material, smoothing away rough edges and inconsistencies.

Sixteenth- and seventeenth-century saints include few real solitaries, though that basic divide still remains between introvert and extrovert forms of sainthood, those who focus on their own inner life and those consumed in administering the faith. This latter category can be further divided into those who minister to small numbers and those who operate on a grander scale, though like a business which begins in a corner shop and ends with a hundred branches, maybe the one naturally evolves towards the other. Teresa of Avila is the most famous example of a saint in whom the inner and outer strains are forcefully combined, one who enjoyed a rich inner life *and* increased the Church's worldly power and scope. St Ignatius seems a more doubtful case, not very private in his most intimate moments, and putting inexpressible sorts of experience into well-calculated order.

But for all one's suspicions of the strange consistencies of sainthood – incredible patience, humility and especially blind obedience – lives of saints introduce one into a world far removed from what is later made of them, or from the papal court and ecclesiastical politics where conditions operate to frustrate anyone like Alexander VII with leanings towards austerity or self-sacrifice. In the papal court his attempts to limit display or the proliferation of offices provoked righteous disbelief. Far from the spirit of the world in which he lived were this pope's fitting up his bedroom with a coffin and his writing table with a marble skull (provided by Bernini, legend has it). But Bernini, of all people, named *The Imitation of Christ* as his favourite book and has among some of his admirers a formidable reputation for piety in his later years.

Devotional practices revived or initiated in the seventeenth century include the cult of the Sacred Heart of Jesus, which seems suitably Baroque in its flamboyance and blatant emotional appeal. By the nineteenth century the psychic shock administered by this opening of the body for exhibition purposes had been transmogrified into the rankest sentimentality, and the colours in which the image was presented had been generally drained of life.

Earlier, the Sacred Heart had allowed obsessive fixing on a single concentrated motif (as in Ignatius's spotlight on the senses one at a time). The Heart is recognizably an organ, not just an outline, but not anatomically exact. Only two features stand out: its piercing and the

flow of fluid from it. These roughly correspond to the process of our attention, concentrating on the image and then letting it unfold and begin to yield something more. Unexpectedly, water and not blood issues from the Heart, a kind of miracle but, physically at least, a reversal of ordinary magical transformations, which turn the lesser into the greater, the everyday into the rich and special, water into wine, wine into blood. Of course this water is the mystical nutrient water of grace, but its appearance here remains in some way paradoxical.

As an object of devotion the heart contrives to be both lurid and disembodied, carrying a sneaking suggestion of scientific dissection of the body, as if radical analysis, which disintegrates complex organisms, were the most profound type of investigation. The eighteenth century was indeed a crucial period in the history of anatomical research and especially of modelling, which made a major contribution to the move towards what we now call a scientific view of the world, a description which begins to seem grandiose applied to the specialized, centrifugal idea of knowledge that passes for 'scientific' in everyday use. However dire one thinks the outcome – and it seems useless to lament something as irreversible as the so-called scientific revolution – it can be very exciting to follow this shift of mind in its early stages.

Franz Xaver Messerschmidt (named after the Jesuit saint possessed by the impossible mission of converting Asia) began as a Rococo sculptor whose portraits of rulers have a startling particularity in spite of appearing to obey the conventions of this pompous genre. Subsidiary bits – tassels, jewels, curly wigs – are preternaturally alive, and facial expressions uncomfortably alert, edging towards grimace.

Perhaps one says this with the benefit of hindsight, because Messerschmidt, an undiagnosed schizophrenic, spent the last thirteen years of his short life in an obsessive, quasi-scientific study of the grimace. The result was a series of about seventy 'character-heads' in alabaster, lead, plaster, marble and bronze, sixteen of which are collected in a museum in Vienna (illus. 20).

One can easily pass by a single one of these works, as a fleeting illustration in an art-historical survey, but the effect of the series is overwhelming. Many have distracting titles, 'Laughing Joker', 'Sly Trickster', etc, dating to the eighteenth century when they were exhibited as clinical curiosities. In fact they are far from prankish or jolly. It would be truer to regard them as images of suffering rather than merriment. Some appear to be smiling, but if one looks closely, the upturned mouths are

20 Franz Xaver
Messerschmidt,
Extremely Angry Face,
1770s/early 1780s.

horribly tense, not relaxing into comfort or acceptance. Eyes are often squeezed shut, and even when staring wide at the end of a craning neck suggest a gaze turned inward.

There is more surface variety in these heads than in images of the Sacred Heart, but they are all the same face, pulling itself into new forms in front of the mirror and trying to populate the world by this means, while knowing it can't work. A contemporary description survives which shows Messerschmidt obsessed with his own countenance, unable to take his eyes from it, yet driven by some instinct to want more, and to attempt to produce it by exaggerated manipulation of his features.

Apparently he nursed grandiose hopes for his project, imagining that he was on the edge of solving the riddle of existence by establishing a universal code of the emotions. He was not the only or perhaps even

the maddest of those who in roughly his time and place imagined that a transcendental message could be read in some aspect of the human frame, in proportions or sizes of facial features, in bumps on the head or lines in the hand.

Messerschmidt's martyrdom is modest in scale but represents nonetheless a momentous development in the use of the self as the raw material of art. A century before, general interest in subjectivity had pushed sainthood in the direction of more intimate, interiorized forms. At the same time, in seeking ways to make art vivid and accessible Baroque artists sometimes came perilously near dissolving any distinction between sacred and secular. Bernini's St Teresa represents for some viewers a confusion between martyrdom and theatre, between high spiritual intention and low forms of gratification.

Perhaps the sacred-secular division applied to Bernini's more-than-sculpture is a Puritanical imposition, but distrust of Baroque spirituality surfaces again from time to time. Certainly the Sacred Mounts lend support to these suspicions, for they are irredeemably earthly, translating mystical visions along with everything else into highly coloured dumbshow.

In the century after Bernini sacred art lost some of its identifying marks, and on the ceilings of Bavarian pilgrimage churches, saints waiting for illumination often resemble strollers in aristocratic parks. Most religious art depends on analogy and shows bodiless concepts or heavenly truths in personified form, but the Baroque takes a further step towards the spectator's own situation. Instead of exotic beings still at some remove from our plane, spiritual personages become loungers and dawdlers, common types on ordinary errands. This remains the case even when flights of putti flutter overhead, who seem no more like different orders of being than those plants which because they can climb walls end up over our heads.

It is a two-way process – as religious imagery becomes more secular in the eighteenth century, religious intensity is leached away into secular forms and finally crystallizes around new cults of sentiment and the picturesque, rogue descendants of mystic piety. Mrs Radcliffe's fixation on the pines which punctuate her heroine's Italian travels bears a clear relation to Crashaw's meditation on Christ's wounds, both of them instances of overheated intensity bordering on obsession. But in Mrs Radcliffe the encasing structure which justifies the emotion is missing, and sensibility is no longer a vehicle but an end in itself.

To Sterne and his contemporaries sensibility appears as a new faculty just discovered, but the real novelty is the loss of a context for feeling, which sets all this emotional energy loose to attach itself to the most unlikely objects – old beggars, sentimental priests, children. For a brief period it becomes feasible to luxuriate in one's susceptibility to strong gusts of feeling without trying to put them to use as Ignatius would have done and without suspecting oneself of falsity or indulgence.

The fact that such surrender to feeling was really worship of oneself was temporarily obscured by its being a religion of weakness. The self was overcome by its sensations and lost the power to contradict them, leading to self-damaging gestures like large donations to strangers met on the road. Sterne, a novelist who was also a clergyman, was one of the leaders in replacing doctrine with feeling, and specifiable structures with that which can't be specified or predicted. Sentimental outpourings of this period retain distorted reminiscences of devotional antecedents, except that now the subject has taken possession of the sacrament, which he administers to himself. Much of the literature of sensibility is confessional: potentially damaging revelations about oneself are a means of infiltrating the reader's consciousness – the reader becomes the confessor, but as a spectator only – and of creating a self which is the unacknowledged object of devotion.

In architecture sentiment makes initially peripheral appearances, first of all in primitive huts, sham ruins and theatrical dairies in English parks. At least one landowner hires a 'monk' to greet visitors when they reach the Monk's Cell in their circuit of his grounds. Then Walpole and Beckford construct monasteries in which they are themselves the monk or recluse. They are now prepared to inhabit the occasional fantasy as a full-time diversion from ordinary life.

British travellers in Italy include a number of real Rococo personalities, among them William Beckford, whose frivolity turned St Mark's into a mosque and the Doge's Palace into a seraglio. Lady Mary Wortley Montagu's son Edward enacted a similar metamorphosis and became one of the sights of Venice in his long beard, Armenian dress and cross-legged posture.

Italy and also Catholicism became a bolt-hole for various kinds of English eccentricity. It was the émigré Jesuit Fr John Thorpe who complained that Protestant visitors to Rome had conceived an enthusiasm for all the more obscure items of Roman devotion and were carting them back to England to decorate their houses. He was a relatively

common type, the priest who dealt in antiquities and thereby managed a comfortable style of life in Italy, like the minor aristocracy who formed the bulk of his clientele. So piety, commerce and social snobbery meet in the rich and confused soil of Rome, in the aftermath of the Roman Baroque and the political twilight of the Papacy.

III

THE VIEW FROM ABOVE

IN THE POPULAR VIEW, far from inward and subjective, the Baroque is an inherently grandiose mode which inflates the act of design to scales seldom attempted previously, rearranging venerable settlements in imperious fashion, or covering enormous walls or canvases with over-sized figures. Sometimes, even when executed, such schemes continue to seem authoritarian fantasy rather than planning properly defined, remaining unreal even though they exist.

Baroque planning is often described as if it always harboured imperial ambitions and easily realized them. True, many Baroque designs begin expansive, but then run up against obstacles in reality which powerfully condition the outcome. Diagrams like Wren's radical proposal for rebuilding London after the Fire of 1666 are sketches which leave a great deal unspecified (illus. 21). Wren's enemy is the confusing warren of medieval streets or perhaps even more the confused pattern of owner-ship to which they correspond. He views the city as an intellectual or aesthetic proposition and leaves politics out of account. As it transpired, no one was powerful enough to override all the separate competing claims of individuals and so no clear routes were driven through the knotted urban texture until the nineteenth century when the importunate technology of rail transport provided a precedent and example.

Even now it is easy to consider Baroque planning in formalist terms, treating cities as snowflakes, variants on a restricted number of graphic themes. Wren's embryonic plan is an instance of a Baroque notion of scale in which regulating lines do the work and details sort themselves out as best they can. In this mode the street pattern *is* the city, which already exists once the nodes where the major public buildings will go have been identified. The city as web or diagram can be ordained in a

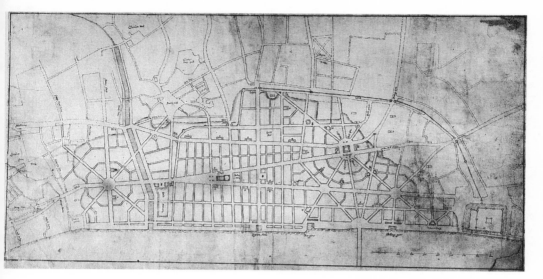

21 Christopher Wren, Plan for the rebuilding of London after the Great Fire of 1666.

number of ways, as an imposition which falls lightly or heavily on an existing settlement as at Rome or Palermo, which lays out a new centre or sector attached to the previous core as at Turin, or which begins from scratch as at Grammichele in Sicily, Richelieu near Poitiers, or St Petersburg, the grandest of all.

If we view these three types simply as different versions of the same thing, we will miss a lot. Baroque plans usually enter complex social and spatial contexts, and the new conception and the existing tangle begin to distort each other almost at once. The more we know about the specific context, the more we are able to detect the ways oddities of land ownership or terrain are responsible for strange but characteristic features of Baroque designs.

Avoiding such complexities altogether, some of the most inventive plans of the period kept to modest briefs like Raguzzini's Piazza Sant' Ignazio, which has probably passed unnoticed by many visitors to Rome (illus. 22). As a piece of display it is recessive even after its recent freshening with new paint and stucco flourishes, but looking at a large-scale map you can appreciate Raguzzini's improvements. Instead of streets branching off irregularly, Raguzzini creates something like a theatre backdrop with symmetrical exits and curved façades funnelling into them. But if you try out the routes you find the orderly display a sham, for one of them leads you round in a circle like a dead end in a

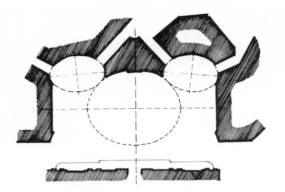

22 Filippo Raguzzini,
Piazza Sant' Ignazio, Rome,
1727–8, plan.

maze. The tidy initial impression gives way to an intensified form of the medieval sensation of not knowing what lies around the next bend. In fact the only route which leads anywhere takes you to one of the most surreal moments in Rome, a huge colonnade left over from a Temple of Hadrian and incorporated in the late seventeenth-century customs building. Individual structures in Raguzzini's scheme are pieces in an urban puzzle which lock into adjacent pieces, violating all ideas of edge or distinct beginning and end.

The intentions of Baroque designers were hemmed in more dramatically by existing uses and property lines in a corner of old Ragusa in Sicily (illus. 23). Here an important palace and an adjacent church were remodelled and rebuilt in the early eighteenth century without violating the cramped medieval street plan or attempting to level the uneven terrain, with the result that the Baroque buildings tumble over each other, with later additions squeezed between them. Perhaps the congestion gives a spur to the Sicilian love of grotesque: jutting cornices and gargoyle crests loom overhead as you weave down the narrow passage which turns scenographically to yield entirely different views. So Baroque components fit themselves into a medieval plan, under which pressure they explode in typically Baroque exaggerations and theatrical surprises.

Elsewhere in Sicily much greater changes of level stimulate still more flamboyant Baroque adaptations. Hill sites like Modica's and Caltagirone's would be unlikely Baroque choices for settlement. Seventeenth-century new towns (or quarters or districts) are generally placed on level or levelled ground (though this is not true of Noto, the most successful Baroque new town in Sicily). Among methods of disguising violently sloping terrain, the erection of long ceremonial stairways was a favourite

in the Baroque, so at Caltagirone and Modica upper and lower towns are notionally united by stairs of street-width. However, these large constructions are visual devices as much as practical routes. A path or perhaps just a vista has been cleared, so you can see the link if not actually use it.

The practically unusable Sicilian routes give us an odd point of access to the new axes which Baroque planners drove through venerable existing cities like Palermo. These new thoroughfares are decidedly usable, but in their own way erase what lies on either side. Again the vista is substituted for the old experience of immersion in the city. In Palermo two seventeenth-century streets cross at a new centre, shaped into a feature, the Quattro Canti, which divides the city into four equal quarters. According to guidebooks these quarters match the ancient neighbourhoods or

23 Baroque buildings in a medieval street, Ragusa, Sicily, looking towards Santa Maria dell' Idria.

districts of the city exactly, which seems about as likely as that the Westway in London enhances old usages.

On either side of the new street is the old tangle, and there are no intermediate zones; you are immediately plunged into a warren with which maps are unable to cope. For the traveller who doesn't know Palermo the Baroque arteries are an immense convenience. Like a good filing system they allow you to zip straight to the part you want to look at. But they are extremely unsubtle mechanisms, which although they traverse the heart of the city, function like bypasses.

As in many Italian towns the ruthless Baroque impositions have been succeeded by an even more aggressive late nineteenth-century imitator. Almost parallel to via Maqueda (early seventeenth century) runs via Roma (1895–1922) which starts from the railway station and is at least twice as wide as the great Baroque thoroughfares. So these have been upstaged, which in their day must have wielded great visual force, opening a line of sight stretching further than the eye can see. For most people most of the time, this would be the artery's main function, to suggest distances they had no need to explore and to do this in the most unlikely place, the centre of a dense human settlement. The axes made one form of travel easier but also ordained a certain remoteness between the person and the place. Thus they represent an important step in the long loosening of our hold on immediate sensory reality.

The abstract, even minimalist tendency of such thinking is clearer in non-urban situations like the garden at Caserta near Naples which improves on its model Versailles by eliminating the spraying or raying routes, to focus all its energy on one, probably the longest vista in any European garden. Contrived monotony like this is far from monotony spontaneously occurring. Perhaps it is akin to the work two hundred years later of artists like Donald Judd or the projectors of Milton Keynes, where again the designer announces his presence by inserting a blank in the noisy hubbub of the world.

The great examples of Baroque inflation more solidly built seem at first the antithesis of this minimalism, filling the world almost more full than it can stand. But sprawl or extension is much the same whether empty or full. Both a string of rooms without much in them and strip development with filling stations, defunct shopping malls and the latest 'big boxes' followed by more of the same, make a kind of desert. A striking instance would have been the Sacristy that Juvarra projected alongside the western transept of St Peter's. This is planned something

like a palace, with a hemicycle of giant columns like a ceremonial entrance but opening on to a dead space that runs into the apse-like end of the transept. The Sacristy is connected to the church by not one but two corridors, a common device in Juvarra.

When we look closely at the proliferation of spaces here, realized in a beautiful model now at Stupinigi, we see even on this reduced scale that these giant spaces are very low in content. The organism replicates its elements in a manner which has no obvious end, like a row of Judd boxes rigorous individually and lax overall.

Similar inflation of the parts and rampant growth of the whole can be found in other arts and activities throughout the seventeenth century. In 1622 Marie de' Medici ordered two series of tapestry-scale paintings from Rubens to decorate two galleries in the Palais de Luxembourg. At the moment of commissioning them she was the Queen Mother, already in a precarious political position which would become worse and halt the project half finished, forcing her to leave Paris and the first of the two sets of huge paintings.

These covered her life; their unexecuted mates would have traced her husband's, disguising the fact that their marriage had been unsuccessful and further entrenching her as an essential figure in the recent history of the Valois dynasty. The twenty-one paintings which exist are one of the most magnificent, hollowest instances of seventeenth-century allegory, where it soon becomes obvious that Rubens is expanding almost non-existent material into an astonishing number of extremely similar scenes (illus. 24). In Christ's Passion or the Life of St Francis we sometimes have the feeling that one event is being broken into several for the convenience of the artist, who has a certain number of spaces to fill and so must subdivide the narrative into that number of parts. But at least the drama thus manipulated was powerful to begin with. By contrast, the drama in Marie de' Medici's life consists of an indistinguishable run of meetings and leave-takings, where the human cast is enhanced by classical gods looking down from the top of the picture and ladies representing virtues or conditions hovering at the sides.

In some sense the enlargement of Rubens's canvas here follows the same pattern seen in American Abstract Expressionism of the 1950s. As the scale of the work grows we find less and less in it. 'Subjects' in Rothko, Newman and Twombly (though maybe not in Pollock) are radically simplified as the area of the picture increases until very few

24 Peter Paul Rubens, *Arrival in Marseilles*, from the first Medici cycle, 1622–5.

domestic spaces are big enough to hold these works. Even the Louvre is hard pressed to find space to display Rubens's series to best effect. As in the rooms where Abstract Expressionism is shown, when you come to the Medici gallery the scale changes, the space expands and it seems that painting is about to burst the bounds of architecture.

Sensations of hugeness in poetry are harder to pin down, but the whole idea of an epic poem is tied up with its scale. Milton spent years

in training for *Paradise Lost* and nursed serious doubts that a Northern person like himself could carry out this great task, never properly undertaken in English before, never yet seen outside the heartland of classical civilization. From our perspective it has sometimes seemed that he succeeded too well, creating an unapproachable Behemoth which advertises its whole enormous weight portentously from the start.

Milton's vast subject reveals itself partly in the mental distances between the different parts of the poem, partly in the length of the great verse paragraphs, and partly in the more literal form of gigantic vistas which constitute Satan's journey from the underworld to earth, portrayed in the poem as a recently invented world, like a new scientific discovery. In an obvious sense these vistas do not belong to Satan, yet he activates them, bringing them before the reader: they are his field, and so we tend to see them as his attributes. Once again, the doctrine and the drama pull at cross purposes to each other.

As a dramatizer of doctrine Dryden has retreated at least a step behind Milton and Rubens in the long poem he wrote in 1687 to assert his recently adopted Catholic allegiance against the Anglican position he had once held. These personal twists lend no noticeable tension to the poem. Allegory in *The Hind and the Panther* resembles cardboard scenery which the characters walk among when the author thinks of it, but which he mostly forgets as irrelevant. In fact it is easier to regard the poem as a conversation between two gents in their armchairs than a battle between wild animals who chance upon each other in the forest. The Catholic Hind (gentle and white) meets the Anglican Panther (savage and black) at a watering hole and after various digressions and debates hospitably invites her home to dinner. Here they tell each other two fables about birds.

Perhaps it is not more ridiculous that animals should argue than that Roman despots should carry out their intrigues in falsetto arias, but there is a difference. Handel's operas substitute one intensity for another. Fits of emotion are translated into fits of ornamentation. In Dryden, however, savagery is replaced by dry wit, a wonderful corrective to certain human excesses but no substitute for passion.

Energy in the poem is mostly negative and this malice towards the opponent often shades into point scoring. Still, it is not believable that the speakers in Dryden would kill each other, even if they are said to snarl or bite. He *could* tell a fable in which animals really misbehaved, but that is not his purpose. *The Hind and the Panther* is a genuinely apologetic

poem, as *Paradise Lost* is not, and its concerns seem small in spite of the heroic or at least generous scale of the verse units, like large rough blocks of masonry. It reads like prose, because it has put itself at the service of a sectarian political message.

Dryden's poem is propaganda, albeit civilized. That is also the concept one needs to interpret Blenheim, designed by Vanbrugh and Hawksmoor and built as a national thank-offering to the Duke of Marlborough, recent victor in Continental wars (illus. 25). It was the most grandiose eighteenth-century building project in England, authorized by Queen Anne to be built at public expense and far outstripping any royal project of the period. Vanbrugh conceived it as a national monument, which gave him licence to indulge all his ideas of masculine force in architecture. He produced a vigorous exposition of the power of stonework, which the architectural historian John Summerson has described with a calculated overabundance of military metaphor: elements in the composition mount short sharp attacks, porticoes march, columns have duties.

Of course there is a certain amount of explicit military and patriotic imagery at Blenheim: towers end in topknots like flaming grenades; inverted fleur de lis and British lions trouncing French cocks are found

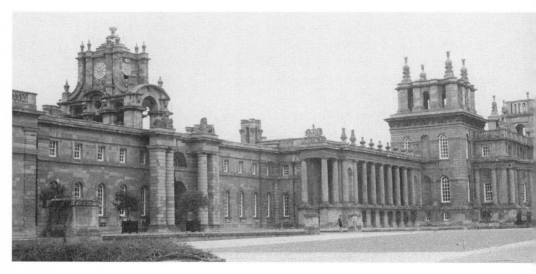

25 John Vanbrugh and Nicholas Hawksmoor, Blenheim Palace, Oxfordshire, 1705–25, skyline with towers.

nearby. The most entertaining piece of this sort is a bust of Louis XIV looted from the Citadel in Tournai which is stranded on the southern front with a boastful inscription. But the deeper infusion of the idea that national grandeur and military might are intertwined comes in the general disposition of masses and the orchestration of silhouettes from afar. Vanbrugh actually tore down a half-built façade to make it marginally higher and more threatening, adding hollow corner towers, which are only chambers for the wind to whistle through.

Motifs used elsewhere by Vanbrugh occur here enlarged, like pediments piled on pediments, which make Blenheim look, massive as it is, unfinished or semi-ruined. The whole idea of a palace for a warrior, a work of peace and permanence for a ceaselessly active inhabitant, is combated by the restless skyline and the heavily defended, if not paranoid, aspect of such outworks as gates and service blocks. In fact Marlborough was off waging further Continental campaigns during much of the construction, followed by foreign exile while out of favour. When he finally came home to enjoy the spoils and inhabit the still unfinished monument, he suffered strokes which left his warlike wife in fuller charge than ever.

After all the stoppages and problems over payment, the house-memorial named after a foreign victory was completed, but without some of the final flourishes the architect intended. The story of construction remains a catalogue of human folly, of intrigues and cross purposes, pressures that could not halt the inertia of construction in the end, which ploughed on until the behemoth stood there in its extensive but provincial location, the English Versailles built for the general who had thwarted the French king's territorial ambitions.

One of Marlborough's allies, Prince Eugen of Savoy, received parallel palatial residences from the Austrian emperor, one for winter in the centre of Vienna, another for summer on the outskirts of the city. In fairly close proximity to royal palaces, these constitute no rivals to them in scale or magnificence. Even so, the metropolitan location makes them more conspicuous than Blenheim, more continuously in public view.

Perhaps there is a parallel in the Jesuit way of commemorating their expansion overseas. For the foreign campaigns of this militant if not military order to bear fruit, they needed to be signalled or commemorated at home. Thus missionary saints figure prominently in Jesuit imagery in their two large Roman churches, Il Gesù and Sant' Ignazio. In fact the scale of these churches is justified in part by the scale of

Jesuit efforts worldwide. An organization that converts thousands of natives in Malaysia, South America and Japan can reasonably raise more prominent piles at home.

Aggressive new orders like the Jesuits were able to make the most of the Church's supranational character and to exploit it in ways others had not thought of doing. There are novelists who think in similarly opportunistic ways, seeing openings for expansion of the novel's subject matter in European colonization of the rest of the world. Many of Defoe's novels contain a considerable element of colonial fantasy, though except in *Robinson Crusoe* it remains one element of many. It is possible that Defoe never got as far as the Continent; certainly he had not visited the American and Caribbean settlements he writes of with such circumstantial vividness. The nearest he ever came was to lose money in ill-considered colonial trading ventures – first in tobacco, then in wine and beer – miscalculations which drove him back to litera-ture to recoup his losses. In some ways he seems the most un-Baroque novelist imaginable, deriving his credibility from the totally mundane and measurable quality of his observation which masquerades as journal or reportage not fiction. Yet much of the fabric is bluff – if we were to go to these places or be these thieves or harlots, our experience might resemble the novel, but the illusion of extreme physical or social location cannot be tested.

Still, this stay-at-home remains a good indicator of seventeenth- and early eighteenth-century expansionist urges. The edge of the European world has shifted and its more adventurous citizens are no longer satis-fied to be contained within the narrow European field. To Defoe, over-seas remains a place to return from, after one has enriched oneself at the expense of new lands and peoples. There is more scope for action than at home, the scale is bigger and the room for invention, but it is natural to come home again; colonies are a kind of secondary reality in perpetual imaginative dependency on their European sponsors.

The New World seemed to present an ideal empty field for Baroque urban planning but, unexpectedly, the imposition of order becomes less urgent and less interesting where no complex human impediments exist. Even today the neatly laid out streets of a colonial town like Querétaro in Mexico or Savannah in Georgia create effects of pleas-antly low intensity. The 'street' is almost as much of an illusion in Querétaro as in a modern suburb. One-storey fronts run continuously along them, concealing even looser density behind, with large open

spaces like farmyards lying beyond the initial tier of rooms. The frame of a city is posited and then one finds one has little to put in it.

The nearest European parallel is the clean slate created by natural disaster or military threat. Forty towns in south-eastern Sicily were destroyed by the great earthquake of 1693 and eight of them were rebuilt on completely new sites. They varied greatly in size and importance then and have had chequered careers since. Noto, the largest then, is the most interesting now. It seems an archetype of the city as a work of art, built all of the same material, a soft gold limestone which makes it feel like a single spreading building.

Based on a grid like most of the other Sicilian new towns, Noto is punctuated at regular intervals by open spaces around which are grouped major public and ecclesiastical institutions. After this regularity, it comes as a shock to learn that there was little coordinated planning of all these reconstructions. In fact certain key questions about the Baroque planning process cannot be answered conclusively, such as why Noto rented its new site from Avola, a rival town nearby, a site which is fairly steep and thus not an obvious Baroque choice when starting over.

The nearest thing to Noto in England is probably Blandford Forum in Dorset (illus. 26), a small market town near Wimborne Minster, less important than Noto, but propelled to something greater by a catastrophic fire which levelled the old timber core. In Blandford the main impetus to rebuild came from a pair of architect-builders, brothers named Bastard. They gave the new town on the old site a vernacular

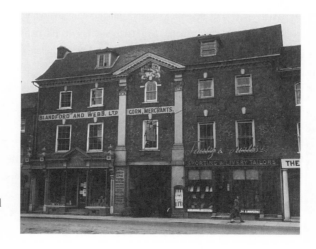

26 John and William Bastard, The Red Lion Inn, part of the rebuilding of Blandford Forum, Dorset, after the fire of 1731.

version of urban consistency – long frontages punctuated by towerlike pavilions.

As in Noto the replanning is better for certain imposed constraints: the curving street plan could not be comprehensively altered, so formality is softened by the inflections of old routes. Like Noto, Blandford seems to have risen above its station, but only in architectural manners not in scale. Pomp without inflation keeps a balance between dreams and reality, and in these places the oxymoron of a tiny capital is brought to pass.

The most rational of all seventeenth-century capitals, Turin, had its origins in a Roman new town or colony, origins which made easier and more logical its Baroque conversion. The Savoy dynasty was constructing itself in significant part through the medium of Turin and needed to press both a claim to the rest of Piedmont and a bid for royal status. A hungry dynasty and an unformed, arbitrarily chosen capital (strategic considerations probably loomed largest) led in the end to the clearest expression of the Baroque city as an instrument of rule and a unified work of art.

Eighteenth-century travellers are full of praise for Turin's uniformity and intelligibility. Piedmontese rule has become real in the plan of the city, which can be more easily read because the ruler could ordain uniform heights for buildings on the main thoroughfares.

A formidable imposition of order was achieved, and yet the plans show further consistencies which were not carried out: diagonal arteries which ran up against the property of a local magnate and were therefore cancelled, or extensions of the grid not built because the ruler's attention was deflected elsewhere.

Studying the case of Turin makes clear why it has few rivals as the perfect Baroque capital. Starting with the Roman grid, Baroque projections found less which they needed to countermand. It was easier to make over the identity of a town not already powerfully marked, with clear gestures like an important new artery to connect the palace and the southern gate. Later this vector is again reinforced when the main railway station is placed where the gate had been.

In fact the names of both principal stations (Porta Nuova, Porta Susa) are now the most substantial records of the old gates, part of a system of fortification which strongly conditioned the form of the Baroque city. Turin's rulers felt themselves embattled, and conceived their new capital as a buffer between French territorial greed and the rest of Italy, so citadel and bastions (of which there are now barely a

trace) gave shape and purpose to the settlement, which presents an idealized picture in early views and plans, of walls in good repair and free of accretions. Bastions in linked series were one of the main means for conceiving of the city as a unit, which could be presented in prints as if it were a large Renaissance jewel, the proudest adornment of the ruler.

The largest royal palaces of the Baroque are so vast they resemble cities and suggest that no single person could know or control them all. Former hunting lodges on the outskirts offer more scope for replanning on a heroic scale than older urban residences. In the largest instances, these monuments to the glory of the monarchy intimidate even their possessors. Before long the main palace at Versailles exists just to provide something to react against; first Louis XV and then Marie Antoinette establish themselves in alternative centres, abandoning the old buildings as happens in more superstitious cultures when they become contaminated by the inauspicious events that have occurred there. (In medieval Japan the capital was abandoned every time a ruler died.) Finally Versailles sounds an awful warning against the overweening ambitions of the Baroque at its most inflated. In the end this palace-town on a suprahuman scale overpowered even the rulers, who were driven to build more modest retreats from the palace in its own grounds.

The original scheme for a country retreat at Venaria outside Turin was so ambitious it could not be carried out in one lifetime and was therefore almost bound to be left incomplete. Even the stranded fragment finally built is now a nightmare of maintenance. Another grandiose plan, Fischer von Erlach's first proposal for a new summer palace at Schönbrunn outside Vienna, known from a large print, looks like something out of Kafka. In the engraving, the space currently filled with gardens is shown paved and divided by a series of walls, gates and terraces, prefatory to the enormous core at the top of the hill. The whole complex forms a ceremonious labyrinth which could swallow much of one's life in the twin processes of arriving and leaving. Even when scaled down to buildable dimensions such establishments produce a dispiriting effect all their own, and raise the spectre of all the hours spent waiting outside doors or traversing connecting corridors or simply riffling through all the rooms which stand between you and any conceivable goal.

Not surprisingly, Schönbrunn was not popular with every Austrian

monarch and suffered its periods of neglect and dilapidation. Successive rehabilitations were stimulated first by the Congress of Vienna and then by Franz Joseph's arrival on the scene. This was the emperor who won his subjects' hearts by behaving like an employee. He was famous for keeping lights burning late in his office and commuted most days from Schönbrunn to the Hofburg.

The inertia of the Habsburg monarchy is somehow conveyed best by the scale and pomposity of the palaces which housed and symbolized it. At the end of this overstretched empire's life they were adding enormous pseudo-Baroque wings to the already labyrinthine Hofburg or palace-city in Vienna, which were only a fraction of Semper's even huger proposals. One of these overscaled improvements provides a triumphal entrance tower where the palace meets the centre of the city, thereafter the most pompous public space in Vienna and ripe for Adolf Loos's modernist intervention on behalf of a clothing store, which the Emperor referred to as 'architecture with its clothes off'. The preposterous gate-pavilion across from Loos's white box ends in a copper dome, imitating a fabric canopy erected for a festival or maybe a military campaign against the Turks. Similar inflations had been tacked on to the Louvre under the auspices of another rickety empire, Napoleon III's, and for this enterprise too, Renaissance motifs were distorted into a caricature of Baroque. Such dreams are liable to descend on rulers even now: in Ceauşescu's Bucharest the ruler's palace was to form the culmination of a mental or physical progress through the city, for which a route was provided wider than any conceivable purpose could require (illus. 27). Ceauşescu was treating the city as his private park from which churches, dwellings and other historical debris could be swept away to provide unimpeded vistas, on the model of Baroque gardens and capitals like Versailles and Washington, DC.

In his idea of magnificence, like other modern dictators Ceauşescu repeats worn-out forms from the past. Two tendencies can be seen in the seventeenth- and eighteenth-century view of the ruler, the first represented by gargantuan palaces that swamp the individual in ritual. Besides Versailles, Vienna and Turin, striking examples are found in Nancy, Naples and St Petersburg. This conception is propounded by portraits like Hyacinth Rigaud's which smother the subject in surprising acreages of satin and velvet flowing round the figure like an unwieldy, theatrical storm. Out of the unlikely chrysalis of this ritual-bound world emerged the competing idea of the eighteenth-century enlightened

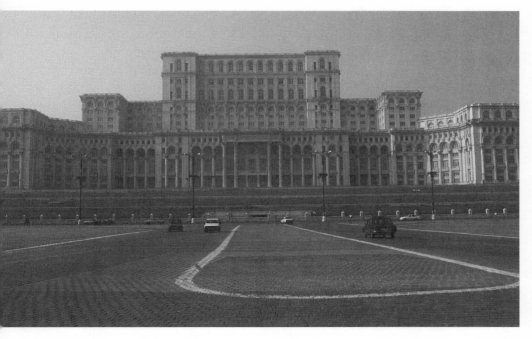

27 Nikolae Ceauşescu's 'House of the People', Bucharest, 1984–9.

monarch, who tends his garden and is mistaken by visitors for a work-
man. He answers their questions without revealing who he is, or
converses with farmers about ploughing methods and by this prosaic
means reestablishes his claim to stand for the whole land.

The ruler's nearness to or distance from his subjects is bound to be a
topic heavily overlaid with myth. In the Baroque it is usually tackled
indirectly; as earlier Shakespeare found it easier to discuss the role of
the mob or populace when he set the action in ancient Rome. As consti-
tutional monarchy develops, hedging the ruler with constraints on his
power, examples of the most arbitrary rule of the past fascinate the
theatre-going public, and tyrants like Nero and intriguers like his mother
Agrippina form the material for ironical operas in which all emotions are
extravagant, in which everyone behaves badly and no one is punished.
It is the vision of a past where every slightest gesture is magnified to
Baroque dimensions and one's involvement is intense and at the same
time inconsequential. The idea of the ruler becomes no more than an
excuse for exaggeration.

At about the same time as such enlarged caricature was appearing,

another kind of scepticism of grandeur appears in art and life. Here the paraphernalia of heroism is moved from the battlefield to the boudoir, and gigantic masculine scale narrows to exquisite feminine. In *The Rape of the Lock* Pope the translator of Homer deliberately incorporates much of the equipment of the full-size epic, now shrunken to toy proportions. Sylphs who are too small or filmy to be seen with the naked eye take the place of Milton's angels or devils, and since they are so small there is room for more of them. Thus, each part of Belinda has its special guards, fifty assigned to the petticoat alone.

Even more than in real epics the celestial beings make little difference, just a pretty film over all too predictable human motives. Women's behaviour in the poem is paradoxical but depressingly consistent – they always secretly want their enemy to win and their howls of displeasure on being violated are a kind of scenery through which they preserve the illusion of virtue.

Like Watteau, Pope is an artist whose polite surface conceals a gloomy view of human possibility. Many myths are exposed or diminished to child-like wishful thinking. Even religious impulses end in self-deification (Belinda worships at her mirror) and add to the catalogue of human folly.

Pope both scorns and relishes his feminine subject and is certainly more at home there than among real warriors. But it will be hard to recover one's belief in important human contests after seeing the field of combat so successfully transposed to the green velvet of the card table. The poet has done his job too well and caged us in a closet six feet by ten, a small private space in which we live out our lives, hearing rumours of far distant places – Japanned furniture, China cups – now reduced to indoor proportions, like a garden in which the plants are a fifth of normal size.

Later in the century the French queen, soon to lose her head in the Revolution, took the lead in scaling down the life of the court to pastoral fantasies more suitable for porcelain figurines. Her Hameau or mock-hamlet on the edge of Versailles was an expensive kind of play, but it was also an expression of corrosive scepticism. The world ruled by women was a place from which many human activities had been amputated.

Handel's operas also have something interesting to say on the subject of masculinity and femininity, not peculiar to one opera rather than another, but deep in the structure of all of them. It arises from the eighteenth-century taste for male soprano and alto voices in leading roles,

a register which could normally be obtained only by castrating boy singers before their voices broke, a custom that the Christian cult of celibacy perhaps made more palatable.

So in Handel's operas the parts of Roman emperors and romantic warriors are taken by singers who are not entirely men and do not sound like it, who are occasionally played off against female singers with lower voices. Alternatively, male roles were sometimes taken by women, a motif which Richard Strauss revived in *Der Rosenkavalier*, his Rococoistic opera set in the eighteenth century.

It is difficult to be sure what Handel's confusions of the sexes mean. They make for surreal fluidity of emotion and allegiance among the characters, so preposterous redirections of passion become plausible. They also reduce the territory open to tragedy and keep the idea constantly before us that these are deluded mortals. But the example of *Rosenkavalier* alerts us to the pervading presence in all these works, however light or sombre their general demeanour, of a darker substratum which comes out through a painfully achieved but false youthfulness in certain key voices. The singers and the audience, for whom human emotions, albeit oversized, have become the highest reality, are trapped in cages of their own making; under the cheerful Rococo runs a current of melancholia. The cult of youth and play wears thin and the Rococo wakes to intimations of mortality.

IV

THE END OF HEROISM

THE TRANSITION FROM BAROQUE to Rococo in opera is seen most clearly in the break-up of heroic subject matter, or the subversion of pomp by irony. Long before Mozart's time Italian opera had already resolved itself into two incompatible forms – opera seria and opera buffa, solemn vs. comic, Baroque vs. Rococo. Nowadays seria is usually regarded as moribund almost from birth, the plots mythological or ancient-historical, their format highly ritualized and designed above all to provide a series of display-pieces for overpaid, pampered singers who always left the stage immediately on completion of one of these extravagant arias, thus eliciting a little interlude of applause. Even the vocabulary of these set pieces was prescribed: love, honour and rage, flames, breezes and storms occur in a small number of combinations.

It is a genre which already begins to seem implausible in Handel's time, many of whose operas are now made palatable by viewing them as ironic parodies of real opera seria. It is true that his characters are more interesting than the form would seem to allow, but it is not true that Handel shows much impatience with the stiff format of arias separated by patches of recitative from which they stand out starkly.

In the decade before Mozart (not yet a teenager) began writing operas, full-scale parodies of opera seria appeared in significant numbers. Yet over a twenty-year period Mozart continued to try his hand at opera seria, beginning with *Mitridate, re di Ponto* when he was thirteen and ending with *La Clemenza di Tito* in the last year of his life. Of course Mozart needed a commission before he could write an opera and at no time was he able to dictate the type of work he was going to produce. Early in his career these conditions operate in a more restrictive way, but even in his first attempts the moribund genre of opera seria begins to come

alive and he finds involving drama in places where others have given up.

Drama in some sense is what interested him most. There is a view of his instrumental and chamber works as inherently operatic, that is, formed on dialogic or agonistic principles, easiest to see in the rivalrous relations between solo instrument and orchestra in concerti. Perhaps this view is most interesting for the key function which it gives to Mozart's operas in his musical thought. Certainly he finds a distinctive voice earlier in opera than in most other species of composition. *Ascanio in Alba* and *Lucio Silla*, written when he was fifteen and sixteen, are more interesting than the other works he produced around this time.

These early operas, one a pastoral pageant, the other a heavy drama from Roman history, are remarkable in their emotional intensity, in announcing themes (like tests of female faithfulness) which will be with him for the rest of his life and in ambitions to blur the internal boundaries of the form or to integrate the parts of these composite wholes to a degree previously inconceivable. Making rituals less stiff and inhuman or blurring their internal divisions, though not obviously destructive like parody, dissolves the old forms even more effectively by letting the participants walk free into a less rule-bound world.

Mozart's last opera seria, *La Clemenza di Tito*, is not his most advanced in total integration because he had to turn the secco recitatives over to a pupil to have any chance of making his deadline, the Habsburg Emperor's coronation as King of Bohemia. So under pressure of time this work reverts to the earlier dissociated form in which arias and the surrounding tissue separate out.

Further cause of the regressive tendency of *Clemenza* might be found in the plot, based on a work by Metastasio the court poet whose name sends a chill down the knowing listener's spine. It is one of those fables of the indiscriminate generosity of a tyrant, and recalls the plot of *Lucio Silla*. These works were both written for state occasions and first performed in front of a ruler. They show the autocrat plotted against and betrayed from all sides, particularly by those to whom he has been most generous.

If one imagines these dramas played out before courtiers, the benignity begins to seem less innocuous. Paranoia in rulers is a perennial subject; narratives like these feed or authorize it. Eisenstein's *Ivan the Terrible* is a recent and more sinister instance which endorses a general purging of the leader's intimates and includes a folksy version of the secret policeman lurking at the fringe of every situation.

Suffice it to say that Mozart's recorded attitudes to unquestioned authority in letters and in other operas, *Figaro* most of all, encourage us to think that he wouldn't have found this fable especially congenial. But the music is consistently ravishing and it is hard to see any way to take it ironically. This condition recurs throughout the later operas, beauty which seems inappropriate, in the mouth of a deceiver or a cynic. All the da Ponte operas – *Figaro, Don Giovanni, Così* – pose this conundrum in different ways. Perhaps beauty of this kind, like irony, is corrosive of rigid morality and authoritarian structures. A general softening in all these narratives points the way to the more permissive imaginative world of Romanticism.

Among Mozart's opere serie one stands out, *Idomeneo*, written ten years before *La Clemenza di Tito*. Some of its defenders insist that it is not true opera seria, because it is not full of set-piece arias, does not maintain the old rigid distinction between arias and recitative and seems inspired by French as well as Italian models. John Eliot Gardiner first gave me this last idea and it is true that French seventeenth- and early eighteenth-century opera, not just Rameau but Charpentier as well, gives the orchestra a larger role in colouring the action than the Italians after Monteverdi. And in these French operas, arias are not so clearly marked out from their surroundings but remain more speech-like and declamatory even in their most lyrical moments. Mozart is reported to have studied French scores for ideas about how to make music dramatic, though he specifically disclaimed learning anything about melody from them.

The pace of these French operas could not be more different from his. They are languid and reflective, periodically interrupting the flow with dances which, sitting at home, you can imagine are the hero's reveries, as he broods on what he has undergone. Staged versions would not easily allow this inward interpretation, but it is still possible to feel Rameau a near ancestor of the Debussy of *Pelléas et Mélisande*. Mozart might have seen in this diffuse kind of structure a glimmer of how the drama could spread beyond the figures into the landscape, making a whole consistent world, rather than a story continually breaking off in the diversions of dance, as in the French prototype.

In *Idomeneo* storms in the breast, declaimed by the seashore, are followed by storms at sea, rendered by eerily soft and non-violent music, descending notes on flutes which give the strongest sense of instability and change. The first meeting of Idomeneo and his son

Idamante is shot through with strange intricacy of feeling. Neither father nor son is comfortable with their relation and the tension assumes deflected form in the music, where their misunderstandings expressed in chilling woodwind figures breaking the calm surface, again make one think of Debussy.

The extraordinarily rapid pace of *Idomeneo*, so unlike conventional opera seria, is achieved through a wealth of fleeting suggestions in an unquiet orchestral commentary which often seems slipped in between the voices where there is practically no space. The result is the sensation of a multiple reality, in which surface sentiments (the sung text) meet resistances, echoes, or reinforcements in another dimension.

Perhaps *Idomeneo* is the first work where Mozart develops in more than isolated patches his conception of theatre as a kind of speech in which different voices can be heard at once and in which no single perspective seems adequate to the reality he wants to express. Maybe this work is something other than true opera seria because of the strong rebuke to the idea of heroism contained in this perception. Irony of various sorts becomes a crucial means of conveying his vision of the world, and of course irony is the mode furthest from thinkable in ordinary opera seria. Thus, choruses in praise of Neptune follow close on the heels of torments caused by the promise, extracted by the god, to sacrifice the first person Idomeneo meets after being washed safely ashore in the storm. Did Mozart consciously apply a perverse twist to this anodyne scene of rejoicing?

A similar situation recurs in *Figaro* when happy troops of peasants come praising the generosity of the Count, who has just been revealed as a predatory and unscrupulous person whose virtue always has an ulterior motive. Here the praises have the unexpected effect of coercing him to behave better in public than he really wants to; they extract a reluctant concession. This represents a later stage in the undermining of a hierarchical model of society, when deference has become a tool clever underlings can exploit, and fixed eminence lies open to manipulation. The text of *Figaro* was famous for preaching something close to insurrection, but from much earlier than that Mozart's art was finding loopholes in received formulas.

Already in *Idomeneo* authority tends to be expressed as injustice, and stuffy consensus tends to be spoiled by an outsider's objecting voice. The disappointed and vengeful Electra veers back and forth throughout the opera, rejoicing when others despair and throwing in the towel

when they succeed. Mozart differs from earlier dramatists in deploying the outsider's voice in concert with the others, and in welcoming the musical opportunities brought by such contrast.

But it is still a large step from including a character who always sees things differently to feeling that many human emotions are more complex than they are normally credited with being, and presenting the responses of a set of characters as an ambiguous whole all at once. By this means Mozart leaves us less sure where our emotional centre lies, or expands the territory it occupies. Sometimes he pulls us through a series of inconsistent positions, sometimes all the possible sensations seem to take place at once. It is the theatrical equivalent of ambiguous Rococo ornament, curling indecisively this way and that, decomposing, at what should be a strong moment in the curve, to a kind of gold froth. Human character in Mozart operas becomes strangely unstable like the plaster disguises of prosaic structures, which periodically revert to purely architectural motifs, only to vanish a moment later in a surreal fog of lifelike cherubs or overblown roses.

A single work of Monteverdi's encompassed the entire gamut, from gods who appeared on stage making ritualized comment on human affairs to grotesque gluttons or boors who were eventually routed. The separation of Italian opera into two distinct forms – seria for tragedy, buffa for comedy – is paralleled in many other cultural forms of the Baroque. Shakespeare's sublimest tragedies had included fools, porters, gravediggers and clowns, all edited out in Dryden's versions of the same stories. But after incongruity has been laboriously excluded, along comes Mozart to reintroduce it. Instead of democratizing tragedy his principal method, like Congreve's, is to deepen comedy.

Mozart will always be remembered best for what he was able to do with the light, if not truly trivial, and inferior, if not actually despised, form of opera buffa. Maybe the most effective subversion was mounted this way in the eighteenth century, not through a frontal assault on heroic genres, like, in painting, mythological and historical subjects, but through the dedicated cultivation of seemingly frivolous territories by artists like Watteau or Mozart. In these forms one does not need to subtract or destroy those elements which habitués will count on finding, but instead to insinuate disruptive new ingredients which can steal up on the observer. Then at some point the audience notices that the real energy has emigrated from the palace to the garden, from the stately file of reception rooms at Versailles to the mock-hamlet scattered around a fictitious lake.

Indeed Mozart dissolves many rigidities in the forms as he finds them, but there are limits to his rebelliousness. As he says at one point in a letter to his father, you represent madness or murderous rage, but you do it in music. That is to say, it must remain pleasing to listeners. Unlike Rameau, Mozart was not a theorist, but he was thought by many contemporaries to produce excessively intellectual music, not a view it is easy to think ourselves into now. Yet this response points up the seriousness with which he questioned the conventions as he found them, stopping short of the out and out defiance which became the signature of his successor Beethoven.

Already in *La finta giardiniera*, an early opera buffa, Mozart is writing symphonically for voices. The technique rises to fever pitch at the ends of the first two acts. It may be surprising that the end of the entire work is not the biggest crescendo of all, but there are good reasons why this is so, for the most enthralling type of Mozart finale, which engages simultaneously a large number of characters who each remain distinct, does not produce a final resolution of tension but leaves matters in an unstable state, showing Rococo tolerance of tangled form. In fact this conception of a finale exaggerates all the latent strains and stresses in the situation, leaving spectators' heads and emotions in a whirl, propelled forward towards a resolution whose form is as yet unclear.

The technique is to rev things up, let them subside a little, add a new ingredient (in the form of a character or two horrified by what they see taking place, or pressing a claim which will disrupt the affairs of those already collected on stage) which raises the tension, which then levels out, only to be heightened by another entry, followed by another drop in temperature and then another entry. In the first finale of *La finta giardiniera* there are three crescendos of this sort in succession, the last of which is not allowed to cool off, leaving everyone at a high pitch of distraction. The formal principle is the same in the nervous plasterwork of a Bavarian church which distributes intense foci all over the interior.

For the responsive spectator, the dynamics of Mozart's finale are carefully calculated to produce peaks of excitement leading on to further peaks with partial relaxations but without true pauses. Is this ascending structure transferred from purely musical forms or is it something Mozart had picked up in the spoken theatre, an entertainment to which he is known to have been addicted?

In *La finta giardiniera* the complexity is comparatively simple – in the dark all identities have been mistaken and every pair ill-sorted, because

the affections of one half of every pair have strayed, leading to a set of unworkable new unions and stranded former partners. There are cases even in Shakespeare where such volatility in the affections makes characters seem abstract quantities or phases of an intricate dance figure, but Mozart is not content to leave it at that. Even stock characters express real pain and infuse the symmetrical little game with uncomfortable stabs of passion. But an overarching control remains. Passion in Mozart always grows on the trellis of Rococo convention or peeks out from behind it. It is a departure that always returns from its brief centrifugal fling.

In later works Mozart begins to show an interest in more dissociated techniques, sometimes resembling surrealist counterpoint, as in the opening of *Figaro*, where the betrothed couple follow different lines, completely oblivious of each other. It is also an instance of setting nonsense or near nonsense to music. The numbers Figaro intones are admittedly words, but reiteration makes them almost senseless, a parody of the aria in opera seria which employs words mainly to exercise the voice.

It is a venerable though slightly surreal device in opera to have one of the characters 'sing a song' to the others. Of course they have been singing already, but the convention sets this 'song' back from us at a greater distance and creates a moment of greater self-consciousness. A subtle version of the effect occurs in Don Giovanni's great seduction aria 'La ci darem la mano', all phrased in the future tense, 'I will do this and then you will do that', not here and not now. It makes it easier to be seduced and to yield if you think there is still time to retract because it is only a kind of child's play and has not happened yet.

But spectators will notice that the actions are a crucial step ahead of the words. Here Mozart's drama resides in the distance between an idealized and an underlying version of events. Here the music is ironic, lulling us with its false sense of safety. We might identify the composer with the seducer, who is able to persuade us of things which are not true. His most ambiguous work, *Così fan tutte*, is his most fundamentally deceptive. Why has Mozart reverted to a story whose rigid symmetries make one think of porcelain figurines and the shallowest Rococo make-believe? It is full of pastoral tonalities but is not about shepherds. It employs a fairy-tale plot but will not let us off the hook by suggesting that feelings were twisted round by magic.

The plot is painfully simple: two men make a bet that their sweethearts cannot be budged from their attachments. They leave them abruptly,

then come back in disguise and begin seducing the other's partner, finally succeeding after taking poison (apparently) which brings them to the point of death. They are revived by pseudo-science, then weddings are planned, and at this point they return as their earlier selves to the shame of the women. The moral insanely derived from this is that women are fickle.

The music of *Così fan tutte* is the most gorgeous of any Mozart opera, which might induce us to argue that it is his most profound work. The final chorus derives a philosophical moral from the tale: reason can lead one via tolerance to serenity. But *Così* leaves us as confused and divided as the women manipulated by the comic intrigue. Its beauty has been thought parodic, suggesting that Mozart is fully in charge, but suppose instead that all this heart-rending pathos showed the composer's own powerlessness, not as a musician, but as a man hoping to regulate his own feelings and to count on someone else's. So what might have been a comfortable eighteenth-century work is anything but. The men's cruel trick, of which they are equally victor and victim, has exposed an instability from which there is no escape except substituting some other principle for passion in one's life.

Both *Don Giovanni* and *Così fan tutte* threaten in their different ways to overturn comic structures in the end. The rent in the fabric of *Don Giovanni* is much more violent; it is the end of the hero which the rest of the cast try afterwards to pass off as cosmic justice. Like the conclusion of *Così* this rings hollow.

The music which accompanies the visit of the stone guest is some of the most shocking in opera up to this time. Just previously the subject matter had turned elemental and primitive, and Don Giovanni had disgusted his servant by his gluttony, like a crude medieval Vice. Right on top of another of his raucous parties (containing parodic treatment of themes from Mozart's rivals) comes the great rent in the fabric of the music, which incorporates a series of screams and plunging figures in minor keys.

The moralized interpretation of this does not match its musical effect. The Guest's appearance has shattered the opera beyond hope of repair, and whatever follows will be severely anti-climactic. The hero is harried off to Hell by a pack of stage demons and the survivors rejoice. So there is an element of melodrama, but in any serious way how is it different from the end of *Hamlet* or *Lear*? First of all, in that the hero seems to have destroyed only himself; but this takes wilful blindness to

believe. None of the female characters has escaped unscathed, and most of the lives which are left remain strangely unresolved.

So at least two of Mozart's mature operas have burst the bounds of comic form in disquieting ways. In the history of the Baroque and its derivatives, perhaps *Così fan tutte* occupies the more disconcerting position – a scaled down, infinitely graceful work which ought to qualify as the Rococo opera par excellence, yet cannot sit comfortably there, undermined by an intensity stronger than all its ironies.

Architecture trespasses most dramatically on the territory of opera or theatre when it tries to act most violently on the spectator, catching him with visual surprises. It is predictable that these effects will usually be nearer to *buffa* than *seria*, even though in German Rococo the most extravagant realizations occur in churches. But in looking at theatrical church interiors by the Asam brothers in Bavaria we must temporarily suspend our notions of what constitutes seriousness or frivolity. As in Mozart, unexpected depths sometimes lie below nonchalant surfaces. Though most Asam spaces are definitely *buffa*, at least one is *seria*, in the abbey at Rohr (illus. 28).

Here the excitement is concentrated in a single effect that takes one's breath away, a levitating figure, who hovers twelve to fifteen feet above the floor. She looks exactly like the distressed heroine of an opera, pleading with the spectator in a Baroque attitude, her rich costume all aflutter. On the ground beneath are the twelve disciples she is leaving behind, who constitute a little audience in enthusiastic poses of their own, each one finding a different overdramatized way of appreciating her performance. They cluster round an altar-like mass of red marble which is actually an empty sarcophagus, for the scene is the Assumption of the Virgin as it might be acted out by some princely theatre troupe. There is another, higher level to the stage and a whole further set of actors perched on the cornices of the altar frame. Here we find the members of the Trinity ready to welcome the rising star, above whose head angels are holding a golden crown so large that she could easily glide through it on her way up. Bernini provides the model for such effects, but the Asams have far outstripped him in flamboyance if not in spiritual intensity.

As the metaphor of theatre becomes more literal and pervasive the role of the spectator radically shifts. In later examples the whole building, not just the end wall, becomes a stage, so at the Benedictine abbey of Weltenburg and at St John Nepomuk in Munich a vestibule is added

28 Egid Quirin Asam,
Assumption of the Virgin,
altarpiece, Rohr abbey,
1717–23.

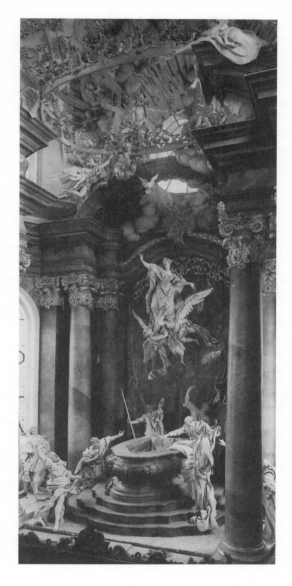

to the space, which frames the nave dramatically. In these two buildings,
both much smaller than Rohr, the experience is broken into episodes
which work like the auditorium and stage of a theatre.

First one enters the lavish prefatory space, lower, more intimate
and domestic than the nave which lies beyond, but extravagantly decked
out in figure-sculptures leaning half free from the walls and miniature
grottoes which turn out to be cosy confessionals (illus. 29).

29 Cosmas Damian and
Egid Quirin Asam, St John
Nepomuk, Munich,
1729–46, vestibule.

At Weltenburg the vestibule bulges into the space beyond but is separated from it by a metal grille which runs from floor to ceiling. On some visits you will not get past this grille, which turns the church into a peep-show. Going beyond the grille is like being allowed to step on to the stage, so an earthly theatre becomes the model for approaching nearer to God. At the Ursuline church in Straubing, the idea of the spectator is dramatized in the vivid little houses or boxes inserted high up between the large pilasters, with windows where the entablature would be, a startling means of animating the classical system.

The idea of the spectator is frequently given unnerving force by sticking in a realistically coloured three-dimensional figure on an upper level. At St Emmeran in Regensburg it is a priest behind a balustrade facing towards the altar. It takes a while to dispel the feeling that we are sharing the space with someone more devout than we are, who redirects our straying attention. At Weltenburg a mischievous person smiles

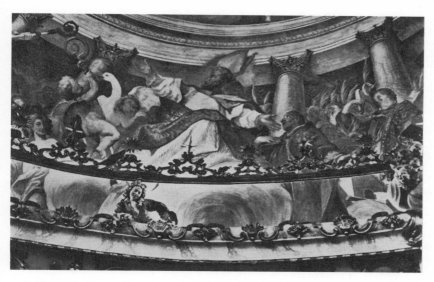

30 Egid Quirin Asam, Stucco figure of his brother Cosmas Damian looking down from a balcony in the Klosterkirche, Weltenburg, 1716–35.

down at us from a perch just under the illusionary vault which turns out to be a self-portrait of Cosmas Damian Asam (illus. 30). These jokes aren't peripheral or incidental; they assert that art is a collaboration between the hoaxer and his willing subject, the hoaxer having undertaken to provide constant diversion for his restless client, who expects a series of highlights, each more beguiling than the last, like the stream of arias in a Handel opera.

The Asams have learned from Bernini, but they are also the inheritors of the approach to spiritual drama pioneered at Il Gesù, the Jesuit church in Rome where all restraint is abandoned and the greatest possible glitter and magnificence is unleashed. The result makes Bernini at his most florid look sober and architectonic. Gold and silver are splashed round without inhibition, perhaps advertising the Jesuit licence to exploit new spiritual markets in America where these metals come from.

In the Asams' hands too, silver and gold are used for their shock value, vulgarly contrasted with ordinary reality. But the Asams introduce an ingredient of their own, a kind of witty inconsistency. The east end at Weltenburg throbs with gold around a central opening like a window, a space the painted altarpiece would ordinarily fill, where instead we find a three-dimensional tableau grouped around St George in armour and on horseback, like a military monument. To one side of

his pedestal the dragon rears up: on the other the princess he is rescuing cowers wringing her hands, the whole theatrically silhouetted by light admitted through coloured glass into an invisible room behind.

The saint is coated in silver leaf while the other figures are highly and naturalistically coloured. One excuse for the difference is the knight's armour, but his face is silvered too, so it appears we have a metal figure and two of wood or plaster. Strong illusionism and an irregularity which disrupts it are common in German Rococo: we have it both ways, and thus our sense of artifice and our role as spectators are heightened.

Such effects are common in the Asams' work: in Regensburg and Munich gilded or silvered urns sit high up on the walls and out of them spring bright green leaves of agaves, lilies or roses, never the same twice, like real toads in imaginary gardens. Near the altar the contents of these urns become spindly streams of water or vagrant clouds of plaster smoke. The vivid colours and wild forms make these into brief out-bursts in milder surroundings, like actors who momentarily drop their masks. It is the designer reminding us we are watching a play by insert-ing discordant glimpses of actuality. Of course the green plants are no more alive than the silver roses strung like Christmas lights along the cornice behind them. The green ones are playing living plants, and the silver ones are playing jewellery, in a single grand performance. In these interiors theatricality can be defined by such moments of internal self-consciousness – one element of the decor explicitly responding to another – and by the way the whole scene invites or refers to the spectator's involvement.

Remodelling the old cathedral at Freising, the Asams coated a Romanesque nave in Rococo plasterwork. This project has no tectonic pretensions; in fact quite the opposite. Essential structure looks flimsiest of all in the new scenario: bits of vault lit by clerestory windows are now rendered irrationally as thick brocade. Lower down is a light-hearted set of scenes from St Korbinian's life. The most characteristic Rococo twist is the addition of spectators to these scenes in the form of three-dimensional putti (illus. 31). These are so lively that they upstage and undermine the grown-up business on which they form a commentary. Every scene is framed by two putti, one each side, who carry fluttering ribbons, if they remember to, which form the scene's descriptive labels. The saint whips wrongdoers and this gives a putto the cue to wield a wire whip, and the matching one to cringe; when the saint is made a

31 Cosmas Damian and Egid Quirin Asam, Stucco putti and a scene from the life of St Korbinian, Freising cathedral, 1724.

bishop, the putto carries a baby-size pallium; when the motto says 'pray', one baby falls into such an ecstasy of devotion that the legend slips away from him and slides under the vault; one putto stares raptly at the scene and the other looks idly out at us; the sober and the negligent baby look equally ridiculous.

These little spectators suggest that there isn't a single right response to great spiritual exempla. The putti have licensed all the random variety of the world and subverted the attempt to teach through stories, which now inspire different responses in different members of the audience. So we can take these narratives as comedies which provoke mainly a jolly irreverence.

The special Baroque contribution is a new three-dimensionality in the decor. In Bernini such effects are carefully focused and the religious content is edited severely. But in other places than Rome the theatricalizing of religious spaces crosses over into the purely secular more irresponsibly. The Sicilian stuccatori of the late seventeenth and early eighteenth centuries inhabit this borderland even more insouciantly

than the Asams. Giacomo Serpotta, the greatest of them, did his best work in semi-private, and thus semi-secular oratories attached to the churches of Palermo. These fall into a recognizable spatial format: modest but relatively high rectangular rooms with a small chancel at one end. The result is an intimate, non-axial space which is more like a ballroom or reception room than a church. The practical explanation lies in its social function as the meeting place of a confraternity. Venetian *scuole* provide a more familiar parallel: inconspicuous altars also fill one end in Tintoretto and Tiepolo's great rooms there.

From such a modest-sounding brief come astonishing confections in which an overwhelming throng of plaster figures and scenes extruded from or burrowing into the walls surrounds you on every side. These walls have become complex spaces which barely remember that they used to be simple planes. The most spectacular denial of the wall plane occurs in the entrance wall of the Oratorio di Santa Cita in Palermo, the wall we must turn round to see after entering. Entrance walls have a special importance in Serpotta's oratories; not only did the governors of the confraternity take their seats against them, but they confirm the self-enclosure of the space; it is like shutting the door behind you.

The conceit of the Santa Cita entrance wall is that it is a single billowing curtain like a large sail full of ripples, lines of stress and folds so deep putti can disappear into them. Iconographical programmes in these spaces usually seem pretexts for multiplying figures and showing off the stuccoist's fertile imagination. But here the subject gives this windblown hanging extra point. This wall celebrates the intervention of the Madonna of the Rosary in the great sea battle against the Turks at Lepanto (illus. 32). The central diorama is full of miniature ships with metal rigging while under it lounge two large sailor-boys, the Christian one leaning on a helmet, the Muslim on a turban, with a pile of armour filling the space between. So the swells and hollows of fabric round the scenes stand for sea swells and air turbulence in the eastern Mediterranean.

Set into the wall around the central scene are a series of *teatrini* depicting the Glorious Mysteries of the Rosary. *Teatrini* are a special Sicilian genre of sculptural relief which became more and more fully three-dimensional until they destroyed the idea of the surface and replaced it with a little stage receding precipitously into the masonry. They are an anti-sculptural and anti-architectural mode in that they mount an attack on the integrity of the material in pursuit of an illusion.

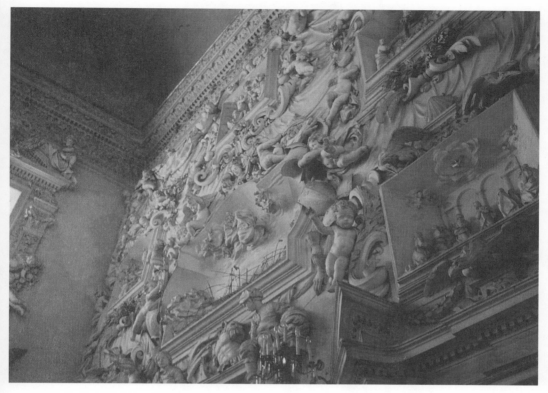

32 Giacomo Serpotta, *The Madonna's Intervention in the Battle of Lepanto*, Oratorio di Santa Cita, Palermo, 1686–1718.

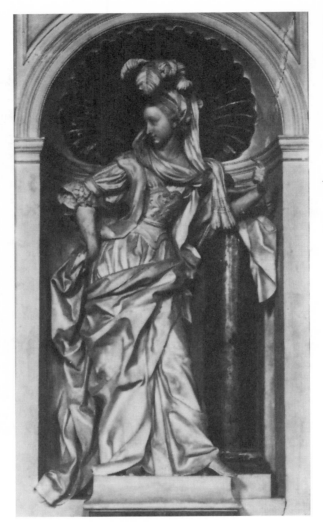

33 Giacomo Serpotta, *Courage*, Oratorio del Rosario, San Domenico, Palermo, 1714–17.

Serpotta's huge populations are more like audiences than casts of characters. Few of them are strongly characterized and many are babies from whom no one expects developed personalities. The Virtues in the Oratorio del Rosario at San Domenico are probably the best but it still comes as a shock to learn that these flighty creations represent solid or positive ideas like Virtues (illus. 33). Serpotta makes even Tiepolo seem wide in the human range he covers, for age, harshness and the grotesque are largely banished from Serpotta's world.

He produces a generalized sense of theatrical occasion like the

animation of Italian piazze. Though his ensembles are among the liveliest of works, they conjure up a distracting hubbub rather than real psychological depth. The medium is stronger than the particular content and its overall colourlessness reinforces this effect. Many of his scenes are taken directly from paintings or engravings, a habit which tells a lot about how he saw his own activity as the manipulator rather than the inventor of the material. Critics sometimes treat these borrowings as if they were confessions of weakness, but workers in decorative mediums often borrow in a similarly unembarrassed way. Among works of the highest sort only the Sistine Chapel is comparable to one of Serpotta's interiors in density of incident and profligacy of figure studies. But Serpotta's achievement, unlike Michelangelo's, consists in turning other people's compositions into wholly other form, colourless but three-dimensional, both more real and more artificial.

When the projector of Forest Lawn Cemetery commissions lifelike diorama versions of world-famous paintings we consider it a colossal error of taste. Serpotta's sources are much less famous: almost no one will recognize them, and thus in some sense the joke is lost. But everyone gets the general idea, a kind of apparition, which might almost have appeared magically overnight. It is a temporary effect made permanent, like the extravagant decor for a triumph. Laborious cogitation wouldn't go well at all with such a sense of the transitory, and Serpotta brushes away any inclination we might have to find profundity in his subject matter. Tellingly, his most important technical discovery was to impart surface glitter to his figures by incorporating marble dust in the plaster, creating a kind of liveliness which is the enemy of thought.

We learn to our surprise that he worked exclusively on religious commissions and was notably devout. At least he spent the year 1690–91, between work on Santa Cita and San Lorenzo, in a Jesuit novitiate. Should we therefore see Serpotta's overdressed Virtues as bait luring one to embark on thinking about serious things, or another instance of Ignatian techniques giving licence to sensuality and making worldliness the main Baroque form of godliness? Serpotta's women are summed up by their clothes and the provocative ways they show them off by moving their hips or throwing out their arms. The exaggeration of the costume, a kind of theatrical display visible from the back of the theatre, devalues facial expression. On top of this, character types are not lined up with the Virtues they supposedly embody: Fortitude is languid, Justice inattentive. Virtues are a language which ceases to make sense to

this sculptor, until the conventional attributes – scales, mirrors, broken columns, swords – formerly superficial clues, are now the only places where the concept (Constancy, Prudence or Charity) resides, while much else contradicts it.

In this story of the migration of the subjects of art away from myth, elevated morality and conventional codes, Watteau holds a key place. While Serpotta subverts the old subject matter, Watteau simply does away with it and paints people of no name in indeterminate places. Sacred or mythical subjects are so rare as to be almost non-existent in his work. Although he began as a painter for the theatre and then found himself mass-producing small devotional pictures for sale in the provinces, before long he was choosing his own subjects and painting what he wanted to paint. He didn't have to wait long for recognition and was invited to submit whatever subject he pleased for admission to the Academy. Even so it took him a long time to comply and to produce the nearest thing in all his work to a large mythological subject, the *Embarkation to* or *from* (opinions differ!) *Cythera*.

Of course there are cultural residues in Wattteau's subjects which do not spring unaided from his own brain. The canvases show women in beautiful yet somewhat shapeless dresses lounging on the grass in a flat landscape attended by men in fancy dress. Not much is going on. The nonchalant rhythm of the grouping is a kind of deshabille in which couples are isolated yet coordinated, like voices in Mozart's ensembles. It is hard to speculate about their emotions, because expressions are not easy to make out, and activities are not specific.

The poetry of these scenes derives partly from the single bit of stiffening in the subject matter: Watteau's paintings are all inspired by the theatre. Everyone in this world is more or less dressed up. Many outfits are hard to pin down, but even the non-expert can tell that this is not ordinary dress. In the women's costumes there is too much cloth and it glitters too much for everyday. Men's outfits tend to stray further from plausibility, for in male garb satin is out of place and the pastel colours seem far-fetched.

Watteau is unusually fascinated by satin and silk, which in his hands come into their own, insubstantial but intense, with unpredictable highlights. Whole dramas are built up and dispelled within a few inches of watery fabric. And then there are his ungraspable colours, faded and practically colourless at times, and transmitting the most momentary sensations. What all this has to do with theatre isn't

34 Antoine Watteau, *Actors of the Comédie Française*, 1718.

hard to see: a medium which works by suggestion and functions best when not too insistent, contented with effects which are comparatively brief.

Literal depictions of theatre subjects will illuminate the relation between the mythical and the ordinary in Watteau's best work. One critic has detected a scene from a particular Lully opera in one of Watteau's paintings (illus. 34), but without his suggestion we would have said that it took place outdoors in a stage-like space (not a stage) and showed actors in costume standing around in between episodes of theatre; in other words, professionals off duty.

There is a pendant to this picture, a rarity in the work of this painter, who changed tack disconcertingly often and left canvases unfinished rather than carrying out linked series. The matching scene shows an Italian troupe at night, as against the French one by day. The French costumes are prettified versions of ordinary dress, while the Italians, among them clowns and caricatures, verge on the grotesque. The second group are shown in an impromptu performance more like a party than a play.

These two paintings are certainly theatrical scenes and help persuade us of Watteau's intense interest in actors. But he is most fascinated by them neither on stage nor entirely off, but somewhere in between, where they can slip in and out of their fictitious character. It appears that he frequented the theatre and liked watching plays, but as a painter he transposed the theatre into ordinary life and vice versa, thriving on interfusions of the two, as in a picnic where time has slowed down or stopped, making conversation practically unnecessary, where the out-

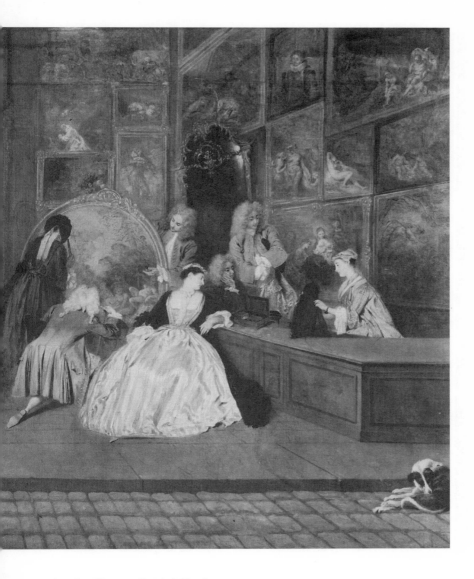

35 Antoine Watteau, *Gersaint's Shopsign*, 1720.

line of a skirt on the grass is imprinted on the viewer's mind like one of
Rameau's stately dances.

Now it is too easy to think of Watteau as courtly or aristocratic, when
he is neither in a strict sense, though one could say that he assimilates
bourgeois leisure to older notions of a luxurious existence. Sometimes
the dalliance occurs in extensive parkland, but the trappings of high

99

status are missing, and interiors are practically unknown. In fact the paintings embody a fantasy of escape from the distinguishing marks of one's social position. Watteau arrives at pastoral anonymity by a different route from Marie Antoinette and finds less amusement in mock agricultural activity than his successors Boucher and Fragonard. But there are hints in Watteau of the cults of landscape and the child, which only became specialized obsessions in the two later painters, and most of the time he has concealed his urban provenance as thoroughly as they.

The single pronounced exception is a remarkable work now in Berlin, the shop sign he painted (in eight days according to legend, usually starting late in the day because of his illness) for his friend the picture dealer Gersaint. This makes a little stage-play of the trade in paintings (illus. 35). On the left porters crate or uncrate a couple of pictures which catch the attention of a lady being greeted by a young man. In the other half connoisseurs with their backs to us are studying a large oval painting, while a group facing the other way makes a similar investigation of a mirror.

The space is a natural stage made from half a courtyard, hung with pictures like a room but opening on to a public thoroughfare, where a dog bites its fleas and a hay cart formerly stopped on one side. The cart was removed when the curved top of the sign was squared up by grafting bits of canvas from the two ends, creating the upper reaches of the present space which make it more like a proscenium stage than ever.

It is outdoor yet indoor, staged yet natural. A gentle movement unites the figures starting at the left. At the back, filling a pause in the group, is one of those economical little vistas familiar from stages since Palladio's Teatro Olimpico, a slit of receding perspective opening on to a high narrow room lit by windows on one side, which carries the suggestion, exciting but false, of further worlds beyond the rear limit of the stage.

The real wit of the picture comes from the focus on people not paintings, people who have stepped out of or are stepping into a painting by Watteau, like actors on a stage whom one can imagine coming to life as the curtain rises and slumping back into inactivity when it falls, life stirred into motion by the demands of art.

It is his most magical picture because it shows the inhabitants of Cythera at home in Paris, in the same space as roughly dressed servants. The idle one on the left may be a later addition, and the tampering with

the picture's dimensions has altered its social composition somewhat. Even so, it gives us a glimpse of Watteau the realist who might have turned to painting social comedy in urban settings, where there is still lots of drama in the buttons of a coat. At moments like this it is not hard to imagine him as one of the precursors of the novel, if not quite of Proust, at least of Marivaux, who has borrowed the old mythical intensity and applied it to the lives of serving girls.

V

THE WORLD AS SCENERY

CONGREVE'S CAREER IS even shorter than Watteau's but for a different reason; not early death but disgust brought his playwriting to an abrupt end. In fact brevity frequently becomes both a theme and a feature of Rococo art, which depicts fleeting actions in brief and brittle forms. Like Pope in poetry, Congreve in drama creates a stylized universe with its own specialized inhabitants and strict rules. The texture of his plays is extremely dense but the subject matter severely circumscribed – wit, affectation, sexual intrigue and fortune-hunting as carried out by fops, worldlings, fools, flirts, harridans and country bumpkins. The hero's equipment consists of greater skill in repartee, the verbal equivalent of pervasive ornament, and a more profound cynicism. He does not believe in his own impulses in the crippling way the others do. Not even the hero is immune to all the rules, though – he falls in love, less help-lessly perhaps, and he needs to inherit like everyone else.

The rhetoric of the play consistently prefers illusions to reality and turns stable values on their head – women show their faithfulness by choosing lovers who resemble their husbands; old ladies are especially flattered by false suppositions that they may be pregnant. Yet all Congreve's plays drive towards a resolution in marriage, the institution at whose expense half the best jokes are told. It is as if the structure of the world is a surface of entertaining talk on top and a layer of not so interesting truth underneath.

One can understand how Pope might have subscribed to the idea that the goals of nymphs and beaux were trivial and hollow, for it was a life from which he was excluded by his crippled body, but Congreve went on to become a character from his own plays when he left being a writer to become a real man of the world. Both of these writers follow

a frequent eighteenth-century formula: the cultivation of seemingly trivial subjects, to which they impart hectic liveliness. Pope's *Rape of the Lock* is a flamboyant case, with its rabble-rousing title and inflated diction.

This short epic describes the morning of an empty-headed girl from waking through to making herself up, after which she takes a boat ride, plays cards, drinks coffee – at which point, when she isn't looking, a man cuts off a little bit of her hair which he plans to wear in a ring. She makes a scene but he won't give it back. The poem ends with the fantasy that her hair has mounted to the heavens as a comet or other permanent feature.

This of course isn't the half of it, because Miltonic and Homeric parallels are constantly worked into the story. Her dressing table is an altar, her maid an assistant priestess and her cosmetics the equipment of a sacred ritual. Her appearance outdoors is a celestial disclosure and the card game a classical battle. The most elaborate conceit is the insertion of supernatural machinery in the form of hundreds of tiny sylphs, the ghosts of dead beauties, assigned to watch over her, perching on her clothes or fluttering about her head. This large population is a transparent device for idealizing the girl, for suggesting a higher, practically invisible dimension, for creating a kind of alluring glitter all round her.

One of the most charming parallels to life-size epic comes when the sylphs are threatened with a miniature Hell if they fail to guard her. They will be dipped, pierced, roasted and dried by different cosmetics and implements of beauty. Like other Rococo artists, Pope is aware that he comes after his themes have been treated on larger scales by other writers. At least the littleness of Pope's work is self-confessed and often further self-undercut. Thus in the card game, when assigned to particular cards, sylphs fight over precedence. Senior sylphs want higher ranking cards to guard. Smallness is piled on top of smallness to bring us up against our own questions of scale.

It is easy to step outside the card game in the poem, where the costumes of the face-cards are minutely detailed to our amusement, but most of us have fallen under the spell of games, as most of us know what romantic rivalries feel like. Belinda's trivial story could turn into a novel by Jane Austen. She would still be given regular cleansing treatments of irony, but there would be no sylphs, who make her into a gewgaw. In the end the epic machinery gets the upper hand. After the battle of the card table we get the battle of the lock, which is less successful, partly because it is a reprise – we've had a battle in one register, now

we get one in another – but also because the real-life parallel isn't there this time – cutting remarks and flirtatious looks don't leave corpses behind. And the denouement is more implausible still: Belinda ends by throwing snuff and a dangerous bodkin at her assailant. Mock epics are doomed to be brief because the narrative is so thoroughly in thrall to the machinery. Thus when we are interested in the girl we find the poem delightful, but when it switches – in the final battle – to a set of correspondences (between the space in front of Troy and a drawing room at Hampton Court) it feels like literary criticism not a story.

Pope's mock epics are most exciting when they stray from their programme, carried away, however briefly, by the negative vision. But even so, the mock epic is episodic by nature and Pope's last, most successful foray in the mode, Book IV of *The Dunciad*, is the most ramshackle structure of all. It consists of a series of brilliant figures for dullness, intellectual laziness, misguided learning, dilettante obsession and cultural fraud. Targets include Italian opera, Continental travel, detailed study of natural history, collecting coins and other antiquities, and literary scholarship. Each activity or abuse is represented by one or more individuals who clamour for the Goddess Dullness' attention.

The poem is introduced as a last demonstration of her power, with her followers paying court before her final triumph over all their brains causes a complete shutdown in which they forget everything, even her. So it resembles a conference of warriors in Homer, except that in Pope there is no business to transact, nothing to decide. Each speaker simply sums up his mode of life before being pushed out of the way by the next candidate for attention. Again Pope produces the typical Rococo effect of an obscure whole from which hundreds of tiny but gorgeous surface features stand out. Dullness is criticized for microscopic vision which loses sight of the whole in pursuit of vivid particulars, which is exactly the effect of Pope's poem.

> Then thick as locusts blackning all the ground,
> A tribe with weeds and shells fantastic crowned,
> Each with some wondrous gift approached the power,
> A nest, a toad, a fungus or a flower.
>
> Yet by some object ev'ry brain is stirred;
> The dull may waken to a humming bird;
> The most recluse, discreetly opened, find
> Congenial matter in the cockle kind.

> The mind, in metaphysics at a loss,
> May wander in a wilderness of moss.

Very characteristic is the conflation of the mind and its object – the shell-student's attention is pried open like an oyster. And the lines describe what it feels like to read the poem, where the darkness is lit up by sudden fires, and quick darts of wit make resounding hits which take one's breath away, causing a kind of hiatus in the forward movement of the verse. Received opinion has it that the couplet too is a kind of inter-rupted form, which continually stops to admire its own completeness. Certainly the lines seem to urge thoughts to fit themselves within their borders, and the moments one is likely to pick out tend to this kind of brittleness:

> To happy convents, bosomed deep in vines,
> Where slumber abbots, purple as their wines.

> As many quit the streams that murmuring fall
> To lull the sons of Margaret and Clare Hall,
> Where Bentley late tempestuous wont to sport
> In troubled waters, now sleeps in port.

These are like surrealist epiphanies: they are startling, and then they are over. Perhaps the nightmare world they conjure up resembles the incongruous epic parallel in one respect: they give you an incredible idea but not one that you can live with for an extended period. You get a glimpse of madness, not madness displayed at full length. Bentley like a worn-out ship tied up at its final resting place, Bentley wallowing in the pleasures of Cambridge tables and after-dinner wines – it is a vision worthy of Bosch or Fellini, but it is fleeting, barely marking the retina, so you wonder if you have really seen it.

The abbot is a near allied thought which has been deployed at a faraway point in the poem, which we might take as a sign that Pope recognizes that this kind of writing shouldn't try to be too continuous. One of the main procedures of wit is to keep changing the subject and to give us the sense of being spun rapidly from one mental place to another.

Wit is one of the great eighteenth-century subjects and defining it is a persistent obsession in all sorts of writers. Perhaps the fascination begins in the brevity, like an effervescence, of the very syllable itself. It is a meeting point of subjective and objective angles of view and refers both to inner capacity and clear but fleeting external signs. Near the

beginning of Congreve's *Love for Love* comes a characteristic tirade on wit which has been located paradoxically in the mouth of a servant – wit is a luxury often given to those who cannot afford it. It is in part a pretty name for one of the driving engines of comedy, a sceptical intelligence which punctures pretence and demolishes traditions, looks askance at titles and makes the possessor feel invincibly superior at least for the moment.

The most sustained passages in Congreve resemble the catalogue and portraits in *The Dunciad*. They entertain us by saying the same thing in a number of ways. In its dramatic form this is a monologue delivered to an audience of one or two other characters, leaving them visibly speechless. To carry off one of these flights successfully is like some difficult manoeuvre in a game, when everyone's eyes are on the player wondering if he will drop the ball, fall from the high wire or be gored by the bull.

One of the other characters may interrupt briefly and then the first speaker will take off again, not grounded by the objection. Or he will be cried down by one of the others and then the tension goes out of the situation momentarily and everyone breathes a sigh. The drama in Congreve follows the structure of games in other ways than this. There is room for a few virtuosi and a larger number of slow-witted dupes and fools. Matching these combinations are two forms of rapid dialogue like passing a ball back and forth. Two witty players successfully evade each other in exhilarating sequence. Alternatively the fool is cornered or defeated by the wit over and over again, as if there could never be enough of victory.

One of the main uses of wit in Congreve is to provide an attractive mask for cruelty. There are scornful jokes about reputations being murdered offstage, but we are not expected to feel misgivings at character assassination carried out in front of us. This is the way of the world: there are different sets of rules for the weak and the strong. So the sufficiently forgetful spectator will experience the play as something like a fireworks display. Memorable lines follow on each other's heels so swiftly they obliterate their predecessors and leave us dazzled, buffeted, with spots before our eyes. As soon as one character is shown off, having been turned inside out – the purpose of his visit inverted or defeated – another appears and we start over, playing by different rules, aiming at another kind of goal and entirely caught up in the surface pattern of the moves.

As in Pope, some of the most fortuitously beautiful moments are provided by the worn-out superstitions of the fools. The astrologer Foresight lets us into a whole other realm, obscure and ridiculous to be sure, but contributing a numinous mystery which sometimes verges on Gothic, like a furtive Romantic impulse before its time.

Grotesque figures of speech often achieve a similar effect on a smaller scale. Millamant is said to hate Mirabelle more than a Quaker does a parrot or a fishmonger a hard frost. It is a joke which treads near madness in its far-fetched irrelevance. Such forays are all the more important because Congreve's world is otherwise so claustrophobically small and consistent. The action never leaves London or a generalized drawing room, a generic indoor space. St James's Park is only a bigger room which lets paths diverge and cross, a place where more than one conversation can take place at once, as in Mozart's ensembles. Like the classical comedies he acknowledges as models, Congreve sometimes uses 'the street outside so and so's house' as his scene, which only confirms the circumscription: outdoors is conceived as the other side of the house-wall.

Into this enclosed world comes the strange freight of other styles of life:

> I hope to see him lodge in Ludgate first, and angle into Blackfriars
> for brass farthings with an old mitten

(a malicious prediction of poverty for the hero). Ben Jonson more than Shakespeare is the model for this kind of thing, which summons up the variety of the city excluded from the stage, in words, and especially in names.

Elsewhere an angry couple splutter at each other like two roasting apples, and a cuckold imagines his forehead furnished like a deputy lieutenant's hall. Enlarging the scope of the drama by summoning up other scenes entirely, by turning a space inside out, or by attributing or taking away consciousness from two halves of the comparison at once – this is wit at its most exciting, disruptive and irresponsible.

Comedy is always foe to some kinds of would-be moral order. Old husbands and young wives come up so often that no one can miss the cue. By now, though, what may have started as a disruptive truth has become a time-worn piety, keeping us from even more uncomfortable truths. The structure of comedy is finally conservative, in spite of its familiar siding with the young against the old – which makes the glimpses

we get in Congreve of truly anarchic thinking all the more significant. Such impulses can never get the upper hand for long, but they constitute a strong undercurrent of unruliness. In part of himself, the dramatist keeps saying, he would like to dispense with rational order and morality altogether and turn the world over to nonsense.

Subversion arises in the strangest places: the neatest structures can produce the deepest moral confusions, as in these verses from *The Rape of the Lock* which match up important and unimportant things:

> Whether the nymph shall break Diana's law,
> Or some frail china-jar receive a flaw;
> Or stain her honour or her new brocade:
> Forget her prayers, or miss a masquerade;
> Or lose her heart, or necklace, at a ball;
> Or whether Heaven has doom'd that Shock must fall.

Shock is the girl's lapdog. The two categories bleed into each other and the one becomes more physical, the other more loaded with symbolic import. The result is a world of dangers in which it is hard to tell what matters, or what may follow what. The irrelevance of the last line cuts more than one way – it cancels all the rest and makes our effort to keep up with it seem wasted; it also makes us doubt the speaker, who can lose track so completely. Thus it reflects or refers to different things which can't be brought into single focus. The universe is pincushion scale, sure enough, and all the more embarrassing our failure to find satisfying sense in it. The microscope has made existence harder not easier. Perhaps at bottom the problem is a world without God, where at a certain moment every principle one can devise gives way.

Not unexpectedly, Restoration dramatists aroused furious opposition from Puritans. Congreve's worldliness must be seen in this context, pushing hard against the cast of mind which had triumphed in the Civil War and the Protectorate. Though his plays are not littered with bigoted and tedious Dissenters as Ben Jonson's were, occasionally it crosses one's mind that a Puritan sensibility is a necessary Other in the landscape in which they occur. That is to say that their scandalous worldliness does not arise in a neutral environment but is consciously directed towards a mental opponent who may never appear in person in the playhouse but hovers around every line in the play. Unless one includes this antagonist, much of the tension goes out of the jokes, and the bravery or extremity of the wit's life, defying morality and religion, is lost on us.

Congreve may be worldly, but he shares more with the Puritans than either of them realizes. He is harbinger of a plainer, unheroic world. Spaces the characters inhabit are cosy, even cramped, and prosaic at their most exciting. When Tattle is threatened with exposure as an indiscreet gossip he provides the best evocation of the intimate setting of Congreve's plays:

> Oh, I shall lose my reputation of secrecy for ever! – I shall never be received but upon public days; and my visits will never be admitted beyond a drawing-room: I shall never see a bedchamber again, never be locked in a closet, nor run behind a screen, or under a table; never be distinguished among the waiting-women by the name of trusty Mr Tattle more. – You will not be so cruel.

One could duplicate these distinctly feminized interiors many times in eighteenth-century comedy, most memorably in *The Marriage of Figaro*. They are the archetypal spaces of the genre and they leave surprisingly little room for the *architetti teatrali* who had thrived in Italy and then in many of the courts of Europe earlier in the century. It is a key fact about both Pope and Congreve that they are poets of the town and not the court; the spaces Congreve writes about are modest or intimate in scale. When Pope's heroine turns up at court, by a kind of inversion this world is presented in miniature, with a card-table top as its battlefield.

Strictly speaking, the *architetto teatrale*'s years were numbered. Commercial theatres couldn't afford a kind of stage design so extravagant it almost formed a branch of architecture. But the dead form remains important because it functioned as a link to the succeeding mode of the picturesque, and thus participates in one of the main transformations of the Baroque into something else.

The *architetto teatrale* was an outgrowth of the seventeenth-century designer of masques and intermezzi, responsible for a whole range of temporary constructions which included lavish catafalques on the occasion of important deaths, arches and pavilions for triumphal entries, and stage design of a grandeur and expense not often seen since.

A single family of designers, originating in Genoa but eventually infiltrating many other courts, dominated late Baroque stage design. The Bibiena's work is instantly recognizable for its massiveness, its diagonal skewing within the rectangular space of the stage, and for dangling volutes and balcony-like features, slightly threatening and

thus disruptive of the pervasive stolidity of all the ridged, bulging, oversized elements (illus. 36).

We don't know exactly what these designs were like, because of course none of them survive. There are a couple of eighteenth-century court theatres, like the one in Munich where *Idomeneo* was first performed, but there is no surviving eighteenth-century stage scenery. One of the luckiest survivals, the first purpose-built Renaissance theatre, by Palladio, in Vicenza, with scenery by Scamozzi partly following Palladio's design, gives little clue because it did not have direct descendants. By the time of the Bibiena the classical models which Palladio venerated and faithfully reproduced had been thrown out in favour of pseudo-classical caricature. In our only sources for their designs, the plentiful drawings and engravings they left, the Bibiena usually show human figures dwarfed by the vastness of their fantasy architecture. To some extent this must be a self-important dream. How could *architetti teatrali* ever have got a free hand to build such immense spaces, most of which towered unenterable over the heads of puny singers wandering about as if at the bottom of the sea? Drawings show pairs of figures spaced so far apart they wouldn't recognize each other, wouldn't hear what the others were saying and represent only little markers showing how extensive the stage is. Many Bibiena drawings, though clearly stage designs, are nonetheless in vertical format. Do we conclude that the designer would actually block off the sides of the stage for that scene, using only a central tube of space which could therefore tower more imposingly over the actors' heads? Or that the designer is only playing with non-existent possibilities of escape from the constrictive format of the stage, always the same flat slice of space?

Certainly the spaces they prefer to imagine do not suit all kinds of drama. Often of course the title of the stage work is attached to the drawings. But surprisingly often the scene is known only as 'Royal apartments' or 'Hall of a palace', extremely revealing for what it says about the autonomy of the designer. Composers like Mozart waited to write most of the music until they had heard the particular singers they would be writing for; the Bibiena method is very different from this. The architecture in their drawings is more elaborate, richer in detail, with vistas of further halls, niches, balconies, than any imaginable drama could require. In fact the drama in these receding possibilities is bound to distract us from whatever the actors will say when they arrive. The scene is entirely sufficient in itself and we would be happy just

36 Antonio Galli Bibiena, *Scena per angolo*, 'Royal Apartments', *c.* 1728.

sitting in front of it until an intermission was called and we could go out, and then come back to find it changed.

But if we must have actors with their petty movements and small affairs they certainly can't be *buffa* ones. A fair number should be kings, and they will need to move in stately ways, until they finally disappear between the bays of a colonnade. Suppose, though, that we have been misled about the scale by the drawings, so that all the fat pilasters and bulging arches and the balconies piled on cornices have to fit into much smaller spaces than we have imagined? Big actors among dwarf scenery bring us nearer to caricature, and the actors, who will still have to wear fancy armour, can devote themselves to sending up the Emperor Nero

and all those old dynastic squabbles. Perhaps the key question is how much has been spent on the sets: is the display real or only painted back-drops? How seriously does one believe in the giant coffers jostling each other in the ceiling? Are they as heavy as they look? Are they even three-dimensional at all? This is the old Baroque problem of whether to believe one's eyes and how to take it if one can't.

In early Soviet times architects turned towards stage design (while graphic artists toyed with architecture) because in a collapsed economy stage-buildings stood some chance of being built. Theatre was one of the main venues for serious architectural experiment in the early 1920s in Russia, and a number of the leading Constructivists practised there. In the late Baroque also, stage design holds a place of special promin-ence, but it isn't obviously radical or experimental, as can be seen in Bibiena designs founded on a few conventions which are then varied endlessly. The most important is the angle view in which a pompous and symmetrical architectural ensemble is turned at about forty-five degrees to the proscenium arch. The effect is startling, the first time one meets it, at least. The spectator's angle of approach becomes everything and a gigantic structure is enslaved by it. It is one of the triumphs of subjective experience, now perceived as more interesting and in a sense truer than classical rules. The trouble is that in the Bibiena designs this perception appears in frozen form. Bernini and Borromini play supplely with the changes perception can produce in the proportions and even the nature of architectural form. The *scena per angolo* gets stuck in a single exaggerated relation between viewer and object, which before long seems a prison rather than a new freedom.

Almost inevitably theatre audiences are glued in place, and genres in which spectators circulate are associated with primitive outdoor forms of drama. So, although the impetus towards the diagonal scene undoubtedly derives from the eccentric worm's-eye perspective, in the end for the audience it is as if these buildings have moved, not them, and they feel consequently thwarted in their desire to see round corners and into adjoining spaces.

Thirty-five years before Mozart tackled Metastasio's pompous text *La Clemenza di Tito*, which he streamlined with the help of Caterino Mazzola, it had been produced in Lisbon with sets by Giovanni Carlo Bibiena, some of them *per angolo* and some of total symmetry, with tunnel-like series of arches beyond the proscenium. These sets conform to the rule that no surface should remain bare, that columns should

develop periodic thickenings or rings, and arches be broken into multiple swags. For the scene in the gardens of the imperial villa on the Palatine, columns get fat towards the bottom like bowling pins and emit water from lion heads but continue to carry roofs like the topknots of Chinese pagodas from which plants sprout and fountains gush. A garden, it seems, is a place where architecture grows, and gets decorated with non-architectural features like a series of choice blooms. It is the most Rococo of the eight designs for this opera, even outstripping the so-called 'Rococo Interior' in which technically Rococo motifs are jammed together by a Baroque sensibility which prefers heaviness to lightness.

The garden scene is the most trivially picturesque, but in this it points towards the future. There's hardly a hint of archaeological curiosity in these sets, no ruins, no recognizable monuments, but they announce a future in which elements will be manipulated for promiscuous scenic effects. The skyline looks classical one minute and Chinese the next, mixing flavours in pursuit of a lively outline. The crucial idea of the patchwork as a positive aesthetic effect occurs around the same time in stage design and on archaeological sites, two locations which meet in the work of Giovanni Battista Piranesi.

Like some other eighteenth-century architects including Juvarra and William Kent, Piranesi trained as a theatre designer, and after forays in architecture he finally ended up making a living from a novel, self-devised form of theatre design, not aimed at actual theatres but at spectators of the monuments of Rome. Piranesi eventually made his name by theatricalizing an urban landscape: an earlier series of engravings was more conventionally theatrical if psychologically more radical than anything he ever did afterwards. These were the *Carceri d'invenzione* or imaginary prisons, a series of fantastic scenes which anticipate the mood of Gothic novels by several decades (illus. 37). Technically these works are surprising in their roughness of finish and their insistent blurring of many contours. They must be among the most heavily inked plates produced in the period.

Along with emphatic technique goes an unheard-of monotony in the subject matter. These prisons are extremely dysfunctional spaces, with gigantic stairs leading nowhere and crane mechanisms which could keep Goliath chained but have nothing to do. Occasionally there is someone being tortured on a rack, or someone stranded on a high pedestal, but by and large these are prisons without prisoners or cells or warders or any sign of purposeful operation. They are abandoned

37 Giovanni Battista Piranesi, Plate XIV from the *Carceri d'invenzione*, 1761.

prisons, ruins which depend on historians or spectators to reconstruct their uses. And so of course the willing dilettante becomes an imaginary prisoner who traverses the spaces, meets the dead ends, looks into the abysses, feels ropes swaying as he passes, or crawls towards the light, teasing himself with a thousand different fears.

To some extent this only describes what readers of fiction and watchers of plays have always done. But it is also different. Piranesi's novelty lies in his specialization. He is a pioneer in the genre of horror which has become voluminous since, isolating specific obsessions in the laboratory and then setting to work to stimulate only them. His success will be judged by the intensity of the sensation he can generate. The best products will be too strong for some of the audience's nerves and they will faint if caught unawares or turn away if they see what is coming. Bernini depicted swoons but did he dream of producing them? Still, it is not an utterly divergent notion of the function of a work of art

to include the spectator in the frame as Piranesi does and to strive for temporary derangements from which you need a moment to recover before going on. If not miles from Bernini, it is another universe from Mozart, and Piranesi signals a strong reaction against the elegance and miniature scale of the Rococo.

As well as a fantasist, Piranesi was an enthusiastic archaeologist who measured and dug on the sites he depicted. He investigated the structure and workings of Roman roads and sewers which he occasionally analysed in helpful diagrams. He also practised as a restorer, pasticheur and fabricator of small antiquities like marble altars and urns. And at the same time he entered vehemently into the scholarly dispute over the origins and merits of ancient Roman civilization, holding the patriotic position that the sources were native Etruscan and that Rome was superior to Greece in technical ingenuity and decorative invention.

So Piranesi was not just an aesthetical idler looking for picturesque sensations. His views of ancient monuments are not haphazard impressions but careful documents, and yet they are highly flavoured and impart much the same tonality to the Doric temples at Paestum and the grossest imperial pomp of Rome. From him we have imbibed the idea of the ancient world as magnificent but unapproachable, its monuments inhabiting our streets as huge dysfunctional lumps, daunting in scale and physical presence, like sculptures left by a race of giants.

Piranesi's series of Roman views, the *Vedute di Roma*, fall into a number of different classes. Some are obsessional concentrations on single monuments in non-urban settings, while the engraved depictions of the main sights seem more made to order, providing a convenient set of reminders to travellers after their return home. These are the ones which turn up regularly in English country houses. They are generally less extreme than the plates of classical sites, but even so impart a gloomy excitement to prosaic open spaces and humdrum palace façades.

Piranesi is a main source for the new eighteenth-century idea of the View. In the previous century people like the peripatetic engraver Wenceslaus Hollar produced panoramic overviews of cities which aimed to pack as much of them into a single image as possible. For these views the artist found a single vantage point – in London it was usually somewhere on the south bank of the Thames looking north. This is not exactly London as anyone experiences it, but London laid out neatly in the mind's eye, where one can enumerate its features and remind oneself of many separate things at once.

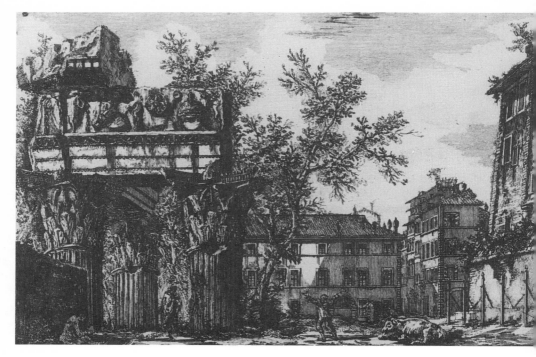

38 Giovanni Battista Piranesi, *Temple of Vespasian*, from the *Vedute di Roma*, 1756.

Most of Piranesi's views are not conceptual tools in this way, almost superhuman feats of assemblage or collection. His works stay much nearer to single moments of experience and show one where to stand in a more practical sense. Hollar's images do not lure people to repeat his viewing feat, but Piranesi might well stimulate certain kinds of exploratory walk. Now there is not one view of Rome (though of course the panorama from the Pincio remains popular with painters throughout the nineteenth century); Piranesi has found over a hundred.

His vision erases discontinuities between the present and the classical world, making the urban whole into a rich stew, so the idea of the isolated sight gives way to enthusiasm for textural detail of the most venerable of cities (illus. 38). However great his learning, Piranesi encourages us to regard fragments of the urban fabric scenically, for the Gestalt. History is turned into scenery and the monuments loom or glower like heroes and heroines on the opera stage, dramatizing an outcome which may retain barely a trace of the original builder's intentions.

A similar sort of inanimate drama is found in John Soane's most

personal architectural project. His house in London might prompt us to read all his work picturesquely and anti-classically (illus. 39). Soane uses fragments of the past to create scenic effects, disguising solid fabric as a phantasmagoric pile of memories. His collection of paintings, sculptures, casts, rarities, novelties and chunks of other structures from assorted times and places cannot really be disentangled from the quarters he has built to house it. The two have grown symbiotically together, until the result has some of the properties of an organism, something formed not made, evolved not invented, with all the formerly distinct fragments now constituting a thick crust or bumpy skin which inti-mates obscurely the tissue and organs which lie underneath.

The overall effect is not so dissimilar from a Bavarian Rococo church-as-bower. Of course the vocabulary and syntax are vastly different. Soane imagines himself resurrecting the past and paying it his scrupulous respects. His compilation smacks of scholarship in a way totally foreign to the Rococo in almost any of its guises. Yet the key to Soane's spaces is the melodramatic physical encounter with looming or beckoning lumps of past time. He aims to overwhelm both himself and the visitor

39 Fragments as scenery in Sir John Soane's house, Lincoln's Inn Fields, London (now the Soane Museum), 1808–9.

with the grandeur of human civilization as perceptible to the senses. At many times of the day it is too dark to read anything in these spaces – candlelight was a favourite effect for Soane – we are more like bandits exploring a tomb than the average museum visitor. Soane demonstrates a kind of continuity, in spite of the neoclassical revival, between the later phases of Baroque and early Romanticism. By his time the Gesamt-kunstwerk (or combination-artwork), instead of being painted or carved by a Bernini or Pozzo and their assistants, is assembled or recon-stituted from found objects, most of them sacred relics in the new religion of history. The artist, Soane, is a pasticheur who exercises his eye rather than his hand, so it is not surprising that he deals so persistently in optical effects and elaborate illusions, for he is trying to make you feel that many random bits could form a whole and that accidental conjunctions can have the inevitability of, say, plant populations on the forest floor.

In these attitudes Soane looks forward to all the cranks who spend half their lives concocting strange grotto-like structures from bottles, cracked tiles, broken machines and many other forms of salvage. And he looks back to late Baroque works which he almost certainly wouldn't have known, that take their cue from the natural world and give you an interior as it were crawled over by vines and perforated by decay like the ruins depicted by Piranesi.

No one has ever suggested that the extravagant Bavarian Rococo spaces alluded to in the last sentence were Rorschachs of their designers' psyches, revealing Romantic sensibilities in embryo. But that is certainly the case with a set of literary descendants of Piranesi's picturesque which overlap in time with the last Bavarian Rococo. These are the so-called Gothic novels of Horace Walpole, Monk Lewis, Ann Radcliffe and others, Gothic because connected to the early Gothick revival in England, because nominally medieval and powerfully gloomy; Gothic also because loaded with Protestant ideas of Catholic ritual. Monks especially carry in these works a threatening and fascinating freight of intrigue, mystery and above all the idea of willing mental slavery. The scenery in Gothic novels, their most powerful ingredient, which includes Alpine landscape and Piranesi-style prison interiors, is softening the reader up for the abdication of the self, which is the real subject. Although a specialized and some would say a lunatic fringe, Gothic novels are mentioned here to indicate that the scenic approach to expe-rience is not just the superficial fad of dilettantes, however bland it may seem at first reading.

The depiction of Italy as scenery in Gothic novels is not generally valued for its accuracy. In Shakespeare's plays we get stereotyped versions of Italy for audiences who could not check them against reality. But by Mrs Radcliffe's time tourism is a sizeable phenomenon, yet her ideas about Italy seem just as fanciful as Shakespeare's. Even if, as seems likely, she never went to Italy herself, she writes in a different climate when tourism has assumed a tantalizing kind of prominence.

Now that the study of tourism is an academic discipline with its own technical literature, which with its focus on mechanisms rather than on places would horrify serious tourists of earlier centuries like Ruskin or Henry James, it is difficult to put ourselves back to the time when most of the English tourists in Rome would be known to each other. Perhaps, though, these are not the natural readers of Mrs Radcliffe. Perhaps her readers are more likely to imagine Italian voyages they will never take. Still, it is a world in which such journeys are increasing geometrically, in which viewing the world as scenery becomes every day more plausible. Of course there are many kinds of tourist and many notions of scenery. Soane's house is in some sense the house of a tourist and his contribution is to conceive architecture as scenery. In some hands this entails a glancing and superficial vision; in Soane it implies a profound but somewhat aestheticized relation to the world, with a new interest in the role of the perceiver.

Dealing with the culturally exotic – which can mean, as it does for Soane, material one is steeped in, but not native to – almost any observer is bound to feel increased self-consciousness and thus to be watching his or her own responses. The sensation of needing to construct one's relation to the foreign reality is one of the problems and pleasures of tourism.

Oddly enough, the place which got most thoroughly converted to scenery in the eighteenth century has no classical past. Venice is probably the least venerable of the main Italian cities, with origins no older than medieval. This meant that Soane had little interest in it and that later, when the medieval past came to seem the most interesting of all, Venice attracted a new kind of attention from Ruskin among others. But the eighteenth-century preoccupation with Venice seems to have had virtually nothing to do with the huge number of medieval survivals found there. At least there is no visible concentration on medieval monuments in eighteenth-century views of Venice. Canaletto seems immune to this aspect of the city.

40 Giovanni Antonio Canaletto, *Venice: The Molo with Santa Maria della Salute, c.* 1740–45.

In fact it is easier to enumerate the features of Venice which Canaletto does not dwell on than to explain his fascination for English travellers. He seems to paint the same views or at least the same parts of the city over and over again. These are the most accessible and easily recognized bits, as if like Mrs Radcliffe he is representing Venice for people who don't know it very well. Yet his clients had generally been there, but apparently they had no taste for obscure corners, or even close-ups of more familiar parts. They mostly wanted comprehensive views somewhere on the Grand Canal or in and around St Mark's.

Of course we were never meant to see three almost identical views at once, as we now can in some large museums, but there is still a kind of blandness or sameness in the treatment even within a single canvas, which sits oddly with the intensified enthusiasm for the world as scenery. Canaletto painted Venice so often, so the usual version runs, that not only the views but the brush strokes became formulaic, and from 1740 onward waves are represented by an efficient shorthand, highlights become ritualized blobs and even faces are reduced to slightly bigger blobs. It is true that the representation gets less individualized and the whole more generic, but it seems at least possible that there is an expressive as well as labour-saving purpose in this. The jewel-like Venice of the later pictures is more magical and abstract, more visionary, less everyday.

41 Francesco Guardi, *Venice: Santa Maria della Salute and the Dogana, c.* 1770–76.

Guardi's generalized flicker, which cannot be much more accurate than Canaletto's highlights, is treated more tolerantly nowadays. This flicker is unmistakably expressive and not just an easy way of sticking dozens of figures in all the windows looking on to a regatta. Guardi shows a different Venice: while Canaletto never leaves the inner city, Guardi is best on the fringes, if not indeed in the Lagoon looking back towards Venice (illus. 40, 41). He is not concerned with accuracy, or his 'accuracy' is different from Canaletto's, as one sees most easily when comparing them on the same subject. Guardi's version is likely to be smaller with fewer buildings, all tilting slightly, their solidity cast in doubt by the brush strokes. The subject is deliberately less specific, yet instantly recognizable. As in other transitions from Baroque to Rococo Guardi signals a pull towards smaller fragments of experience as more absorbing. Like those drawn or driven to the fringes of Versailles, he feels impelled to explore obscure corners, a penchant he follows until

the View isn't a view any more but a perishable instant, recognizable of course to the cognoscenti, yet not easy to repeat.

Although Guardi's scene cannot always be precisely located, it could never be anywhere but Venice. This loose, allusive treatment is only possible after Canaletto, when Venice is so well established as a picturesque subject that a minimal code will reawaken it – water, a bit of low-lying land, a mouldery building and a gondola – that is enough. Probably the sparkle is important and the light more delicately rendered than one consciously notices, but it feels both minimal and atmospheric at the same time.

The necessity of Canaletto as the precondition for this seemingly effortless achievement can hardly be exaggerated. He made Venice recognizable and put the idea of a whole city full of idlers on its feet. Characters in Congreve don't have jobs; figures in Canaletto spend their day strolling and chatting or waiting on those doing nothing else. In Canaletto's Venice we are all theatregoers morning noon and night, a much more fantastic vision than the rather tight technique suggests.

There had of course been bird's-eye views of special festivities in the two preceding centuries, but it was something new to impart the holiday spirit to ordinary days, and the water and boats are crucial equipment in bringing about this transformation. In Canaletto idleness looks solid and cheerful, in Guardi melancholy and insubstantial. Yet even at his gloomiest Guardi comes across as light; there is no Piranesi for Venice.

Many of the eighteenth-century view paintings of Venice show pavilions or decorations knocked up for a passing festivity, and at a certain point this process runs backwards and someone asks why not permanent architecture with these properties of playful extravagance and painterly, light-catching inconsequence. One could go back at least as far as Codussi's façade for San Zaccaria and the Lombardi's church of the Miracoli to find Venetian buildings already treated scenographically, pictorial in themselves and contributing to the idea of the city as a succession of noteworthy views. The idea reaches fulfilment in Baldassare Longhena's plague church of Santa Maria della Salute, which feels as if it could have sprung up overnight and strikes us as extremely uncogitated, like a fleeting thought fortuitously hardened into permanence. In fact it took over fifty years to complete (1631–87), and Wittkower has argued for its synthesis of a wide variety of sources ranging from late antiquity to Palladio. But somehow the experience of it cancels all such references.

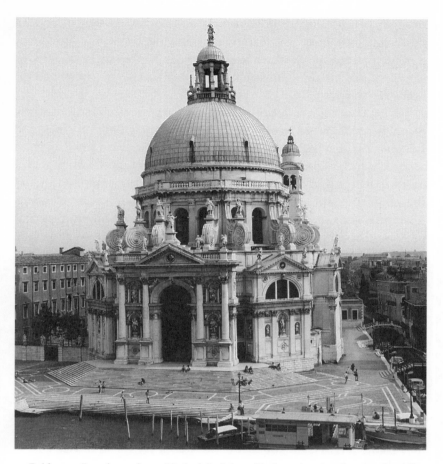

42 Baldassare Longhena, Santa Maria della Salute, Venice, 1631–87, showing the riding statues.

The architect building scenographic architecture is in a way cutting out the need for a painter to show us that the city is viewable. With the Salute everyone knows this, and no building ever needed discovering less. Longhena's church is practically unique among Baroque buildings, not in the form alone, which strongly suggests movement round it, but in the combination of that form and a certain kind of siting (illus. 42). The Salute is located near but not precisely at the entrance to the Grand Canal, where the watery surface turns from a huge piazza into a wide street (or conversely, coming the other way, where the water switches from a passage to a plain).

One feels its transitional character when one is static at any number

of points on the opposite bank, but one notices it even more as a passenger in a boat whose motion echoes the swaying garland of motion on the exterior, which becomes most flamboyant in the famous scroll-volutes and the statues which ride them, a kind of shorthand for riding the waves.

No one ever got another chance like this. Free-standing centrally planned buildings are bound to be rare in densely built up cities, and Longhena's other large Venetian buildings are all more or less flat bits of scenery, which if he is lucky come near a bend in the Grand Canal, a location which multiplies the building's aspects. Both the palaces and the churches depend on such deep relief – architectural elements treated almost as sculpturally as the plentiful applied sculpture – that it looks as if bulging and deeply undercut swags, bosses and keystones are actually falling off. The aggressive presence of jostling figurative bits leaning into the narrow street which passes in front of the Ospedaletto caused something like seasickness in Ruskin. He didn't want to acknowledge that in the absence of a canal Longhena was turning to the stonework itself for those rocking sensations familiar to anyone riding past Venetian buildings.

Baroque dynamism is more deeply engrained in the fabric of Venice than in any other city. The fact that most of the structures are clearly pre-Baroque has surprisingly little force against our perception of the shape of the journey down the Canal as one great Baroque S-curve. Seventeenth- and eighteenth-century sensibility has transformed Venice into something Ruskin couldn't entirely approve of. The scale of the city's back streets may be indelibly medieval but the dynamic of the Grand Canal is Baroque, so that now we read even the Doge's Palace scenically, as the setting for the life which takes place in front of it. So perhaps Vanbrugh, Hawksmoor and Soane might have found more stimulus here than they would be ready to admit.

English cities don't invite Baroque gestures, and the most effective Baroque buildings in England are isolated in landscapes which can be manipulated to form complete worlds. The most theatrical of English Baroque architects came to architecture by way of theatre, but there are no obvious connections between Vanbrugh the dramatist and Vanbrugh the architect; Vanbrugh's buildings are theatrical in ways which are not illuminated by his plays. But his interest in architectural fictions and in non-functioning elements which recreate a vanished history, is thoroughly literary.

True to a theatrical approach, the outlying parts of a Vanbrugh composition are often the most scenic, creating a frame or stage within which the central structure should be viewed. At Castle Howard this consists of mock fortifications which set up barbed and constricted entrances, two sets of them in rapid succession marking the stages of one's progress towards the house. From these gates, fortified walls are thrown, punctuated by a series of towers, every one different, all carried out in Vanbrugh's rough military style (we remember that he began writing plays while a prisoner of war in France; in his first career he was a soldier).

Vanbrugh is one of the first English architects to clothe buildings like stage characters in a promiscuous variety of costumes. He was an early enthusiast for preserving the architectural relics of assorted historical periods and wanted to make the ruined manor at Woodstock a feature of the Blenheim grounds. In this he was overruled by the unsentimental Duchess who had the confusing history of the site obliterated. Earlier Vanbrugh had contrived quarters for himself in the semi-derelict relic. This showed a dramatist's imagination, populating the inanimate carcase of obsolete architecture and responding to the suggestive qualities of the fragment.

At Blenheim he had to watch relics knocked down, but at Castle Howard he got permission to erect fictional ones, positing a more primitive or violent past than those intimated by any stone left standing. Vanbrugh's subtlest theatre is not the whimsical historical revival of these mock fortifications however, but the intimation of defensive necessities in the heroic masonry and furtive towers of the main and kitchen blocks. And at Blenheim the subliminal impression of embattled skyline and central mass distorted by conflict is his final triumph over opponents of architectural symbolism.

This strand of Vanbrugh's theatre is not comedy, but melodramatic recovery of a more savage stage of human life. The vocabulary is classical, but the content is secretly Romantic. That division explains the disquieting effect that Vanbrugh's and Hawksmoor's buildings almost always produce. They conceal passionate narratives which classicism cannot comfortably contain. The severe forms do not always look Baroque, but the powerful underlying tensions make dynamic imbalance out of rectilinearity and stolid symmetry. So at Grimsthorpe in Lincolnshire an orderly scheme is sabotaged by puzzles and discomforts of scale. The two little pavilions thrusting forward at the corners

43 John Vanbrugh, One of the paired pavilions at Grimsthorpe Castle, Lincolnshire, 1715–30.

of the court are absurdly small, and the giant paired order on the main block is painfully big (illus. 43). Why is this exciting and not just inept?

Because the architect has had the novel idea that purely architectural elements could be used scenically or plastically with scant regard for use. Hawksmoor at All Souls can be seen taking a classical building and translating it into Gothic forms to satisfy the demands of the client. Vanbrugh may be doing something similar from a more deep-rooted motive, reproducing a fortified dwelling in civilized dress. But the contradictions within this building cannot (as at All Souls) be reduced to questions of style-clothing however interesting.

They reveal an architect possessed by a powerful cultural ambivalence and trying to satisfy the more savage self which is fascinated by war and violence and earlier stages of human development. This drama is fought out above all on the stage of the prefatory spaces at Blenheim, Castle Howard and Grimsthorpe, in courtyards and porticoes where the visitor momentarily resembles the attacker besieging the fort, the outsider who may not get in.

VI

BAROQUE NATURE

PERHAPS AS TIME WENT ON the Baroque grew away from its Catholic roots. Certainly we have our reasons now for wanting to detach it and to consider these energies to be more generalized and less time bound than they seemed to most contemporaries. Students of almost any historical phenomenon are always making this extension whether they wish to or not. Even the vogue for authentic performance of seventeenth- and eighteenth-century music, which appears to have a contrary tendency – making the old works sound less familiar and therefore less easily accessible – is bringing old artefacts closer by choosing tempi and imposing psychologies which suit current preoccupations as much as they reproduce forgotten ones. Putting oneself entirely at the service of the past is an unattainable dream but the wish is extremely revealing about one's own emotional centre.

So we must be prepared for our model of the development of the Baroque to be in some part the model we need. We take an authoritarian, orthodox mode and find in it heretical promptings and centrifugal tendencies. To declare a preference for Borromini over Bernini marks one as a heretic drawn to exceptions and immediately disqualifies one to write a normative history of the Baroque.

And yet . . . even Bavarian church architecture, clearly descended from Roman models and staunchly, even fanatically, Catholic, is slipping unmistakably further and further from any recognized version of Christian piety and all previous codes of architectural decorum. Ornamental fervour is difficult to police and before one knows it, by incorporating wider references to the natural world (plants, water, rock forms) and secular activities (dance, theatre, pastoral rambles) we have ended up outdoors in some fundamental sense, in a looser universe than the Roman church can keep track of.

Of course Bavarian Rococo interiors did not turn peasant congregations into revolutionaries, and Catholic countries (except France) were not the main seedbeds of scientific discovery. But there may be more relation than we are used to finding between the new science of the seventeenth century and Baroque forms of all kinds as they evolve.

In this 'new science' we bundle up together a great many diverse activities: telescopic observation of the moon and planets, microscopic investigation of crystals and living cells, formulation of new theories of motion, gravity, circulation of the blood and the behaviour of light. The tendency of much of this learning is to make the world seem more intricate. Even when satisfying consistencies are found, they do not fit inherited models, so Aristotle's diagram of the physical elements which make up reality no longer compels belief. New species of plant and animal are turning up from overseas with increasing frequency, species which previous models of creation can't find room for.

Boundaries between plant and animal become interesting and then dangerous. Zealous overseas missions unintentionally add to cultural confusion as Jesuit fathers send back myths which will be used in the first modern studies of comparative religion. And this expanding, destabilized world is the intellectual equivalent of Baroque space in some respects at least. Without full measure of the final consequences, Bernini and the others had given subjective responses a new centrality. One result was a new, relativized sense of anyone's place in the scheme of things.

New conceptions of the nature of plants and our connection to them may be slow to appear in gardens, may even be permanently excluded, but Baroque gardens are not untouched by mechanistic, experimental views and attitudes which spread from theoretical science to other spheres of life. The early Baroque garden on Isola Bella in Lago Maggiore represents a great feat of engineering, colonizing an unpromising geological niche: much of the earth had to be brought in to cover and soften the original rocky outcrop. The final result is not much like a mountain, and consists of ten terraces which conceptualize the slope as large stairs, each step of which has its pierced stone balustrade and its fringe of obelisks and statues (illus. 44). From above, these are usually silhouetted against the surrounding water, creating a continual sense of multiplied precipice, making us feel how precarious our position is on a little lump of rock stranded in an alien element.

From below they rear even more vertiginously above us, in telescoped

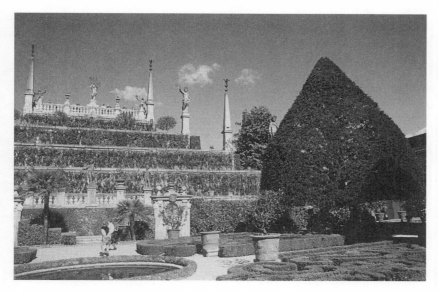

44 Garden on Isola Bella, Lago Maggiore, 1632–71.

series at the corners. Paths here are almost ledges, and the little lawns, never large, are havens saved from the sea. But on top are surprisingly expansive spaces; the biggest is, unbeknown to us, actually the lid of the reservoir supplying all the fountains which, sitting as we do in a large body of water, we have taken too easily for granted. It is a garden which turns things upside down, placing the largest usable space at the highest (or almost the highest) point and dead level, a culmination which might be dull if it weren't unexpected and difficult.

This garden is reputed to have lost the clear outline of a huge ship which it once had, through the obscuring growth of trees and shrubs. Adding prows and sterns to islands is an old conceit. The ancient Romans did it to the Tiber island and the ruined prow of that boat spurred Piranesi to one of his most dramatic *vedute* (illus. 45). These strategic bits of masonry don't make the island with its trees and buildings into a lifelike ship but raise a few phantom possibilities: that the island is a construction and that it floats or sails, like an independent realm with its own laws. In a lake these fantasies are more powerful, and this garden is clearly an isolated geographical fact: not just *on* an island, it *is* the island, an effect enhanced because from many angles the little service-village at its foot is hidden.

Isola Bella is a fulfilment of the garden as unnatural and heavily

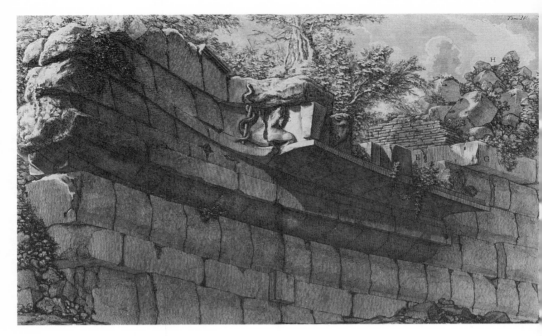

45 Giovanni Battista Piranesi, 'Prow' of Tiber Island, from the *Antichità Romane*, 1756.

constructed, something which cannot or should not be where it is. So perhaps the critics are correct who say you were never meant to lose yourself in the trees. Instead, it should be like walking on deck, constantly aware of sailing through the alien element of water, continually pleased at the triumph of building over unregenerate nature. Isola Bella is also the nearest thing to pure skyline, but shows how diverting this can be, both coming and going. Against the sky as you approach, it changes continually, and is just as good from inside, looking out through the decorated edge across the water. It is the complete apotheosis of the View, the least rooted of gardens, somehow appropriate to an age of European (though not Italian) expansion overseas.

Tiered or terraced arrangements are an Italian speciality which promote condensed rather than expanded perceptions of terrain. At Isola Bella you start at the bottom to explore a complete symmetrical form something like a pyramid. At Giardino Buonacorsi in an obscure location on the Adriatic coast you start at the top and see five narrow ledges spread out below you like a map. It is consciously a fragment, not an entire world transformed, not even a whole geographical feature but part of one side of a hill.

Water jokes which drenched the unwary spectator and thus drew him into something more than a peaceful rural idyll had been known before. But it is not until the Baroque that you find a whole garden like Buonacorsi carried out in the spirit of light-hearted play, where the largest features are toy size. Lively stone figures, demure obelisks and lemon trees in pots are mixed together on these narrow ledges until you find you are regarding them all in the same way: plants, people and geo-metrical figures, all mildly personified, all clamouring for your attention.

The rarest survivals here are some clockwork automata – shepherds, Turks, blacksmiths – originally powered by water and an offshoot of the technically minded culture which in the seventeenth century is visibly replacing one based on myth. Though at Buonacorsi technology is still placed at the service of idle games, these mechanisms show the idea of function and of working parts intruding on the aesthetic realm.

The greatest garden project of the century drew or intended to draw on the latest technology. If they had not been diverted by a war, Louis XIV intended to employ a whole army in assuring a better water supply for the fountains at Versailles, by building a gigantic aqueduct to bring water from the river Eure. As it was, the huge 'Machine de Marly' raised water laboriously from the Seine. War and gardens were parallel mani-festations of this ruler's oversized ambitions. Both of them are ways of claiming territory and expanding the King's scope. The fountains at Versailles of which he was inordinately proud were not a quixotic whim but an exhibition of his power over nature, which will do his bidding whatever it takes to bring it about, so dry land is made to gush with a hundred spouts.

On the existing water supply the fountains couldn't all function at once but played in a prescribed sequence, regulated by teams of gardeners and boys with whistles. The King wrote a famous guide to his gardens in which he advised a certain direction for the visit. This was not nature in random order or at ease, but something like a carefully calculated pageant. Much of the incidental intricacy has been swept away, leaving the huge perspectivized expanses fairly empty. The vast-ness was achieved at considerable cost: many workers died from marsh gas excavating the holes for these great sheets of water, including three kilometres of canal stretching away from the palace, deaths which instead of undermining the enterprise validated it. Such was the scale of the work that it cost among various other expenses these as well.

At Versailles new techniques were used to enforce old values.

Distances so vast they summon up thoughts of telescopes and an ex-
panded cosmos had regressive meanings. The canal was sited towards the
setting sun, the final emblem of the fertilizing power emanating from
the King. Louis and Apollo, the Pharaohs and Amun-Ra, such mytholo-
gizing seems an enormous step backward. The royal establishment at
Versailles is one of the most outlandish impositions by a ruler displacing
the government from the old capital. Partly it is the familiar wish to
ordain one's own greatness with no help from one's predecessors.
Acting from different motives, the heretic Pharaoh Akhenaten moved
the capital of Egypt to a new, quickly built city – not a lucky precedent.
Versailles was in part a paranoid response to a fright suffered by Louis
XIII, chased out of Paris by a mob. Eventually of course the mob would
find its way to Versailles.

The enormous political investment in gardening which Versailles
exhibits, far from a lonely aberration, provided the model for most
European rulers in the eighteenth century and as recently as the 1980s
the inspiration for the reorganization of Bucharest. One of the most
lavish older derivatives of Versailles, Nymphenburg outside Munich,
lays out the alleys and bodies of water in both directions from the
palace, which thus becomes a kind of hinge between two orchestra-
tions of landscape on a more imposing scale than architecture could
offer. It is like leaving the earth at the centre of the universe but reduc-
ing its prominence in the scheme of things. So the grand format which
asserts man's sway has the unforeseen effect of dwarfing the individual.
Outdoors even the ruler becomes one mote among many.

The series of bird's-eye views at Nymphenburg by Franz Joachim
Beich is extremely informative about how these gardens were seen in
the eighteenth century (illus. 46). On the one hand there is the forceful
geometry of canals and paths like regulating lines in a perspective
which converge at the vanishing point. On the other are human activ-
ities – all small-scale games, chores and unstructured amusements –
which the vastness allows to occur simultaneously without impinging
on one another.

But an incongruity begins to be felt. Such gardens are like cities with the
buildings removed. Here as in city streets people are going their separate
ways, with the difference that when they look up they see all the others.
Among the various motives which led to the English landscape garden
was an urge to reinstall privacy and to lessen the hubbub of activity. If you
couldn't see the others you weren't aware of these discords.

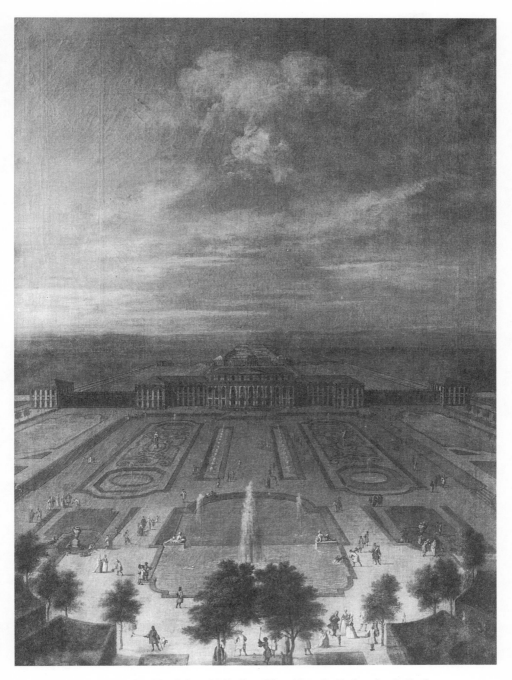

46 Franz Joachim Beich, *The New Palace of Schleißheim Viewed from the Gardens*, first half of the 18th century.

Of course the paintings probably show a more vivacious life on these paths and lawns than one normally found. But an emptier scene might be more melancholy and incongruous still. In fact, these expanses are not adjusted very comfortably to the scale of daily life, and the Hameau at Versailles is a kind of necessary hiding place from the exposure of the parterres and vistas. One cannot live one's life on a beach and will sometimes seek shelter. So the grounds at Nymphenburg are dotted with small pavilions at regular intervals, each of them with a specific putative function, but really respites on a different scale from the enormity of the garden, reassertions of human dimensions against Baroque inflation.

Exquisite pavilions like the Amalienburg set in the garden at Nymphenburg are as dense as the surrounding parterres are (or were in the eighteenth century) empty. Here another paradox confronts us, a richer vision of nature indoors than out. The central salon in this little building, though a perfect circle, feels like an unstable oval. It is lined with large mirrors like windows on to a silvery world, hazy and disembodied but infected with glitter by all the silvered plaster round its edges, plaster ornament on the point of turning into something else, a generalized froth. When one looks closely one finds that the substance is sometimes leafy sprigs, sometimes little roses past their best and shedding petals, sometimes fishing nets blown about by the wind, sometimes strings sailing up to attach themselves to birds, part of a comprehensive vision of life outdoors in which everything defies gravity and death by a magical lightness which means they will never have to come to earth or obey the rules which make things regular or straight (illus. 47). The vision is in an obvious way escapist. Latterly it has been described as frivolous, but when new it represented a bold adventure, for among other things it has thought its way out from under morality. It inhabits a world without God and at that point it touches the concerns of contemporary science, which begins to view the natural world as a self-contained system with its own laws.

Later Rococo gardens embody some of these attitudes in more diffuse form. One of the finest surviving, which noticeably lacks a single Christian reference, was created for the Prince-Bishops of Würzburg at Veitshöchheim in Franconia. Now it is a hedge and tree garden and the playground for swarms of joky statues representing Roman emperors, shepherd couples, continents, and most numerous of all, babies in funny costumes. These children represent times of the day and year or

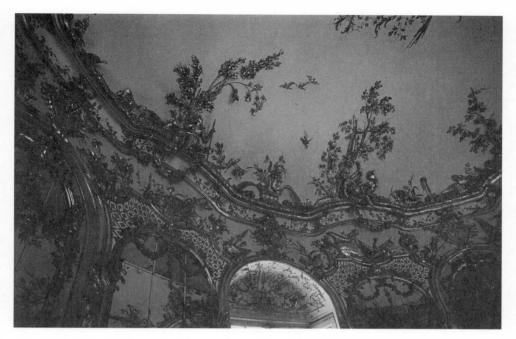

47 François Cuvilliés, Plasterwork vegetation, Amalienburg pavilion, Schloß Nymphenburg, 1734–9.

48 Ferdinand Tietz, Sculpted babies representing the seasons, Veitshöchheim, Franconia, 1763–8.

the arts and sciences, ponderous ideas which they lighten or dissipate altogether (illus. 48). It is a garden of small features, hedge-lined cupboards of various shapes which nowhere suggest a comprehensive style of visit. The largest feature, a lake called the Grosser See, keeps its ruffled edge from an earlier more ornamental phase and conceals tiny rooms at its corners, hiding places reached via little hedge corridors and inhabited by babies carrying easels, set squares and telescopes. There are only four of these spaces but in memory they seem more. Apparently, like most of the other figure sculptures, these were originally painted, glazed and gilded to resemble porcelain. It is a degree of artifice now difficult to recover, so apt seem the present stone colours sprinkled with lichen. Formerly we would have found these colourful characters like snatches of a Mozart opera scattered carelessly about, and maybe when we came to the green theatre we would interrupt a play in which the actors were dressed as lichen-besprinkled statues, a whole company of stone guests.

The eighteenth-century obsession with babies, who are definitely not visitors from another sphere as in early Renaissance or classical manifestations, relieves pressures and banishes responsibility. The idea of iconographical programmes becomes a joke – we do not live in the kind of Aristotelian universe where there are three of this or four of that. Such orders have broken down but nothing has replaced them, so we are left poking fun at them. The hiding places at Veitshöchheim are thus signs of a momentous intellectual atomization. Before long everyone will be ensconced in his own little corner, walled off from the others by a labyrinth of hedges. These statues, delightful as they are, and this garden, among the most charming, have given up the earlier ambitions to express the overarching order of the world by laying out plants and avenues. Avenues have virtually disappeared and planting seems mainly directed to creating private space.

In one of the most perplexing of all Baroque gardens a whole population of statues has been banished to the perimeter wall, where the town of Bagheria in Sicily has encroached considerably on the former territory of the Villa Palagonia, whose sculptures seem to have functioned, deliberately or not, and from an early date, as deterrents to the local population. Pregnant women were advised not to pass where they might see the monsters at the main gate.

In the parade of grotesques along the wall-horizon dragons follow dwarfs, who sit next to rustic maidens or bagpipers or old magicians with oversized spectacles (illus. 49). The effect resembles those graveyards

49 Parade of grotesques at the Villa Palagonia, Bagheria, Sicily, 1747 onward.

with the tomb slabs made into a stone fence around their boundary, leaving a lawn in the middle, now disinfected of the gloomy thoughts this space used to provoke. In Goethe's novel *Elective Affinities* there is a fervent little sermon on this subject: it would be so much more humane for graveyards to become parks without obtrusive and primitive markers. We would all be reunited with the natural forces we are part of, joining a wider landscape, not just a cramped rectangular slot.

This new conception of a graveyard as a park without detailed verbal reminders of every bit of flesh and bone buried in it marks a shift in the imagined relation between man and nature and between human history and the general history of the world. The advanced view is content to see the human record obliterated in the interest of a post-linguistic merging with the cosmos.

As worked out in Goethe's novel it is not a fully consistent position. The disappearance of individual identity advocated there is powerfully post-Christian, yet the propounder imagines the newly liberated and featureless ground still consecrated and tied to the church it continues to sit beside.

At Bagheria no one has detected pantheistic urges; the isolation of the sculpture at the edge seems a matter-of-fact kind of storage, but forces of reason and superstition come into play here too, and interestingly

137

enough Goethe commented on folk attitudes to these particular gro-
tesques, which confuse the boundary between the secular and the
numinous. Even the owner who wants to gain space is afraid to throw out
the impediments, so he moves them to the edges of his field of vision.

The moment when graveyards become parks, their underlying func-
tion disguised or made practically invisible, was anticipated earlier in the
eighteenth century when a new idea of the purpose of gardens produced
an odd convergence. The evolution of the English landscape garden is
one of the most dramatic shifts in the whole history of the form. Soon
many Continental landowners were converting their formal parterres
into rolling 'countryside' on the English model, a fad which never
percolated very far down; outside England, only large parks ever
followed it.

The English garden is not simply a reversion from the artificial to
the wild, though it is true that certain signs of art become taboo, like
regular planting, straight paths and clearly defined zones. This is not
a simple love of disorder for its own sake, but the fervent pursuit of
larger temporal vistas. The visitor who knows how to read them will see
that the odd scraps of building scattered about form themselves into a
continuum stretching back to the beginnings of one's own ethnic group
and even beyond into the prehistoric past. Temples, huts and grottoes
are reminders of the stages through which humanity has passed, and
the whole conglomerate gives one a vaster, if more relativized picture
of the human story than Versailles.

The field is enlarged to take in time as well as space, but the vision is
decidedly retrospective. One is daunted, though in a pleasant way, by
the scale of it. The landscape on one's doorstep has opened up into
something sublime and revealed itself as an enormous graveyard, the
burial place of a body of collective memories. The devisers undoubt-
edly relished the melancholy reflections their new parks called forth,
where a widened view leads one to see the wisdom of inactivity.

A coda to the eighteenth-century symbiosis between cemeteries
and gardens is provided by the remarkable graveyard at Painswick in
Gloucestershire, where ninety-nine yews have given powerful unity to
the path system and a series of Rococo carvers have turned tombstones
into giant tea caddies and other agreeably ornamental forms (illus. 50).
If it is death we are thinking of, we have come to feel it is a light and
elegant subject, which matches the sociable outings organized in Jane
Austen novels.

50 Yews (mostly planted *c.* 1792) and tombs of an earlier date in the graveyard at Painswick, Gloucestershire.

Another surprising convergence occurs in this period when interiors of Bavarian Rococo churches begin to resemble gardens or bowers. In garden pavilions such transformations are not surprising, but in pilgrimage churches the camouflage is more momentous. It bespeaks a powerful urge to naturalize religion, analogous to the new view of graveyards, by removing some of the distinguishing marks and submerging the familiar equipment of ritual in depictions of weather, botany and geology. So at Die Wies in southern Bavaria the pulpit becomes a grotto, an eruption more unexpected and compelling than the main altar because it breaks out in an asymmetric location.

At Vierzehnheiligen in Franconia an even more unusual dislocation occurs. A kind of grotto has materialized in the middle of the nave like a large porcelain table-ornament eaten away to make lots of windows or openings like the diverting holes caused by erosion in the special rocks prized by classical Chinese gardeners. This construction is like a natural feature which becomes, through a process of refinement or perhaps just veneration, elevated into an art object (illus. 51).

The actual sequence was of course quite different from this hypothetical scenario. First a peasant had a vision on this very spot before there was a building or even a place in the current sense. Next a modest

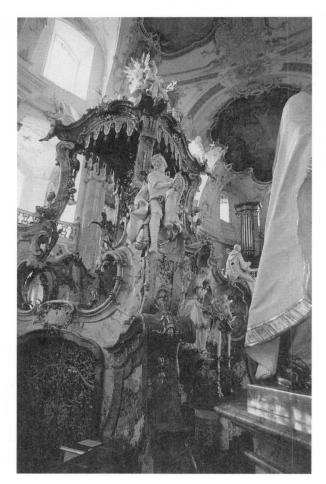

51 Johann Michael
Feichtmayr,
Vierzehnheiligen,
Franconia, shrine,
1767–8.

shrine was built and crowds began to frequent it, and then almost three
hundred years later a neighbouring abbot took it over and involved a
well-known architect and various craftsmen (the shrine itself by J. M.
Feichtmayr) in encasing the simple rustic spot in an awesome and
sophisticated representation of naturalness.

So perhaps the botanical and geological imagery contains a theory
concerning the relation between heaven, the churl who found the spot,
and what we are doing here now, peering through ornamental slits in
this rocky porcelain outcrop to a patch of pink and sandy soil which is
the precise bit of the ordinary natural world on which he stood while
fourteen saints swirled or stood to attention in the air above him. Or so
we believe. But how many times have you returned to a field to look for

something and got entirely disoriented about where you had previously been? And can we accept that after it has been a building site the surface of the ground will remain undisturbed?

The little stretch of sandy earth stands for something, our heavily mediated contact with a reality which lies all around for the taking, for the building is surrounded by fields to which our access is much less impeded. The bit of earth specially designated lies imprisoned in something like a hermit's cell with a metal grille between us and it. It can only be viewed from one side and so we must wait our turn for a glimpse, perhaps studying as we do the wedding cake of perches which has been erected over it for the fourteen saints to roost on. Fourteen is a hard number for which to find a satisfying layout, and the grotto-mountain is a great help in keeping us from seeing this awkward throng all at once.

However jolly, secular and unprescriptive the decoration of such spaces may be, they promote the very opposite of an investigation of the natural world, offering instead a highly structured glimpse, almost a literal eyeblink's worth, which has been interpreted in definitive fashion long before we arrive. Suggestions that sacred and scientific cultures are converging in such spaces are therefore wildly optimistic.

Yet a certain vision of the natural world is what these interiors are all about. At Zimmermann's Wieskirche in southern Bavaria it bursts on you with the force of a spring flood. The exterior has been nondescript, a blank, a baggy envelope. The interior is a vision, where matter goes berserk, full of punctures, until the space ends riddled with holes through some of which small paintings are glimpsed or light streams. The pulpit gushes silver water and twists itself into unsuitable forms (illus. 52). High above, grotto-caves are improbably repeated, like drunken Chinese pagodas giving on to little balustrades, nooks where single musicians used to sit and play. The fabric feels magically alive and the Scourged Christ to whom it is all dedicated seems an intruder from a grimmer world. Turning away from Him, a visitor at Wies can spend a long time seeking out further orifices, exploring crannies like a naturalist who has left doctrine behind.

Another kind of bizarre naturalism mesmerizes the visitor to Ettal, not far away, a Baroque imposition on an older medieval fabric. Where Wies is fat, Ettal is spidery and brittle, its stucco forming itself into fingers, tentacles and occasionally dragons. At Wies shell and rock forms, at Ettal insects and reptiles hover somewhere behind all the empty gilded cartouches. Rents in the fabric, seen in these spaces on many scales,

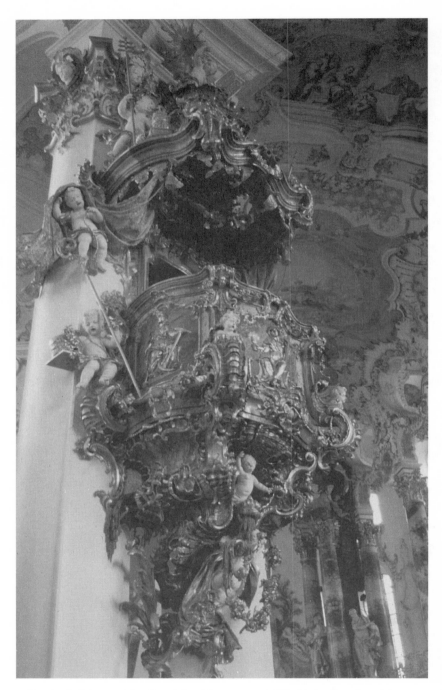

52 Pontian Steinhauser (after Dominikus Zimmermann), Wieskirche, Bavaria, pulpit, 1750s.

from the single sconce at Ettal to the large central shrine at Vierzehn-
heiligen to the whole perforated interior at Wies, can mean many things
from joyful lightening of the building's mass to fatal indications of
decay.

Light Rococo colours occasionally turn nasty, as in a few side altars at
Vierzehnheiligen whose fake marble looks like unhealthy tissue, bruised,
flushed or discoloured. Flushes are a favourite effect of the Rococo,
where hues shade from intense to vestigial without a clear break. In the
chancel at Wies around the large earholes or mouths knocked through
the wall above the arcade we find a particularly violent form of uneven
colour like the inflammation of a sensitive part of the body. Here the
colours suggest not human flesh but distant life forms, such as one
might find on the sea bed.

Is it fanciful to connect Bavarian Rococo colour schemes with
winter and with snow? That would make sense of their unearthly white-
ness. They are imaginings appropriate to a cold climate, where colour is
the little flicker of warmth in an unresponsive vastness. Their paleness
is their vulnerability and the sense of transience conveyed even by the
white monks, that of flowers which will fade, is distinctly non-Christian.

Underlying much Rococo art we may detect camouflaged fertility
myths or little narratives of sterility. A rich streak of paganism resurfaces
also in eighteenth-century parks and gardens. Likewise everday interest
in the natural world during the Baroque may have its mythic component.
How else can we explain the strange craze for tulips which struck
Holland in the mid-1630s? Tulips had first been sent back from
Constantinople in the sixteenth century, and the first sighting in print
occurs in 1559, when a Zurich physician-botanist sees them flowering
in a garden in Augsburg. Soon after the plant reached Holland fortunes
were being squandered on the peculiar variegated breeds known now as
Baroque tulips. These are the sorts familiar in seventeenth-century
Dutch paintings, with ragged edges and splotchy two-tone colouration
that makes them look like marbled paper, tortoiseshell or some other
naturally veined substance. The combination of the frayed edge and the
spattered colouring – usually red or violet streaked with white – seems
damaged or tampered with and hence sophisticated. They are flowers
which look like something else, like feathers or torn silk. Another name
for this kind of tulip, parrot tulips, makes the connection with other
exotic species brought from the East Indies by Dutch traders at this
time. These tulips are like parrots in gaudiness and feathery variegated

outline, in raucous assertion, in mimicry of something they are not.

Flowers which are not like flowers or which violate botanical norms, emanating from bulbs more readily than from seeds and possessing strange leaves like unfurled stems, tulips are different from most of the economically valuable plants brought back by traders in the East, like camphor and tea, because they are useless as food or medicine. Perhaps the surprising virulence of the tulip craze in the most rational capitalist country derives precisely from the purity of the speculation. The trade in tulips brings the arbitrary nature of market forces into the highest relief.

These perishable prizes have left a surprising amount behind in the form of paintings and special porcelain appliances for the display of blooms. In late seventeenth-century Spanish still lifes where tulips play an inordinately large part they are often shown drooping or sagging, not an allegory of suffering but histrionics in an unexpected place, something like a grimace (illus. 53).

It is hard to see these flowers as 'just flowers'. They may be less not more than flowers, but they are not *just* that, in their furling, clenching,

53 Antonio Ponce, *Still Life with Artichokes and a Talavera Vase of Flowers, c.* 1650s.

sprawling, their veining like perspective lines going towards the vanishing point – these are the Baroque artist's favourite forms which he can force out of almost any situation. The flowers which suit him best are not fresh, but overblown and semi-exhausted. What unnaturalness the Baroque painter of nature is driven to; the amazing variety of expression in his flowers does not strike us as natural, but a kind of theatre contrived for our benefit.

The final twist is now supplied by the discovery that these streaks and contorted forms are symptoms of disease caused by a virus, not the last time we will find the Baroque drawn to biological freaks. By this strange route organisms arrive at effects like art, and 'Baroque' tulips can be mistaken for fruits of a design process, however out of our control this may be. Of course meddling in the natural world to improve on God's handiwork is nothing new. Breeders of plants and animals must for many centuries have had quite a sophisticated sense of what 'natural' means.

In the seventeenth century certain species became emblematic of the human power to bring nature to heel, making things happen which are impossible in the normal course of things. Tulips were one and pineapples another.

This is a species known initially from explorers like Columbus and Raleigh and exercising a fascination whose cause we can only guess at. Like the tulip the pineapple is often represented by artists, who bring out a contradictory character in the plant, which looks both succulent and dangerous, heavily armoured yet known to be sweet. Its barbed leaves could be shown with exaggerated torque forming a kind of Baroque swirl (illus. 54). Pineapples were rare and curious enough to make suitable gifts to rulers, and a concerted attempt was made to grow them in European glasshouses. When a Dutch landowner finally succeeded she had a medal struck to commemorate the fruiting of this special plant, as one would the arrival of a royal heir. Paintings and publications followed.

Both pineapples and tulips lie outside the old European mythology and cannot be keyed to classical stories or references in ancient authors. Citrus fruits on the other hand, though retaining an exotic aura, were regularly assimilated to the tale of the Hesperides as the golden apples of the sun, from a place without the inclement weather we are used to. The most thorough treatise yet published on a single genus, the orange, based among other things on an immense amount of direct observation,

54 Vincenzo Leonardi,
Pineapple, c. 1625.

still called itself by a mythical name, *Hesperides,* and included a sprinkling of allegorical scenes by the best artists including Poussin and Guido Reni, illustrating the introduction of the fruit with divine aid or its cultivation overseen by nymphs and personifications.

It is hard to tell whether the name of this book really perpetuates the myth or adds a superficial gloss to a scientific project, borrowing the formal dignity of poetic association, perhaps luring an aristocratic audience not completely comfortable with rational inquiry, like the society ladies who found themselves attending anatomy lectures a century later in France. Whichever account one opts for, fields we are used to separating are here confused or joined.

The exhaustive attention to the physical world seen in works like this treatise on oranges includes careful delineation of all stages of growth and a particular concentration on oddities, which comprise less familiar subspecies like navel oranges and eccentric abnormalities like the deformed fruits produced by the soil around Vesuvius. To this day we anthropomorphize or at least keep the memory of such thinking in our name for navel oranges. But we imagine the seventeenth-century attitude to have contained more, to have regarded the idea of the orange's mother and its broken connection to home more fervently than we do.

Of course this isn't where the orange was joined to the tree anyway, but the end from which the flower petals dropped off.

Seventeenth-century drawings of such features are often breaking free of mythological thinking, especially in their concentration on the part at the expense of the whole. It becomes common in scientific drawings to isolate the features which particularly fascinate you, the porcupine's quill or the navel of the orange, and somehow this concentration undermines inclusive or grandiose conceptions of the whole. Two kinds of disjointed presentation become common – the stages of growth all collected on one sheet but subordinated to an idea of sequence, and separate features of one organism with empty space in between – the porcupine's ear, its teeth, its feet and its quill (illus. 55).

The idea of details isolated for clarity is so familiar to us that it takes an effort of imagination to grasp what a revolutionary step this was. It is as if our eye has become a microscope which cannot take in much at once, but sees that little with new-found intentness. Because you are not relating it to anything else you are empowered to view the chosen detail as a little universe with many sub-features of its own. 'Wandering in a wilderness of moss', Pope's gibe at naturalist-dilettantes, catches in spite of itself the magic of this stage of scientific inquiry. The chosen object, insignificant to normal vision, a species with no place to speak of in the grand scheme of things, or even a single organ of such a creature, becomes a whole world when one gives oneself over to it completely. The scientist studying his fly's wing or his citrus fruit is lost to the rest of the world and may spend a lifetime on the habits of the porcupine or the varieties of orange. New ranges of complexity in the physical world first revealed in the Baroque, in part through new machinery of observation, powerful lenses or more detailed taxonomies, make such maniacal concentration seem possible and also worthwhile.

The encyclopedia is a typical late Baroque form which is in certain ways inimical to the principles of Baroque art. The French *Encyclopédie* of 1751–72, often credited with a decisive role in hastening the Revolution by the unfettered dissemination of knowledge, is a late, clarified product of the urge which relies on a learned community to produce a single compilation of all knowledge, theoretic and practical, near and remote. Earlier instances in seventeenth-century Italy are wilder, less synoptic and hence in some ways more interesting. The Accademia dei Lincei (of Lynxes) was founded in Rome in 1603. It began with six members, comprising a minor nobleman from Acquasparta in Umbria

55 Vincenzo Leonardi, *Anatomical Details of the Common or Crested Porcupine*, early 1630s.

(eighteen years old at the time) and his friends. Eventually it included Galileo and other well-known scientists of various kinds. Cesi, the nobleman from Umbria, undertook a number of projects which had their roots in the rugged country round his family seat, such as a study of fossils and of a kind of petrified wood common in that locale. These

148

forms were interesting because they lay on the boundary between two categories, organisms and minerals. The fossils in particular got him into trouble with the Church, and perhaps it was these tensions rather than perplexities brought on by an excess of data which prevented him from assembling his findings for publication before his early death.

One of the later Lynxes, Cassiano dal Pozzo, has since loomed largest because of his collecting activity. He left an immense mass of papers and objects behind, which a band of modern scholars has promised to publish in various forms. It appears, though, that Cassiano was a would-be encyclopedist totally overwhelmed by the diversity of knowledge. He collected paintings including a roomful of Poussins, antiquities, inscriptions, botanical and mineral specimens, but most important of all he commissioned visual records of other people's collections which all went to make up his Paper Museum or visual encyclopedia which included careful drawings of antique sculptural fragments, mosaics, coins and gems; reconstructions of ruined buildings, antique customs and pagan rituals. For our present purposes the most interesting part of the huge conglomerate is the section devoted to natural history, which includes drawings of botanical and zoological specimens from life, and also the borderline categories like fungi and fossils and the magical or unclassifiable substances like asbestos.

Cesi once sent someone to Sicily to bring back records of the antiquities and the fossils, ruins of culture and geology respectively. This is a blurring, even confusing, of boundaries which Cassiano would have seconded enthusiastically. It may look like the omnivorous and indiscriminate lust of earlier assemblers of cabinets of curiosities, whose goal was an overwhelmingly dense physical conglomerate where everything jostles everything else in a crowded space and drowns reason in a riot of different textures. Strangely enough, John Soane's house in London, assembled two hundred years later, is the nearest thing to a survival of that earlier mentality.

Cassiano's museum filled a whole series of rooms but was crucially different from the earlier treasure troves in its reliance on paper records which have no texture and no smell. His approach is systematic and comprehensive in a new way. He places individual phenomena not just in the space of his museum and his collection, but in the wider imagined space of all the species which exist. So he is not content with his own premises but takes as his territory the natural world itself as catalogued by modern experimental understanding, not the neat natural

world of the four humours or the four continents, which used to fit comfortably on to the sides of a rectangular space, as is still seen in Tiepolo's great staircase hall in Würzburg, where the ceiling gives a rich, hackneyed view of exotic species. In that world it was not uncommon for unfamiliar objects to be given familiar names. The West Indies and American Indians are striking instances of the attempt to make something new and strange look known and old.

Like Cesi before him, Cassiano is breaking free of the old model, especially through his particular interest in classes of object, like fungi and fossils, which don't fit his model of the universe. But categories were falling all around him, and Cassiano cannot accurately be portrayed as one of the great mental adventurers of his age. His interest in fungi as an intermediate form, not exactly a plant, is a sign of new attitudes, whereas the interest in flamingos, which is stronger because he thinks it is the bird sacred to Isis in ancient Egypt or the one referred to in classical Roman recipes for cooking its tongue, is a survival from an older world. We don't know whether Cassiano and his friends, who corresponded so eagerly trading this ragbag of lore, had actually tried this delicacy or not. His interest in art and in scientific-style observation could be said to converge in some astonishing descriptions (evocations even) of the shifting colour effects he observed on birds' feathers.

Perhaps it is not always possible to separate the lynx-eyed curiosity of the scientist from the flitting fancy of the dilettante. When one sees a painstaking rendition of the Buddha's-finger citron, a gnarled fruit also familiar from Chinese jade ornaments, one tends to assume an idle interest in the weirdly complicated form (illus. 56). Maybe one should imagine instead a probing of technicalities of the growth process. One can treasure oddities in themselves or one can use them as an aid to understanding normality, because they are stuck at an early stage of development or because one element in a process has run away with the rest. There are plenty of signs of the latter approach in Cassiano's assemblage of those mountains of information which need to be digested on to sheets of paper to fit into the kind of space he has available.

In the lives of seventeenth-century scientists a significant pattern often emerges. They began by studying theology but felt a need to escape and came upon geometry with a sense of discovery. Over and over again each of them comes half-innocently to a crossroads where they choose secular instead of religious studies and are immediately relieved of a burden they did not know they were carrying. In the same

56 Vincenzo
Leonardi, *Digitated
Citron*, before 1646.

period wars of trade replaced wars of religion and began to be truly global, between the Dutch and the English and then the English and the French. This whole process of colonial expansion would work untold change on all the parties involved. Though at first scientific research appears to form a very small part of the total enterprise, the most momentous changes sometimes arrive from unexpected quarters, and so it was here. Ship's doctors often doubled as the naturalists on early voyages, for whom collecting specimens was no more than a private hobby. Occasionally, though, it formed a key part of the expedition, seeking exploitable plants which could be grown as crops to make the colony pay.

Various strands lived happily side by side. The pineapple which a Scottish landowner used, magnified and translated into stone, as the topknot of a huge folly, whose curling lower leaves contained an octagonal room (illus. 57), was in other minds altering how the plant world was understood. Benjamin Franklin studied storms like problems that needed to be cracked or solved, and Rameau put them into his operas as a kind of rational substitute for visits to the underworld. It is wonderful to think of the composer out in a storm with his notebook and pencil, trying to record in musical notation, as Mozart did with bird song, what the heavens were saying. Unfortunately it is not a likely scenario.

Not that the storms which pepper his operas are not exceedingly unexpected and unconventional, much less formulaic than the trips to Hades with which they sometimes coexist, but they so clearly function as figures for certain emotional excesses or the simultaneous entertainment of conflicting states of mind.

Perhaps at an earlier point, in Monteverdi maybe, plumbing the underworld was a way of probing the psyche, but by Rameau's day, in French opera at least, it was so thoroughly obligatory that the accompanying gloom is highly ritualized. So storms and volcanoes represent a real breaking out of artistic confinement. Rameau's storms may not be much like any weather you have ever heard, but they have led him into

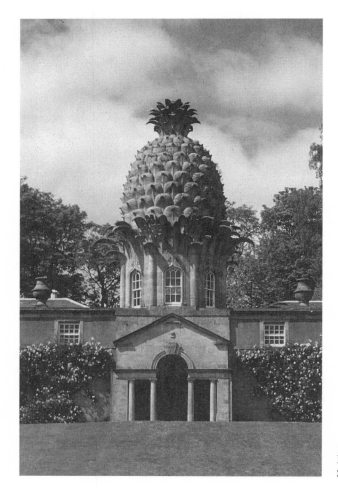

57 Pineapple folly, Dunmore Park, Stirlingshire, 1761.

a world without the usual harmonic or textural coordinates. Bracing shocks occur, but cannot be carried on for very long. In Hell conversation is possible, but a storm or an earthquake takes place outside the human world and doesn't leave much room for human intervention. Bystanders are awestruck and they say this, but it is a static response.

In his last opera, *Les Boréades*, never performed before the twentieth century, Rameau makes the wind and his children into some of the principal characters. It sounds like a regression which will ritualize natural cataclysm into something like the old infernal excursions, and if we are expecting an estranged Debussyian drama all transposed into the upper air, it doesn't happen. But such a possibility is suggested, in which wind – flutes skipping, clarinets sighing, drums trembling – becomes the main medium of the opera. Like the wind, intensity in *Les Boréades* comes and goes, intermittently hinting at a disembodied drama where the unearthly sounds and textures of the orchestra usurp the place of the characters. Such tendencies are enhanced by keeping Boreas offstage until the last act. Before that, though dreamt of, mimed, loudly invoked and held responsible for the weather, he can only be realized wordlessly.

As infernal visits had been before, storms become formulaic in eighteenth-century music and many operas contain them. In spite of their eventually hackneyed character, storms signal a decisive transfer of energy from the supernatural to the natural, though the natural at its most numinous and unfathomable. Storms in eighteenth-century operas are pre-Romantic inklings which will have their fulfilment in Berlioz and Wagner.

Baroque interest in freakish extremes of plant life or weather conditions can seem one of its most regressive promptings. But fascination with what are or appear to be pathologies are not always dead ends. Human (as opposed to botanical or meteorological) monstrosities which interest the Baroque tend first of all to more lavish scales than the nearest Mannerist equivalents and therefore act differently on the spectator. Even in their most conventionalized form they incorporate more direct observation, and are therefore more disconcerting in their effect. Here in the realm of the grotesque the Baroque dissolves old categories and crosses long-established boundaries so aggressively that finally in an artist like Hogarth the grotesque is no longer kept in its place but practically identified with the truth.

Although relatively late, the library of the Cistercian abbey of

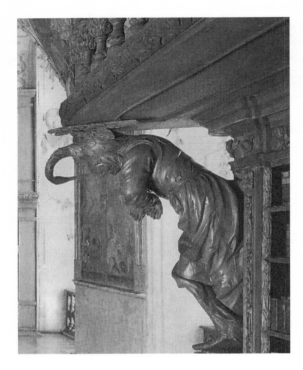

58 Karl Stilp, Atlantid (figure with crane head-dress being pecked by its beak), Library, Waldsassen Abbey, Oberpfalz, 1724–36.

Waldsassen in a remote location near the Bohemian border harks back to older Mannerist models. Among the lavish fittings of this long rectangular space by far the most interesting are embellishments of the wooden bookshelves. Between the shelves bands of carving display small animals like moths and lizards in cartouches, gallery railings conceal Bosch-like creatures among the leaves, and half the engaged columns turn into infants trapped in pierced leather and knotted cloth. At different times the scheme smacks of Watteau or northern Mannerism or medieval manuscript borders.

The most powerful element of all is a series of ten Atlantids, life size and leaning aggressively towards us to support the gallery. These figures include a badly pockmarked man, a Moorish bully, characters from Italian comedy, a fool with ass's ears, an old gent in a shroud, and a halfwit in a crane-headdress which bends down and grabs his nose with its beak (illus. 58). At first it seems a prank without a programme, but because this is a library in a monastery it is hard to leave it at that. There have been unsuccessful attempts to find caricatures of specific vices in the figures: arrogance and ignorance appear more than once and the sequence has no particular logic. Even more specific pro-

grammes have been sought – can it be an elaborate depiction of heresy, for instance? In that case, the attributes of arrogance and ignorance could not be repeated too often and the whole would embody a Counter-Reformation obsession. The craning figures would become awful warnings not to let your thoughts run away with you while delving into potentially dangerous texts.

But perhaps the figures are admonitory in a different sense, not models to follow or avoid, but a liberation of the mind in a new spirit of play. So the classical practice of putting prisoners or captives, different images of the state's enemies, to work in architectural ornament would be a misleading precedent. If one must find a logic in the disorder, better look for it in Carnival costumes, some of them perhaps peculiar to this provincial location.

In fact any such consistency makes the set more awkward, not less, for then it seems directed more intently at the minds of the monks, and how can it be telling them anything useful? It is there precisely to show that we no longer need improving messages and only want to be diverted. Uncovering surprises like the inclusion of the emperor Nero, killer of Christians, among the busts of heroes, confirms that in some sense no one is watching or censoring the contents here. Scenes reinforcing doctrines or depicting miracles are kept safely overhead on the painted ceiling, while down at human level the energizing dance of theologically pointless grotesques takes place.

One of the most entertaining Baroque schemes of grotesques has had the misfortune to be upstaged by Tintoretto's greatest cycle of paintings. In the Salone of the Scuola di San Rocco in Venice, Francesco Pianta carved a series of twelve caryatids (four more on the stairs) which culminate in caricature-portraits of himself and Tintoretto, the two main contributors to the space we are in, representing painting and sculpture. The most famous of the sixteen figures is the most flamboy-antly enigmatic and shows someone wrapped to the eyes in a swirling cape, a piece of real virtuoso carving (illus. 59). His hat with furled brim is pulled down. Below him lie a dark lantern and a not very silent looking shoe to suggest furtive footsteps. If this figure is a portrait it will never be verified, because only the eyes, the bridge of the nose and a few locks of hair are visible.

Pianta's figures are all half-figures, excessively animated yet conform-ing to the old type of the herm, which shows life trapped in a decorative role. Here the realism of the carving sometimes makes them look

59 Francesco Pianta, *Excessive Curiosity*, Scuola di San Rocco, Venice, late 17th century.

like anguished fragments or even dwarf-like distortions of the human frame. They spill out of their assigned places and drop confusing clues in the form of odd footwear or obsolete tools. Not many of the allegories are recognizable: Tintoretto is and Pianta isn't, ironically. But Pianta has provided a key right here in the room, if you know where to look for it, which I did not, though certainly in need of it. It is written on one of the sculptures on the stair: Mercury carries a scroll which identifies all the figures and tells you in what order to look at them.

Pianta was right to think some people might want this guidance, of which we felt the lack at Waldsassen. The spy in his cloak turns out to be Excessive Curiosity. The whole series in its proper order goes Melancholy, Honour, Greed, Ignorance, Science, the Distinction between Good and Evil, Fury, Excessive Curiosity, Scandal, Honest Pleasure, Sculpture, and Painting, with Plenty, Stratagem, Reproach and Mercury (who holds the key) left over for the stairs. It is a narrative so

idiosyncratic that we more easily imagine it as a moralizing novel by someone like Samuel Richardson than the decorative scheme for a room which few if any will ever read in the proper order.

Then there are the inconsistencies: Vices, Disciplines, Moral Distinctions and Momentary Impulses jostle each other in ragged sequence. But the truth is that the characters have outgrown their names. Near the end of the allegorical tradition an ingenious artist has decided to use a lot of conventional equipment to fashion a private code. Maybe Pianta is really a satirist after all, whose wealth of ideas would be more at home in a looser medium. He is most Baroque in his ambivalence over allegory, which he can neither entirely believe nor happily jettison.

It is a recurrent phenomenon of the Baroque that the most rambunctious artists with the most unruly material saddle themselves with allegorical schemes of medieval rigidity. Thus Hogarth is drawn to serial compositions which put him under constraint to match them up with each other and which sacrifice the painter's autonomy to the novelist's kind of necessity. It is as if in a Protestant country even painting must fall under the sway of literary forms. Like Pianta's half-figures, Hogarth's series can do with a lot of explaining, and every figure possesses its gobbet of explication. All this comes into its own when the painting is reproduced as a print with a detailed, printed notice attached. From a certain perspective it is a strength not a weakness for the visual form to be so deeply implicated in the verbal. Then, only then, is it fully part of culture. Then it has knitted itself thoroughly into social discourse, no longer a mildly embarrassing ornament.

Hogarth began by painting shop signs and engraving shop cards and ended as one of the most trenchant antagonists of many of the themes of this book. He was intensely interested in the theatre, but he turned the subject inside out. The spectacle which came to interest him most was not the play but the audience. He found the pretensions of the Italian opera ridiculous from the start, but his representations of random slices of audiences are among the most arresting images of the period, which forget overall composition in their concentration on the twists and turns of individual physiognomy. So the picture is a series of stacked rows, potentially the dullest of formats, but each of the pieces is so alive as a system of lines that one is tempted to claim that Baroque dynamism has reappeared at microscopic level in the springy silhouettes of chins, noses and outlandish wigs.

His most moving essay of this sort is the crowd of six of his servants'

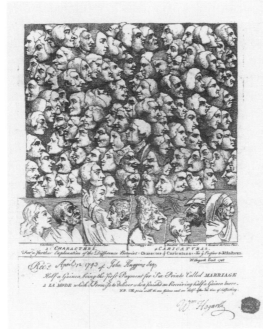

60 William Hogarth, *Heads of Six of Hogarth's Servants*, c. 1750–55.

61 William Hogarth, 'Characters and Caricaturas', subscription ticket for *Marriage à la Mode*, 1743.

heads on one canvas, a great landmark in the perception of human indi-
viduality (illus. 60). The strangest in the series is a polemical piece which
functioned as a ticket for subscribers to prints of the *Marriage à la Mode*
series. This ticket shows something like a hundred heads taken from the
six *Marriage* paintings and piled on top of each other in approximately
six rows (illus. 61). They have been translated from paint to the sharper
medium of engraving and brought together to prove that Hogarth
paints characters not caricatures.

It is a sore point for him which is never quite resolved. His venal
judges, corrupt officials and lascivious parsons are often recognizable
portraits. Contemporaries began to identify faces in his work even when
Hogarth didn't intend such precision. Late in life he is still troubled
when his satire backfires as his victims respond. He seems genuinely
shocked to find that those he ridicules are not content to play their parts
in the comedy, for by now he has converted them to creatures of his
imagination and cured himself of his initial aggressive urges.

So the audience is never quite the equivalent of the scientist's
sample, data collected and sorted, which gives one a comprehensive
view of a limited sector of reality. From the beginning Hogarth had had
a penchant for looking in crevices not usually explored or even seen
before in art and finding subjects there. He paints the theft of a watch
or a man tucked up in bed vomiting from over-indulgence. He realizes
that a wrestler demonstrating a hold is a perfectly noble subject for a
tombstone, or he finds himself fascinated by a notorious murderess
and paints her portrait. There is often a hint of aggression in Hogarth's
choice of subject – they are defiantly anti-academic. As with Pope,
when he borrows from the grand style it frequently turns to mock
heroic.

He parodies the motifs of the Grand Tour: he and four friends set
out from Gravesend on a five-day ramble through an obscure bit of
Kent, the Isles of Grain and Sheppey and so on, and they record their
boozing and minor mishaps in imitation of grander tourists. Hogarth
never tires of hitting out at antiquarianism; in *The Five Orders of Periwigs*
he makes archaeology seem a trivial pursuit, fixated on tiny shades of
difference in something which doesn't matter much in the first place.

Such is his insatiable appetite for human difference that the whole
almost invariably comes apart. In Hogarth every situation, including
portraits, wants to turn into a crowd and every crowd, into separate
atoms. At *A Christening* everyone is doing something they are not

supposed to be doing. They flirt, fondle their neighbour, sleep through the service, fight, play a game. It is like Bruegel's *Tower of Babel* in variety: no one can really keep up with the level of activity in Hogarth's most complicated compositions, and the whole falls apart into fascinating fragments. Only in the last big series *The Election* has he found the secret for imparting unity to his anthill.

Bruegel's depiction of the human mass is an anthill perhaps, but Hogarth's is the furthest thing from that. It shows life lacking overall plan or direction except insofar as everything tends to subversion or dissolution. The knowing spectator may say a hundred different times yes, that is just how people behave, stealing from benefactors, buying what shouldn't be for sale, transmitting fatal diseases. There is a paradox at work, as if one watched a squabbling mass of individuals, all united by their desire to do each other an injury and falling off a cliff together. In spite of the intensely extrovert quality to his work, whose subject is always the public – an idea which has a wider meaning than it has had in any earlier painting except possibly Bruegel's – to look hard at the public is to see it fragmented into a million pieces. So the inability to construct believable Baroque compositions, an effort Hogarth was slow to abandon, is rooted as much in his vision as it is in the Philistine anti-visual environment he railed against.

At times Hogarth's battles as an artist threaten to become the subject of his art and it would not be hard to narrate his development as a pugnacious response to the intractable class structures confronting him. In the later eighteenth century artists' personalities become more clearly implicated in their work, and instances of eccentricity so extreme they look like madness become more frequent. One can thus see Pope and Hogarth as forerunners of artists and tendencies with whom they finally have little in common, like Blake and Cowper, where the artist's personality becomes the true subject, after traditional heroic or pastoral motifs have been defaced beyond recall.

The Austrian sculptor Franz Xaver Messerschmidt has always looked like the most freakish unassimilable growth, in the obsessive series of leering, grimacing, glowering heads which he produced in provincial seclusion over the last thirteen years of his life. But in the perspective provided by the English development from eighteenth-century satire to pre-Romantic self-absorption, Messerschmidt looks prescient and a sign of things to come. Apparently he thought that his bizarre heads, which are often like strange fungi (illus. 62) and not

62 Franz Xaver
Messerschmidt, *Second
Beak-Head*, 1770s/80s.

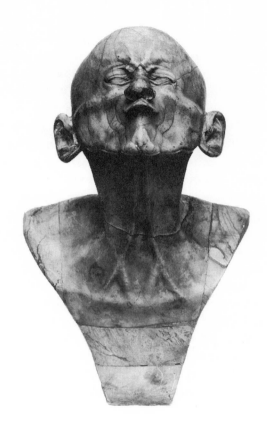

human in any ordinary sense, were a summation and concentration of
all the possibilities of art, while to us they seem products of the most
complete alienation, and fascinating for that reason. Hogarth was always
defending himself against charges of exaggeration; Messerschmidt has
gone far beyond anything previously imagined in distortions of the
countenance, deliberately stretching his own features to their limits by
moving the facial muscles in ways that ordinary expressions never call for.

He is a scientist in pursuing the whole range of physical possibility in
a systematic way and in taking the most emotive surfaces and treating
them with complete detachment. But it is an instance in which detailed
observation seems mad: mad in part because experience which observers
recognize as painful is not seen that way by the subject himself, as if the
muscles remain but the nerves have been cut.

The difference between Messerschmidt and ordinary anatomical

models is that he creates his 'models' because he wants to say something, though he has only an inkling what it is. Unlike ordinary scientists', his works are unmistakably products of an ego, however much it may try to sublimate itself in striations of the cheek muscle contorted in imitation of a smile. The Baroque interest in highly coloured representation of the passions, verging on or even entering ecstatic states of love or rage, has been distilled by Messerschmidt into eerie residues which look at first like caricature. But he carries it on so long that we become uncomfortable, as when asked to regard lasting self-mutilation as an art form, when modern teenagers put metal rings in every feature of the body which protrudes enough to pierce. Messerschmidt signals a breakdown in the economy of expression which occurs in many arts at the end of the eighteenth century, responsibility for which we can either lay at the door of Baroque exaggeration for emotional effect or blame on the final dissolution of Baroque consensus about the aims of art.

Signs of a new consciousness can be detected in many places. As often, parodies give unexpected glimpses of what the future might hold. In music-theatre, *The Beggar's Opera* sounded the death knell of Handel's grand and stylized investigations of overmastering passions. For feuding princes Gay substituted thieves, whores and prison warders. In one sense, like Hogarth's forays into the grimiest corners of urban life, it represents a real widening out. But it is a breath of fresh air which heralds a complete collapse of the structure you have been living in. The heightened eighteenth-century interest in prisons and madhouses, and in criminals and lunatics, is a tell-tale sign of an old order breaking up.

Already in Handel's *Orlando* madness is something more than a convenient formula. It provides the occasion for the longest monologue in any of his operas, which the castrato for whom it was written refused at first to sing, perhaps because of the extreme dissolving effect on musical structures which the idea of 'madness' produces here. This madness is not a noisy rage but a muted torpor, in which an identity quietly comes to pieces. In the midst of this suppressed intensity it is possible to observe very closely each of the aberrant thought processes exhibited by the character Orlando. Then this alarming calm is shattered in the second section of the monologue – for the action resolves itself after all into an aria, 'Vaghe pupille', after wandering at length in a sketchy and wayward accompanied recitative.

Handel is not mad; Messerschmidt is. So there is a vast gulf between

our relation to these two treatments. The difference is fundamental, yet we feel strong convergences. Handel is pushing himself towards an edge, which we could describe entirely in technical terms, pointing to suspensions, changes of direction and forms of losing the way which could look like loss of control, except that all these musical oddities have been given dramatic meaning in the portrait of someone out of his mind. Handel's 'madness' is a technical experiment, but it also reveals a wish to enter a certain mental territory, however briefly. This composer is more deeply interested in such dissolution and in what happens when identity is shattered than the other eighteenth-century musicians who depicted madness, including Haydn and Vivaldi.

In Messerschmidt the densest detail occurs where reality is negated, in wrinkles round the eyes clenched shut in a powerful rejection of the world. Perhaps it is treacherous, the painstaking elaboration of this subject which is no subject. The culmination of the eighteenth-century interest in places where the human being is destroyed but survives and can still be carefully anatomized, occurs in the work of Goya. He is powerfully drawn to hospitals, prisons and asylums, peacetime equivalents of the battlefield or the war-ravaged land, another subject he did not shirk. Goya is a pivotal figure, who began in Rococo tapestry designs where everyone leads the life of happy children, except that they begin to look up from their games, having lost the thread. By the end of his career he presents any human jollity which survives the brutality of the world as truly demented. So the Rococo dances are repeated with different actors, who look out on the world with complete incomprehension and fixed idiotic grins which Messerschmidt would recognize.

VII

COLONIAL BAROQUE

IN THE EIGHTEENTH CENTURY European Baroque enjoyed a surprising afterlife or apotheosis outside Europe. This expansive mode happened to coincide with a key phase of the European expansion beyond the bounds of Europe which, beginning in the sixteenth century, has been one of the formative movements of the modern world. In what we now call Latin America Spanish explorers found a populous urban civilization established in large impressive cities, while in New England English settlers found semi-migratory hunter-gatherers inhabiting the land less densely.

To a disconcerting degree these conditions mirror the nature and intentions of the colonizing forces. The English were a splinter group of dissenters inclined to further fragmentation on ideological lines, separatists who were not done with separating. They brought a minimum of architectural baggage and they had no systematic plans for converting or employing the natives.

The Spanish incursions may have begun as something like bandit raids but before long they were weighed down by much more complex and interesting cultural baggage than the English. On top of which the native population of Mexico was harder to overlook than the woodland peoples of the North. The wealth of their cities whetted the appetite of adventurers and the exotic rites and imagery of their devotional practices attracted the attention of the highly organized Spanish church and particularly of mendicant orders, among whom spiritual responsibility for the whole country was divided up along clear geographical lines. For two hundred years or more, North America had nothing to match the centralized Spanish administration of Mexico, which included the laying out of grid plan cities, the building of large cathedrals and

privately sponsored convents, and the founding of mission establish-
ments in areas where there were few Spanish settlers.

To a degree at least the spiritual colonization of Mexico ran at cross
purposes to the general settlement and exploitation by Spanish immi-
grants. Mission establishments were in some ways safe havens for the
natives who were there protected from the worst ravages of enslaved
labour for Spanish landlords. But the cultural price was high. Priests
stripped them of traditions, rituals and local art forms in order to make
them over as versions of themselves. The translation of doctrinal texts
into native languages, the attempt to create an Indian clergy and the
establishment of centres of learning are sometimes quoted as signs of
high-minded care for native welfare, but they can be read just as easily
as intellectual and spiritual takeover, such as is commonly practised by
conquerors who want to control the minds as well as the labour of a
subject people.

It is notable that the greatest sixteenth-century Spanish student of
Mayan culture was also its most fanatical destroyer. In 1562 Diego de
Landa, author of a history of the Yucatán, staged a public flogging and
torture of Mayan 'idolaters' and a gigantic bonfire of Mayan codexes,
sculpture, and over five thousand clay idols at Mani in the Yucatán, as a
literal and symbolic indication of Spanish intentions. He did not mean
to coexist with native culture even in a dominant-submissive relation:
he meant to obliterate and replace it.

By the stage we are principally concerned with, this obliteration is all
but complete in New Spain. The large congregations of native converts,
who had stirred the monks to devise a novel spatial form, the so-called
open chapel, to accommodate them, are no more. They have been
decimated by European diseases, above all measles, to which they have
no resistance. Others have died of overwork and by 1620 less than a
million remain from a native population which had numbered twenty-
two million a century earlier.

So if we had hoped to find here a Baroque interpreted by or filtered
through a lively native culture, we are doomed to at least partial dis-
appointment. Yet we do not see as in North America just a clumsy if
charming replica of the European model, work which is quintessen-
tially provincial. Of course there is disagreement about the nature and
the extent of Mexican Baroque's independence of Spanish models.
Some writers, like Kubler, who do not tend to be Mexican, are at pains
to deny seepage from pre-Conquest forms, and to account for any

seemingly Mexican peculiarity by referring to Spanish precedents. Inevitably in this perspective Mexican Baroque looks like a bad copy of something of which the colonial craftsmen possessed only misleading reports or partial understanding.

Perhaps it is often some variant of Mexican patriotism (and for this one needn't be Mexican) which tempts one to deny this. One wants to insist on the Mexicanness of Mexican Baroque even before one has begun to think about it. There are those who find the absence of technical sophistication a decided plus, those who follow the disintegration of the emperor's profile into something which looks more like a rooster – in the Gaulish derivatives of Roman coins – with mounting excitement, who prefer controlled infusions of anarchy to sclerotic forms of order, who want to believe that Gothic tribes brought welcome vitality to a moribund Empire.

Maybe a parallel can be drawn between the development of Roman into Romanesque and what happened to Spanish Baroque when it was imported into Mexico. Of course the second development is much shorter and far less obscure, but it might similarly be seen as a helpless regression or degradation in which the sense of many elements and especially of structural logic becomes blurred or entirely lost.

In some way this colonial process represents the victory of ignorance over highly developed and long refined system with an accompanying loss of intellectual coherence and complexity. It is undoubtedly true that if one looks in Mexican Baroque for rich iconographical schemes or elaborate embodiments of concepts – the sort of thing which one finds in Borromini or Fischer von Erlach – one will become impatient with these buildings. But there are other forms of complexity besides those derived from a close acquaintance with European Renaissance art.

We may not agree on what are the essential features of the Baroque. Is it unthinkable except as a learned style, virtually a commentary on the normative Renaissance forms from which it perversely departs and knowingly distorts, so that one cannot understand Baroque artefacts without a grounding in Brunelleschi, Raphael, Peruzzi, Michelangelo? A folk-version of such an enterprise seems a nonsensical idea, but of course what we now recognize as standard Renaissance motifs were recherché before they were familiar, and their diffusion in Northern Europe bears a certain pale resemblance to the transmogrifications of Baroque in Mexico. Elizabethan prodigy houses look clownish to strict classicists.

But if Baroque was learned, it was at the same time deliberately incorrect and aberrant, which helps make it a harder mode to define satisfactorily than its predecessors. Mexican craftsmen caught the exuberance and excess of Baroque even if the fine points of its commentary on Renaissance forms, in-jokes intensely enjoyable to those who notice them, were lost or misunderstood. By this route and using this conception of the style's essence, emphasizing its exuberance and incorrectness, one can say that Mexican Baroque is the most complete fulfilment of the potential of Baroque perception. The strengths and weaknesses of this European style are more richly present in the New World than anywhere in Europe.

The further one strays from the metropolitan source the more watered down, rustic or eccentric the provincial or colonial variant becomes, so the conventional version runs. But there are many ways of being provincial and many sizes and sorts of artistic consensus. New attitudes in the arts often look provincial at first, especially when, as with Romantic poets in the Lake District, their subjects are defiantly non-metropolitan. Indelible provinciality has often been a source of strength as Blake and Whitman and Dreiser show, each one differently. Besides, the apparently clear distinction between province and colony, between a remote but integral limb of the main body and a distant, disconnected outpost, even that fails to hold up as well as one had expected. Or at least provinces often seem on the verge of declaring themselves colonies – exploited, unrecognized, alienated and therefore candidates for independent status.

One tends to assume cultural homogeneity in places where it does not exist, to assume for example a unified sense of mission or goal among the Spaniards in the New World, only to find out that ordinary settlers resisted the arrival of the Dominicans in San Cristóbal de las Casas for example, so the great Dominican church there, which has been seen as one of the prime examples of collaboration between Spaniard and native and a key monument in the transmogrification of Spanish Baroque in Mexico, was constructed in something like a state of siege or violent hostility between rival groups of Spanish immigrant.

This antagonism between the religious orders and Spanish settlers recurs constantly in the history of Mexico and is explained in contradictory ways. The orders, so the story goes, were the conscience of the Spanish presence in the New World, likely to speak out against other landowners' employment practices and to bring about (or at least

attempt) governmental restrictions on employers' freedom. Or, alternatively they were rivals occupying valuable land and enjoying special privileges in exploiting it.

So we are liable to misinterpret the fortified appearance of rural churches in the Yucatán, for example, which were embattled in a way we are not likely to guess. And the place of the natives in any of these situations is more complicated than we first suspected, so that our initial idea that Mexican Baroque is either a legitimate derivation or a helpless caricature of European antecedents will not do. How stable is the concept of caricature anyway?

Almost all derivatives will look like caricature to a viewer out of sympathy with their aims. There are two easier test cases nearer in time than the Mexican examples, the so-called Turkish Baroque of the late eighteenth century and Edwardian Baroque (a more familiar coinage) in the Britain of 1900. Both these names must have seemed ridiculous at first, before they became indispensable labels. However lively, the Turkish examples cannot easily shake off the imputation of slavish subservience to Western models and remain dependent on an arbitrarily selected foreign ideal. Similarly, the Edwardian buildings, though exuberant and charming, seem magpie products whose best ideas are stolen and whose own contribution is simply innovations in trim. Both Turkish and Edwardian variants of Baroque were the result of freer and more conscious choices than the native builders of Mexico could make. The forced union of cultures in Mexico is more traumatic and more authentic than such effete derivatives.

Sophisticated caricatures can never stray too far from the model, for they need to be recognized as a witty approximation to something in particular. If it outstrips the model it does so within narrow limits – *Der Rosenkavalier* realizes the sensuousness of Rococo better than true Rococo ever does, but never escapes from tutelage altogether. Strauss may be more sophisticated than his tutors in some way, but he is still guided by a path they have laid out. Certain key Strauss characters are familiar Mozart types with an extra Freudian twist.

To some observers Mexican Baroque is nothing more than caricature of its European parents, but what looks to an unsympathetic eye most like caricature, because furthest from remembered European models, is actually that which has achieved the most complete escape. These are humbler, non-metropolitan structures like the Sanctuary at Ocotlán on the outskirts of Tlaxcala, one of the most folkish of the

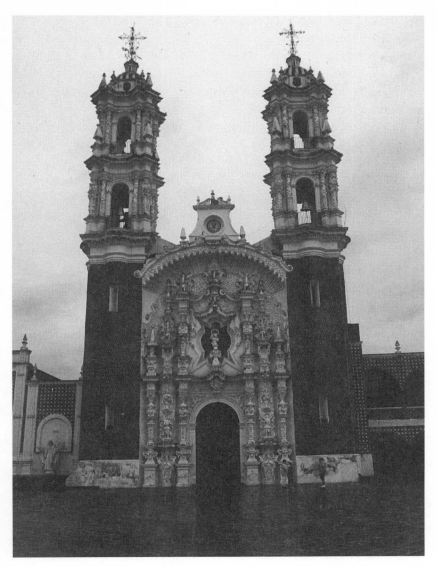

63 Francisco Miguel, Stucco façade of the Sanctuary at Ocotlán, Tlaxcala, Mexico, completed 1750.

sizeable churches of Mexico, and more authentically a native posses-
sion than some of the others (illus. 63). It commemorates a vision
vouchsafed to an Indian in 1541, seventeen years after the first party of
Franciscans arrived in New Spain. This Indian's name is Juan Diego,
just like the one who had seen the Virgin of Guadalupe ten years earlier

in another vision on a hill now swallowed by Mexico City. Then and for a long time thereafter Indian converts weren't given surnames, so there weren't many names to distribute. The earlier Juan Diego's vision in Pocito reproduced a famous devotional image from Cáceres in Spain, an image the Indian could have seen earlier, which now imprinted itself on his rough cloak, a cloak still preserved in the shrine.

The eighteenth-century shrine at Ocotlán also has a stronger Indian stamp than usual because its designer, like its visionary, was another Indian, Francisco Miguel, who died some time before it was completed in 1750. Though supervised by a local priest, he and the other Indian workers produced one of the most exuberant façades in Mexico, which imitates stone forms in stucco, producing a wayward result in the more flexible material. Because stucco is more perishable than stone we cannot recover the chisel marks or finger prints of eighteenth-century carvers. On the contrary, this concoction which looks in some lights like paper or bread, like one of those small sculptures in dough which are among the traditional folk productions of Mexico, has been frequently recoated, and fattened or thinned each time.

The stark white central panel of the façade at Ocotlán is framed by two red towers, which look from a distance like down-to-earth brick but turn out to be hexagonal tiles, like the cells of a beehive, and therefore only a phantasmic imitation of masonry. The plaster centrepiece, glittering harshly in the sun, is a giant two-storeyed niche, containing Juan Diego's vision depicted as an explosion from which other elements of the façade fall back as draperies or curly pediments split open by its force. At the very centre is a black hole (in fact a window opening), like an elongated star, and the whole central scene is framed by six columns like candlesticks two storeys high, some whittled to toothpick thinness, others flattened like pennies on railroad tracks.

Over the central vision is a broken pediment whose curls look like eyes, part of a giant face. The content of the vision itself is puzzling and comprises the Virgin supported on three globes which rest on St Francis's back. He is turned so he cannot see her, but does not look towards us either. There is no sign of the Indian who saw it, unless it is intended that the spectator should take his place.

Visionary appearances to Indians were an important stage in the naturalization of Christianity in Mexico. At Ocotlán the vision was rooted in the local vegetation; Juan Diego saw an okote pine tree split open to reveal the Virgin within it. Monks retrieved the physical record

of his vision, persisting in the blasted tree as a wooden figure of soft pine. Afterwards, although Juan Diego's vision is the founding event of the shrine, the native visionary disappears, to be replaced by St Francis, and the shattered pine tree is converted to abstract jaggedness on the façade – curtains, window frames, mouldings. Finally the event is recorded in cold if visionary whiteness.

The eighteenth-century priest's conception of how the vision should be commemorated at Ocotlán has two poles, an inner and an outer manifestation. At the far end of the sanctuary is a secret enclosure, the so-called Virgin's Dressing Room, where the miraculous image is dressed or prepared on days of major processions (illus. 64).

The general layout is familiar from a Spanish antecedent, the *camarín* or small chamber for displaying the Host which appeared in Valencia in the 1650s, in more or less this position, visible behind the main altar but not obviously accessible. Already the idea exists of a further sanctuary beyond the sanctuary, more special, more private. But the Mexican instances (at Ocotlán and Tepotzotlán above all) animate and domesticate this idea more intensely. These are the private quarters of a local personage, the Virgin as she has appeared in this out of the way place; without a trace of the everyday the room has still picked up some of the flavour of the archetypal Rococo interior, the boudoir. So this is where

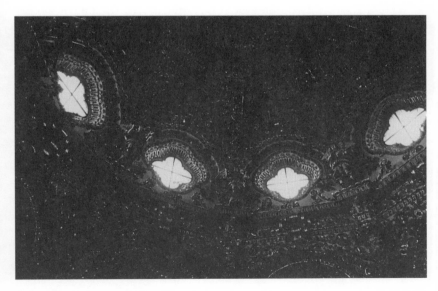

64 Interior of the *camarín*, Ocotlán.

the Virgin decks herself out in innocent finery and comes to look more and more like the highest embodiment of womanhood. Again one thinks of another archetypally Mexican form, portraits of nuns covered in flowers as brides of Christ, which are throwbacks to some pre-Hispanic idea of the adornment of a sacrifice, and a profound confusion of the idea of beauty with death.

The Virgin's flowery bower at Ocotlán is a domed octagon covered in lively plasterwork with very little breathing space between the bulgy flowers, fruits, garlands and cherub heads. The major imagery is as usual formulaic – Pentecost at the centre with little disciples all writing or reading at tiny desks, eight doctors of the Church who stand stiff in their niches and hang improbably overhead in the dome, then best of all eight boyish angels on spiral columns. Again not an Indian in sight and the doctors taken straight from engravings.

But the space does not feel Spanish or European. The life of it lies in the fatness of the curls and the individuality of all the nameless details and most of all in the colour – gold, red, green and white thrown together promiscuously. It forms a gorgeous costume or dress which does not need to wait for those few occasions on which the Virgin comes here to be dressed, but realizes in the larger outline of a skirt or mantle, seen from within, the idea of transfiguration through adornment.

Such Mexican environments may be populated by friendly presences – on the façade at Ocotlán the twelve disciples peep out of square columns like little animals hiding in trees – but their precise identities count for little. The goal is animated substance which levels its various constituents, whether they are flowers or saints or pastry twists. Indian craftsmen represent what they are instructed to represent, without much feeling one is sometimes tempted to say. But the feeling is seen in the redressing of balances and reassigning of importance. The little saints can look particularly puny perched in the marvellous gold forest of a retable, as if they have climbed up for the view but will never get down. Sometimes while examining these staggering products of enthusiasm the feeling comes over one that Christian imagery has been swamped by something else, and this in spite of the fact that Christian piety in Mexico is often alarming in its intensity.

Another architectural form which obliterates the distinctness of parts and has a particularly folkish feel is the tile-covered façade, which enjoyed a special vogue in Puebla and the immediate surroundings in

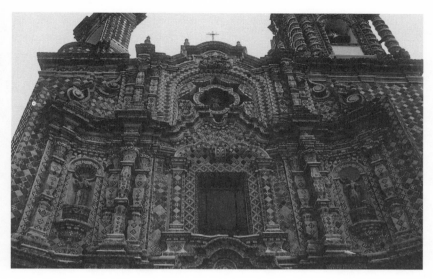

65 San Francisco, Acatepec, Mexico, *c.* 1750, tiled façade.

the mid-eighteenth century. Portuguese precedents, to which Kubler turns to account for the Mexican version, use tiles in more rational and hence restricted ways. The wall is conceived as a flat surface on which pictures and patterns can be hung like tapestries or paintings. Ordinarily these don't depart from blue and white, which make a dazzling but fairly uniform and, by comparison with Mexico, tasteful effect.

There is, it is true, a type of Mexican tiled façade which is essentially a flat surface brocaded with tiles. This is not usually treated pictorially but as a space for fine-grained pattern like an animal's coat or a fish's skin. At San Bernardino Tlaxcalancingo it is a simple zigzag based on a fired but unglazed deep pink. These are interspersed with flowers, crosses and suns on yellow and blue squares. Both long or square tiles are laid in diagonal or diamond orientation. The result is a vibrating shimmer into which the few architectural details fade, the doorframes and fat little obelisks which are tiled too.

More complex but not necessarily more satisfying are more three-dimensional conceptions like the façade at Acatepec nearby with a three-tiered composition framed by columns, punctuated by niches and topped off at every stage with cornices and curved pediments (illus. 65). All this architectural detail is sheathed in tiles like an extra layer of festive decoration hiding the real nature of the structure and preventing us from seeing what prosaic stuff it is made of.

Three-dimensional effects in tile seem a perverse denial of the nature of the material. The nearest parallel to this way of dressing up architecture comes from much further afield than Portugal: fourteenth-century Persian tombs and mosques in Samarkand and Isfahan pit two forms against one another in a similar way, lush vegetation drawn on individual tiles and an underlying geometry running at cross purposes to the surface pattern.

The tension in such Islamic monuments arises from prohibition: many images are ruled out and energy rechannelled into exuberant semi-abstract pattern. The Mexican psychology may be vaguely similar, in that the workmen feel the prescribed narratives to be alien and escape into non-narrative decorative excess. Whatever the impetus, whoever the workmen, the result is a defacement of architectural form and the replacement of European solidity and substance with an optical vibration, a sermon high in doctrinal content with the sensuous immediacy of a warm and colourful blanket.

It is commonplace for folkish products to override the boundaries of divergent styles; thus the overall format of a façade like San Domingo in San Cristóbal de Las Casas can be plain Renaissance rectilinearity, but when all available surfaces have been covered with floral patterns in stucco derived from wood carving or fabric designs, not technically Baroque but far more primitive, the result is nonetheless Baroque in its animation. Motifs can have very clear derivation, like the caryatids in the San Agustin cloister in Querétaro, taken straight from a Mannerist engraving. But if the vocabulary is Mannerist, the expression is wilder and more gregarious. These designers cannibalize the past without being tainted by it and subsume what are ordinarily strong flavours into something else entirely.

The most disconcerting products of all, from the point of view of the history of European styles, are found in more remote locations. In the back country along the Morelos–Puebla border are a few extreme instances which even tolerant critics have labelled 'perverse' or 'naive', meaning that they violate architectural decorum to a degree rare even in Mexico. Santa María Jolalpan is probably the most exotic of the group, a florid product full of incongruous juxtapositions of writhing or stiff elements of two or three dimensions, exhibiting a plump voluptuousness reminiscent of Hindu sculpture or the nightmare structures of the Facteur Cheval, the early twentieth-century French autodidact who built a fantastic castle in his garden (illus. 66). Many Mexican Baroque

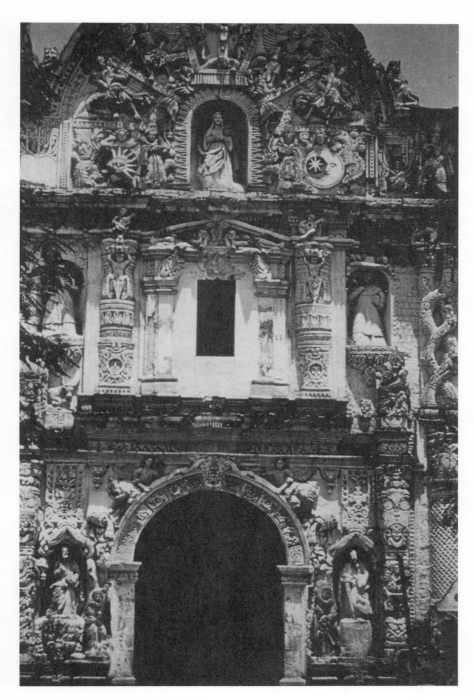

66 Santa María, Jolalpan, Mexico, *c.* 1760.

structures verge like this towards something outside the cycle of styles, products of a universal quasi-pictorial imagination which keeps adding imagery to an already heaped up pile. Such deeply transgressive products as Jolalpan take up the invitation implicit in the earliest Baroque works, to violate the classical rules more and more completely. Key elements have melted while others have dried out and become porous skeletons and still others have grown grotesquely fat, so that important features disappear in bulges of flesh. Some parts of the body have acquired tattoos and others have spawned crowds of little cherubs like lice.

There is an immense distance between this profusion verging on chaos and the overwhelming but coolly managed density of sophisticated works like the Sagrario in Mexico City, whose architect was Spanish, but had spent about twenty years in Mexico before undertaking this commission. The Sagrario is a large addition whose façade is joined to that of the cathedral but outdoes the main building in colour and richness. It looks like an immense non-functional shrine, an impression increased by false walls like billboards disguising its Greek cross plan and presenting it as a pyramidal cake of red volcanic stone with portals in grey.

In spite of its appearance the Sagrario had a workaday not a ceremonial purpose as the main parish church of the city. The result is generally credited with establishing the *retablo*, a type of gigantic altarpiece, as the model for façades, a transfer characteristic of later Mexican Baroque and signifying a desire to move to the outdoors and a larger scale the kind of enveloping richness which in most European cultures has been saved for indoors (illus. 67). In this case there could have been no wish to create an intimate effect, for the Sagrario opens on the Zócalo, then the largest public square in the world. But it is misleading to compare this square in Mexico City to the piazzas of Rome or Madrid, because space has a different value in the New World.

The Sagrario is also regarded as initiating the triumph of the *estípite* column in Mexican architecture, an element not invented but perfected by Lorenzo Rodríguez, its designer. The *estípite* (from the same root as the word for constipated) is one of the great victories of excess over reason and of decoration over structure in Mexican Baroque. It resembles an inverted column, fatter at the top than the bottom. It is usually segmented and changes its form completely more than once in its progress. Along with these irregularities of form go violations of conventional architectural elements, especially capitals.

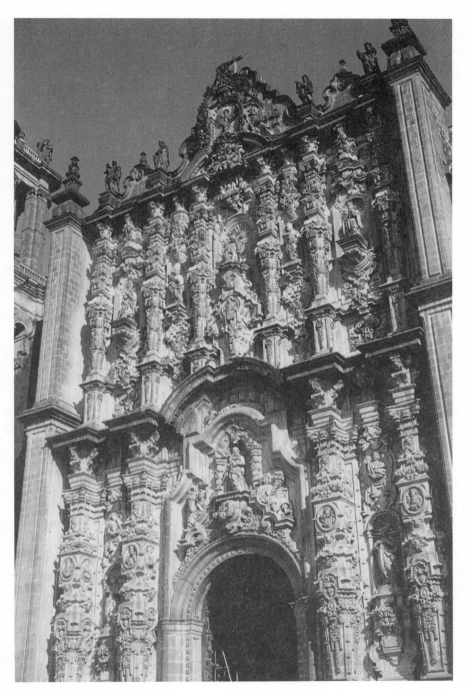

67 Lorenzo Rodríguez, Sagrario, Mexico City, 1749–59, façade with *estípites*.

Adjacent columns blur into each other, or radiate in receding stages, sharp edged but signalling a profound uncertainty in the form. Taken separately they look like stacks of nothing but capitals, or like figures with various loads piled on their heads, or like Piranesi's rickety towers of ruined fragments. But the wild multiplication is held in check by sober accompaniments, like an entablature heavily indented but continuing unbroken across the whole façade. Likewise the cornice above it, even more deeply shadowed, makes another firm horizon which is broken only once, in the middle.

So a few of the classical elements, like the cornice, remain almost themselves. But each column includes two capitals, one above and one below the entablature, the lower one Corinthian with the pulp sucked out, and then flattened; the upper more roguish, perforated to a trellis-like state. A column with two different capitals is the greatest possible affront to architecture, making nonsense of the old anthropomorphic derivations of the classical system. A column with two heads belongs in the same realm as Siva with four arms, a denial of reality and its constraints.

The Sagrario starts from European premises and a familiar European formal vocabulary, which assume that rectilinear geometry is the native language of buildings, expressing what is most important about them. Only traces of this belief remain around the edges of the Sagrario, yet it keeps measuring itself against the discarded rational ideal, first of all in lining up a series of supports which don't support. In the upper level some of the statues stand on 'corbels' which look like architectural plans mounted vertically, reproducing themselves in receding series like Blakean emanations. But every time this work appears to obey an established rule or architectural principle, it deflects, for the aim is ecstatic release, even when the medium is hard-edged geometry.

The *Blue Guide* to Mexico is one of the best of that generally stuffy tribe, but faced with an overload like the Sagrario façades, it is reduced to tabulating the iconography and naming the saints, disciples and doctors who populate one side and then the other. Reading both these catalogues, one realizes that they will not help much in sorting out the experience. Individual figures have virtually no character and could be scrambled or redistributed without affecting the meaning of the whole. There are slots to fill, and if it is four, the Evangelists will do. But they could just as well wait. This level of detail can be left to a late stage, like

the question of whether one wants roses, grapes or bay leaves dripping from a certain pedestal.

This is not true of every Mexican façade or altar, but it is true of many, as it is of many, though not all, Hindu temples. The imagery, prolific and luxuriant as it is, may be more generic than we think and thus have less doctrinal significance than is commonly believed. The parallel between eighteenth-century Mexican and ninth-century Indian cannot be very exact, but both of them are remarkable for using certain kinds of proliferation to achieve rich effects. A few principles of development are the same in both: to take a simple structural idea, six columns supporting a roof or cornice, and then to cause each element to fan out in subsidiary duplicates of its original outline, and to do this in all three dimensions, so that you get a lot of receding or exfoliating series which go up, back and sideways. It sounds unlikely but produces some of the most mysterious results in the whole history of architecture.

Even relatively small Indian buildings like the Varahi temple at Chaurasi in Orissa outdo any Mexican example in elaboration (illus. 68). Only the lowest level preserves anything much like a wall. Although there are two clear storeys above that, they are essentially elaborated roof and no more. Yet you cannot say this is a one-storey building with a top-heavy roof, rather that the upper storeys are notional and that exuberant elaboration is eating up the possibilities of windows or practical use.

Unlike the Mexican examples where the façade is only one element in a larger whole, sculptural ornament in the Indian temple is absolutely inseparable from the rest and is the outermost evidence of the stone's presence. Stella Kramrisch advises us to imagine Indian architecture radiating its force from the centre outward. This happens to fit the physical form of many temples which are centripetal stone masses with very little usable internal space. They are like sculptural beacons releasing their meanings evenly into the landscape on all four sides.

Sculptural expression is kept more firmly in its place by the Mexican format, though Rodríguez's two-sided Sagrario is a kind of diagrammatic overturning of the single-axis orientation of most Mexican churches. In two of the Baroque convents of Querétaro, insidious sidelong entry into naves entirely coated in retables seems aimed at the same goal, the breakdown of linear hierarchy.

A brief encounter with Indian spatial organization shows us that one needs little previous experience of the Indian architectural system in

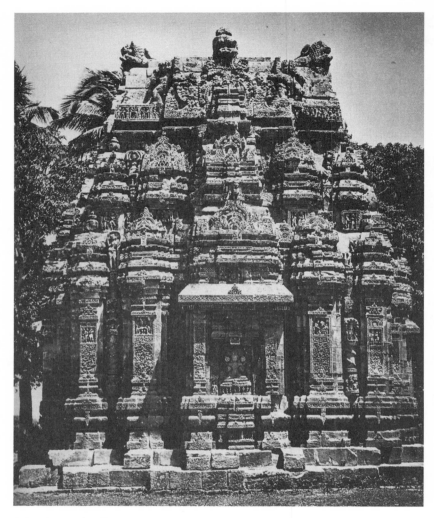

68 Varahi temple, Chaurasi, Orissa, ninth century.

order to understand something of what is going on in these temples. We may not know what Indian eaves, cornices and pillars are usually like, but we see that at Chaurasi we have a proliferation of these elements surplus to any reasonable requirement, proliferation meant to suggest general abundance and to remind us of the richness of the world. However ignorant we are of what the building is for, we can appreciate the ingenuity which fits further reminiscences of the original pillar in each series into a space already dense with other presences. The

Hindu example makes us suspect that someone who had never seen a Corinthian capital would still get the point of the Sagrario, and that the means by which this Mexican church organizes its forms are more universal than details of Greco-Roman inheritance.

In Portuguese India where an infiltration by Hindu forms is at least conceivable, there is virtually no sign of it in the major monuments of the capital of Goa, where plenty of large, vaguely Baroque churches survive. In outlying villages Hindu figures sometimes creep on to church façades and architectural detail is folkish if not positively Hindu. To see European forms infused with Indian imagination one must turn to small devotional items in ivory, mass produced in the eighteenth century for export back to Europe. There we see Christs of distinctly Indian type hanging on crosses like tropical species of tree.

Goan Baroque architecture, on the other hand, is a little stodgy, under the influence of the Portuguese Plain Style, which had dampened Baroque excess in the mother country, or in the defensive attitude of the outpost. Unlike Mexico where there is a whole New Spain to inhabit, Goa remained a glorified trading post, successful at its height but always visibly precarious. The most interesting peculiarity of the Goan buildings occurs outside human intention when tropical damp mottles all exterior surfaces with declassicizing flowers of mould.

Suppression of Hinduism was so violent in seventeenth-century Goa that it caused serious economic damage, driving a large portion of the native population just over the borders of the territory. In these areas, later incorporated into Goa, the most original Baroque structures in Portuguese India were built – Hindu temples to replace those left behind and destroyed by the Portuguese. Though fleeing from and persecuted by the Europeans, Hindu builders based the new structures on European models.

The most striking element in these temple complexes is usually the Lamp Tower, a form peculiar to Goa (illus. 69). The biggest are octagonal, five to seven storeys tall, and finished off with elaborate crests and domelets. Each storey is boldly arcaded with fat columns and cornices which distantly echo in their plumpness the repletion of earlier Hindu architecture. At festival times, with lamps in every one of the fifty-odd openings, they would possess an animation typically Baroque.

Goa is a key site in one of the great failed projects to Europeanize the East. St Francis Xavier set out from here to convert the East Indies,

69 Shri Mangesh Temple, Goa, 18th century, lamp tower.

Japan and China, and in the end his body was brought back to Goa, where it largely remains, though small bits were dispatched to Rome and Japan in the seventeenth century, and a toe was later purloined by a devout Portuguese lady from Lisbon. Contemporary reports and his own letters suggest that the saint was a very remarkable man, but the enterprise looks in most respects a sad and myopic failure. He ended his life on a small island off the Chinese coast, still denied entry to his last goal, the largest, most venerable Far Eastern country.

But in some sense Francis Xavier's influence exists independent of the practical outcome of specific projects. So it is not entirely surprising that the only original opera which survives from the Jesuit reductions in South America treats the subject of Francis Xavier's missionary foray to the East, reductions which brought the natives into reduced areas where they could be more easily instructed and employed. Apparently, the story that 'Indians' on the other side of the world most needed to hear and be inspired by, was the lonely venture of a Spaniard who left home in order to bring light to many strangers of different races.

It is a striking instance of deflection, and a tactless choice of theme to be played before colonial people in a mission compound, the story of a single European going forth to replace exotic cultures with his own, cultures he does not need to learn because he is about to supersede them. Thus this play may be suitable fare for the Chiquito Indians of Bolivia precisely because it shows that resistance is useless, for Europeans are setting off in all directions at once on such missions. So the South American mission is a microcosm repeated many times around the world, and teachers could choose from myriad instances in enforcing the one message of submission.

The little Jesuit opera, recently titled *San Ignacio* by its modern editor, comes in two parts which the manuscripts identify tersely as 'Messenger' and 'Farewell'. The first consists of dialogues between Ignatius and two angels, followed by an encounter with a seductive demon who provokes the Jesuit founder to imagine himself leading a flying squadron into spiritual battle, an episode which might remind the audience that Ignatius began as a soldier and discovered his vocation while convalescing from war wounds.

The second part shows Ignatius suggesting the great missionary voyage to Francis Xavier. The two priests are never at odds with each other, yet suppressed tension runs through the section. And again the simple but effective format for spiritual struggle is a duet in which the

voices alternate before combining, to express the difficulty in arriving at a point where two individuals can speak the same words. It is far from the straightforward exposition of doctrine, and in spite of vagueness about time and place, the opera constitutes a strong instance of the Baroque grounding of spiritual truths in everyday emotions. Undertaking a grand mission is represented as a form of saying goodbye, so whatever sense of triumph you extract from it will be matched by a powerful sense of loss. Both saints continue to exclaim 'Ay! que tormento' long after we thought them reconciled to separation. Through musical intensity strong counter-currents are set up to the simple doctrinal point, and the resulting view of sacrifice gains surprising emotional depth.

Despite its exotic features, this colonial work is clearly related to a seventeenth-century European genre. After secular opera developed in Florence and Mantua, there occurred in Rome under the influence of aristocratic clerical patrons a reaction against profane and particularly classical-pagan subject matter, so operas began to focus on sacred themes. Far from constituting a simple straitjacket, this constraint provoked from librettists and composers contorted and ambiguous works, the equivalents in music of Bernini's rapturous expiring saints, works in which sensuality directs itself most improbably to other-worldly ends.

Lives of obscure local saints were favoured for these dramas, like Alessio (or Alexis) chosen by a Barberini cardinal for a lavish production (sets by Pietro da Cortona) to be performed in his Roman palace rebuilt by Maderno, Bernini and Borromini. Alessio seems an odd choice for wealthy private patronage: the son of a Roman senator who disappeared on a pilgrimage to the Holy Land and returned incognito as a beggar to his father's house, where he lived in squalor under the stairs, teased by the servants who failed to recognize him. He refuses all earthly attachments, longing for death and finally expiring in his cramped space under the stairs, at which point heavenly portents and a message in his own hand give away his identity and he is welcomed into heaven as a saint.

Alessio's stair is still preserved in the Roman church dedicated to him near his father's house on the Aventine, a local relic which would allow spectators to feel a proprietorial interest in the story. But it casts a strange light on aristocratic Roman wealth. Even more awkwardly, it is the tale of a hero who spends his time avoiding drama, which thus

tends to be deflected on to his earthly family, who continue sounding like disappointed lovers, most of all when claiming to be reconciled to his death. As in the simpler Jesuit piece the emotions and situations of romantic secular drama are seized and twisted round to preach denial, which carries an exactly contrary charge to its meaning in a love story. Alessio's incognito, a mythical or magical motif, works perversely to facilitate his worldly defeat. Stefano Landi, the composer of *Sant' Alessio*, here relishes the extra layer which reverses the moral valency, like further twists in a Baroque drapery.

Even more explosive material of this kind is supplied by female saints, because their potential as sexual objects lies nearer to the surface. The Neapolitan Francesco Provenzale, whom Bukofzer (author of the best book on Baroque music) calls the most neglected composer of Baroque opera, wrote several sacred dramas on such themes, including one on a favourite Baroque saint called *The Phoenix of Avila, Teresa of Jesus*, now unfortunately lost. *The Wounded Dove*, an opera about the local Neapolitan saint, Rosalia, survives.

Rosalia is one of that well-known breed who opt for a convent instead of earthly marriage. Like Alessio's story, this is a drama of refusal or giving up the world. In the hands of Provenzale and his librettist Giuseppe Castaldo this becomes an overheated metaphysical poem about the impossible union with an alternative bridegroom, Christ, presented as a rival one cannot say no to, whose flirtatiousness and jealousy are more persuasive than an ordinary lover's, and whose Mother is a force to be reckoned with, especially by a bashful girl hoping to enter the family.

The huge gulf between the two conceptions of love, earthly and heavenly, is bridged by strained imagery and transpositions from earthly arousal to spiritual longing. Eventually Rosalia is a presence in her own right, but she begins as a subject talked about. In the opening scene powerful forces are wrestling over her heart, both claiming to have wounded or to be about to wound it, for here love is a painful, bleeding injury to the body. First, Divine Love and Cupid contend over who can hurt Rosalia most. Later an angel and a demon appear as hunters and stage a slanging match over who will bag the prey.

Most of these figures are borrowed from secular love poetry. The strange twist is that the sacred drama goes one better, taking the far-fetched ecstatic images literally. Given the awesome power of Rosalia's new companion, these metaphors need be linguistic conceits no longer,

for He can make them come true – her heart will be pierced, she will fly, and in the most awful figure of all, will retreat into her proper nest, the Virgin's womb, a regression which cancels her earthly self. *The Wounded Dove* enacts the most powerful and perverse Baroque transformation, in which self-denial (at both superficial and profound levels) becomes a complete sensual fulfilment.

Provenzale's opera ends in intense private rapture at the imminence of death, which is presented as a form of indulgence. At this stage there is a strange collaboration between Mary and Christ to seduce Rosalia. Though the opera concludes with a joyful chorus in which stars turn to flowers that drop their petals on the new saint, it remains introverted and not public or ceremonial in tone even at the end. Provenzale's work is one of the strongest instances of that Counter-Reformation paradox in which the armoury of the body is employed to enforce spiritual truths.

At about the same time as Provenzale's *opera sacra*, a new form of musical performance appeared which out-operas opera. Developed under the influence of the Jesuits, this genre known as *oratorio erotico* forgoes costumes, stage scenery and gesture, but goes further in the pursuit of extreme emotional states and lurid psychological entanglements than any seventeenth-century opera. One of the most unnerving examples, *San Giovanni Battista* with music by Alessandro Stradella, has been compared half seriously to Richard Strauss's *Salome* for its morbid fascination with perverse sexuality.

This work which lasts about seventy minutes in performance (not really opera-scale) concentrates on the relation between Salome and Herod and particularly on the strange scene-changes in Salome's mind as she carries out a seduction which starts playful and turns anguished, then sombre and finally gloating. Perhaps the strangest moment comes near the end of a long monologue in which she claims that the mere sight of the Baptist *discolours* her enjoyment of life. She fastens on the word, which the vocal line discolours most incredibly, ending up two octaves below its starting point.

Further exotic vocal blooms are produced on related themes, ornamentation at the service of the most peculiar impulses, which are whims, but whims which totally possess the personality who experiences them. Thus, after a long stretch when she has held the stage alone, Herod responds with a supportive fit of anger, like a sudden ejaculation, and they are briefly at one. At this moment the saint reappears longing for

death, so there is a weird convergence between the two sides, expressed in an agitated duet between Salome and the Baptist who both welcome his death to a driving beat. Salome triumphs, Herod experiences a kind of post-coital sadness, and the work ends with girl and ruler singing together at cross purposes. This duet ends on an unresolved chord and the word *why?*

Stradella wrote a number of operas, but *San Giovanni Battista* was reputedly his favourite work. Recently his escapades like those of a character in one of his lurid dramas have been better known than his music. He had already come near being killed by an angry husband's hired ruffians before it finally happened when he was thirty-eight years old. Perhaps the torments of the libertine are as real as the ones suffered by the devout. In any case the presence of sacred themes seems to push human emotions into stranger, more contorted forms, and sacred operas and erotic oratorios (both oxymoronic expressions perhaps) exert a special attraction on connoisseurs of Baroque curves of the emotions, and of deliberate attempts to graft religious truth on to the most outrageously profane art form.

Perhaps this offers us a clue to why the Baroque was so successful in Latin America, apart from whatever special rapport we may hypothesize between pre-Conquest and European forms, based first of all on *horror vacui* and a resulting overload of doctrinal imagery. Even before it attempts to accommodate exotic cultural material, it seems that the Baroque thrives on contradictions and flowers in those perverse enterprises which try to insert contrary motives into a prescribed format, prefiguring European genres as the medium for rambunctious native imagination. In fact the authoritarian intentions of the Baroque seldom entirely conceal its origins in anxiety and spiritual conflict. The formal principles on which it is built more easily lend themselves to stimulating intimations of primeval chaos than the establishment of classical order.

One of the most revealing depictions of the diversity and conflict of colonial society is a table-top model of the main square in Mexico City now in the Viceregal museum at Tepotzotlán. It shows powdered Spanish grandees in gilded carriages next to Indian women selling strange New World species of fruit, grain and textiles. The surrounding streets are peopled by a complete spectrum of racial types, suggesting that this was a more confused and open society than anything in Europe at the time. But what guarantee do we have that this tableau is any more accurate than one of Cecil B. De Mille's reconstructions of

street life in Imperial Rome? And yet, if no one but vulgar entertainers embark on such exercises, then to them we must turn, because these mock-ups are a way of thinking out social relations which we should not forgo from motives of scholarly caution.

A dispiriting possibility suggests itself however; perhaps the model in Tepotzotlán is derived from a single source, a marvellous eighteenth-century painting of this very scene which turns up in every illustrated account of colonial life in Mexico. It shows the passage of the Viceroy marqués de Croix through the Plaza Mayor. Small crowds are gathered along the route and a military band stands ready for his anticipated arrival at the cathedral, while normal buying and selling continue apace from the Indian stalls of the market. Can it be that this is the only detailed pre-nineteenth-century image of street life in the Mexican capital, so that we must always be sent back to the same source?

Whether or not, it deserves its status as an archetypal image. One could write an essay about costume, based solely on a detailed study of the hundreds of figures in the painting whose idiosyncratic dress is precisely registered. Likewise an essay about diet, or about public amenities like fountains, roads and notice boards. And of course an essay about class and relations between professions, trades and ethnic origins. The painting is truly encyclopedic and like an encyclopedia can be read in fragments, small pieces at a time. But it is also an appealing over-vision of its complex subject, and gives one the thrill of seeing everything all together which a text never can.

The teeming square is the social equivalent of the teeming façade which looms over it, a special kind of colonial composition which migrates most improbably from inside the church. This sequence occurs very seldom in the history of art, the transposition of indoor forms to outdoor situations, even to conceive which requires an imagination untrammelled or naive, unaware of or unintimidated by some strong proprieties. But the facts are inescapable – at a certain moment in Mexico forms derived from altarpieces turn up as façades. The retable is the Mexican form par excellence and the apotheosis of a decorative exuberance reminiscent of pre-Conquest forms. Its transfer to the outdoors is a final freakish confirmation of this special status and for us constitutes a last goodbye to Mexican excess.

One of the neatest sequences occurs at Tepotzotlán where the interior of the Jesuit church of St Martin is known to predate the exterior,

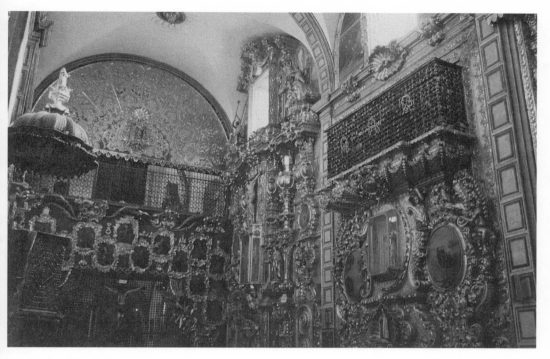

70 Retables, Santa Rosa, Querétaro, Mexico, 1770s.

and a staggering series of retables dating from the 1750s are followed by a retable-style refashioning of the façade in 1760–62. It is easy to understand the appeal of this indecorous transfer because no earlier format evolved for exterior elevations comes anywhere near the Mexican retable for concentrated hieratic richness. So there is a compelling logic for extending this kind of exuberance into the outdoors. All one needs to do is to substitute stone for wood and plaster.

The enormity and incongruity of the project can be grasped by relocating it to Rome or Bavaria. Bavarian pilgrimage churches are famous for the dullness of their exteriors. Their magic depends on the surprising eruption of the interior. Even an experienced visitor is in some sense unprepared for the explosion of light and colour, because the casing intimates something quite different. Similar, in a soberer key, are the Roman examples, also founded on the principle that insides and outsides are separate worlds not in competition with each other.

Part of the answer lies in the Mexican sun, which will light up all the variety more reliably. Sicily provides a parallel, where the Bavarian proportions are reversed and the best effects instead of being saved are squandered in the strong light outdoors; after you have grasped the façade, the building is essentially over.

By contrast, gilded retables are the final apotheosis of Mexican Baroque, which show us ornament gone wild and architecture reverting to the jungle. These constructions fill the whole end wall, pushing up to the vault and leaving the clerestory window free like a break in the trees. Individual elements look like fruits which have split their skins, or, the larger parts, like feather beds breaking out of their covering. At Tepotzotlán the main altar spreads round the corners and becomes three altarpieces in one, a forest of motifs where you can pick out a few of the saints at random, intrigued, for instance, by the Japanese martyrs ensconced in their little roundels, but also confused by the gargantuan hubbub.

Great families or ensembles of retables survive in surprising places. In the drab church of San Agustin at Salamanca the large transept altars create jutting roomlets in which to stage their scenes, topping them off with openwork crowns like airy domes. Structural elements are light and spidery, and only interrupt momentarily a slippery overall effect. The ambition to spread as completely as possible over lateral spaces creates an unbroken coating of lesser altars over the whole interior. To portray such sequences as unstoppable growth is tempting but fanciful

– they had to be paid for by someone after all. In the north, wealthy owners often salved their consciences with extravagant building projects, as at La Valenciana near Guanajuato, where the miners were regularly forced to contribute. The motivating purpose of the two convents with the best series of retables in Querétaro was similarly entangled in structures of secular power: they existed to give rich girls a place in which to follow the religious life (illus. 70).

But granting all that, in these interiors usually assembled piecemeal of parts not meant to match perfectly, there is a powerful urge to escape from boundaries and by complex alchemy to turn prosaic things like walls into something more like women's clothing than anything else. In both Querétaro convents, Santa Clara and Santa Rosa, visitors enter inconspicuously from the side, a more haphazard version of Bernini's preference for coming at one of his ovals from this angle rather than the end. It is a disorienting experience, for it feels as if the space is slipping away from you rather than lining up neatly in front.

The normal wall of entry was occupied by the nuns. There, behind gorgeous grilles, they enjoyed a frontal relation to the space, a tantalizing vision from which they were physically shut off. This is perhaps the ultimate refinement of the Baroque attempt to depict unattainable truths in grotesquely solid forms, in shells which turn into leaves or dissolve in water-veils all made of the same false glittery stuff, which successfully deceives us because it remains just out of reach.

VIII

NEO AND PSEUDO BAROQUE

FROM THE START Baroque designers operated through the distortion of classical models and norms. So that when Baroque itself proved unusually subject to distortion there was a suitable irony in it. In fact, no style has ever been so widely and irresponsibly copied or promulgated in so many unlikely new guises. To begin with, it was the first style to be diffused across the world to a wide range of non-European cultures, yet it would be vain to look for the causes of this diffusion in the forms themselves, causes which lie instead in a European hegemony to which art and architecture make their highly visible though non-essential contribution, purveying some of the same aggressive and extrovert qualities which mark European culture as a whole.

Baroque in Latin America remains a Roman Catholic style, however subverted by executants imperfectly imprinted with the creed or bent on expressing meanings at odds with it. Now we move further afield to non-Catholic and then non-Christian borrowings, and finally in still wider rings, to later, more tangential material. Seeing familiar motifs caricatured or adapted to new and not so congenial purposes can be surprisingly illuminating for students of the source-phenomenon, like listening to someone who doesn't speak your language well. Thus we might go looking for interesting mistakes by venturing out in new directions from the Roman heartland of the style.

Baroque is a more exotic implant in Russia than in Bavaria: it had to travel further and, as in a game of Chinese whispers, got transmogrified at every step along the way. There is an easy method of overstepping the complicated transmission process, which is to import Italian architects. But strangely enough this was not always as direct a route to true Baroque results as one might think. Like native builders in Mexico,

Italian architects in Russia are carrying out alien commands, with the crucial difference that their technical if not their ideological superiority is conceded from the start.

The Church of the Virgin of the Sign at Dubrovitsy not far to the south-west of Moscow is the most Italianate early Baroque building in Russia (illus. 71). It breaks the Orthodox taboo against statues and dots them defiantly about on parapets and balustrades. Its rayed and symmetrical plan has been compared to Borromini's Sant' Ivo and comes nearer to fluid Baroque space than any of its rivals. Yet it remains a gloriously ungainly freak, hamstrung by requirements of orthodox liturgy and traditions of Byzantine layout which collide almost violently with Baroque preferences. And the experts cannot tell or at least cannot agree on whether it was designed by Italian or Ukrainian architects, leaving amateurs to draw the conclusion that at this point Italian architects in Russia are quite unfree to be Italian, unable to impose imported principles forcibly enough on native forms to produce convincing versions of the newfangled mode. Who knows if better architects

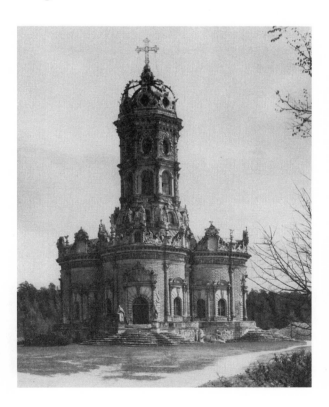

71 Church of the Virgin of the Sign, Dubrovitsy, near Moscow, 1690–1704.

might have brought this about? It is, though, a fantastic speculation to imagine that the best Italian architects would have been tempted by offers of work in Russia.

In fact, so idiosyncratic is the phenomenon called Moscow Baroque that it is usually identified as the brainchild of one man, Prince Lev Kirillovitch Naryshkin, the patron who commissioned the closest cousin of the church at Dubrovitsy, another estate church near Moscow at Fili, also of the showy pavilionesque tower-type, and dedicated to the Virgin of the Intercession (illus. 72). This building is sometimes linked to another phenomenon little known in the West, Ukrainian Baroque. It is all very logical, such a cultural chain, yet it feels too tidy, and smacks of art historians making more sense of the world than is there to be made. Early Russian Baroque is a fragile bloom, an exotic cultivated by noblemen on their estates and never comfortably naturalized. Perhaps it is equivalent to the earliest appearance of the Renaissance in England, over-dependent on engraved sources and always carrying a hint of

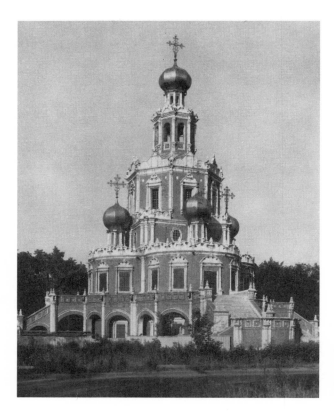

72 Church of the Virgin of the Intercession, Fili, near Moscow, c. 1693.

crankiness. Baroque in Russia remains for a long time at the stage of novelty, never fully adapted to the peculiar uses of the country.

Strangely enough, Baroque forms seem more at home in Muslim Turkey than in Orthodox Russia. Both of these cultures took their main architectural inspiration from the same source, the Byzantine buildings of Constantinople deriving in turn from late Roman examples. But the Ottomans found themselves at the centre while the Russians never lost a sense of being on the periphery. The greatest Byzantine church, Hagia Sophia, became a mosque and the model for the grandest later mosques, which are centralized domed spaces, a format followed in no other Muslim country. So grafting Baroque details on to this classical substratum proves less outlandish and causes less of a wrench in Turkey than the attempt to do the same in Russia. One of the most venerable Byzantine churches, SS Sergius and Bacchus, of approximately the same sixth-century date as Hagia Sophia, has been Baroquized by painting blue and white arabesques above the entablature which runs around the base of the dome. This imitates a coating of Iznik tiles, the established Turkish method for turning large wall areas into brocade.

Rococo forms were also effortlessly adapted to a whole other range of uses, which one could call the architecture of pleasure – diverting pavilions in palace grounds, and their urban equivalent: frilly canopies over the public water outlets, usually placed at converging points of streets and treated in far from utilitarian ways, as if the idea of water bred romance even in the humblest setting (illus. 73). If they are reminders of Roman fountains they make the institution both more architectural and more intimate, for these glorified conduits are often almost boudoir-like, screened enclosures hinting at something within.

Topkapi palace in Istanbul, for long the main residence of Ottoman rulers, suggests anything but the despotism we imagine inhabiting it. It is the most dissolved, the most thoroughly Rococo palace in the world, a loosely linked set of pavilions like a graceful collection of tents, the dwelling of a restless and whimsical ruler like some king in a fairy tale. As in eighteenth-century European complexes of similar purpose, we see here the beginning of theming. There are mirror rooms, porcelain rooms, blue and pink rooms and the crown of it all, the Çinili Köşk or Chinese Pavilion, which like the Chinese huts and Moorish tents in English gardens feeds the dream of being magically transported to a strange and faraway place, rather than of paying an anthropological

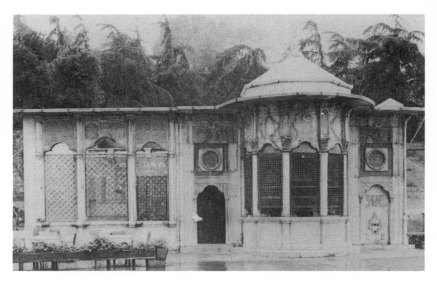

73 Haci Mehmet Emin Agha fountain, Istanbul, 1741.

study-visit. We might take it as an index of boredom, or remember that many of the inhabitants of Topkapi were prisoners who couldn't travel beyond its walls, shut in their little Rococo paradise like the porcelain in its cabinet.

Topkapi is Rococo before its time: much of the relaxed layout, so strongly reminiscent of the European eighteenth century, dates from the sixteenth. Cultural sequences can be more confusing still: Persian painting of the seventeenth century picks up what look like European traits, but it is possible they are filtered via Mughal India, a cultural eddy or cross-current which would make disentangling the influences extremely difficult. Besides, the typical situations in Persian love poetry are already near to the galante subjects of Watteau. The Persian tendency to discover mystical meanings in appliances of worldly vanity like mirrors may even find a blurred echo in Watteau. Defiantly secular subjects treated soulfully enough can provoke thoughts of the divine and, like the poet, mirrors disembody and magically transform the reality they represent. So there is a certain kinship in function and attitude between Persian art and European Rococo: miniatures end up decorating pencases, caskets, bindings, mirrorcases – the equipment of refined dalliance. Under their coat of golden varnish the tiny figures in their cartouches live a timeless existence filled with flowers, wine and fountains.

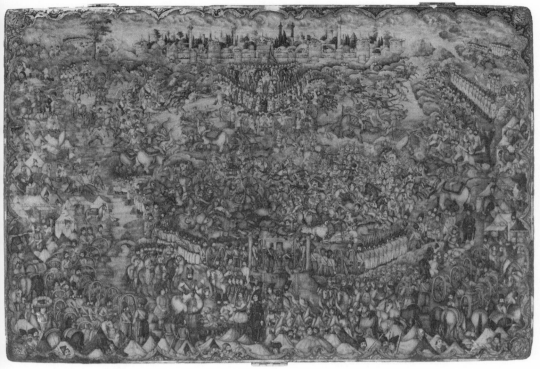

74 Muhammad Isma'il Isfahani, Box top depicting Muhammad Shah's siege of Herat, 1865.

The most surprising product of this art stuck in Rococo conventions long after they have disappeared from Europe commemorates a grisly military exploit in the same vocabulary used for ladies playing in gardens (illus. 74). On this casket ten inches by twelve is detailed the siege of Herat in 1838, in which thousands of tiny troops take part. At the side numerous captives are beheaded, elsewhere prisoners are tortured. The Afghan enemy rides in on elephants and at the top stands the tidy and symmetrical city. The entire scene is set within a scrolly Rococo cartouche, which is repeated in two sub-cartouches inside the picture formed by lines of soldiers. Around the edge of the main scene and all over the sides, window-like panels open on minutely detailed roses, irises and tulips. The little casket makes the strangest piece of would-be imperial boasting: the Shah held the city for just three months and then at British insistence released his hold. So this Rococo depiction inhabits the wrong time. It displays an event which belongs in the world of fable; one must keep within its very artificial borders to believe in it.

Another kind of make-believe appears in late Victorian architecture, as English architects searching for a properly imperial mode hit on Baroque. Self-consciousness about the British Empire finally surfaces in architecture when, unbeknown to contemporaries, the Empire is in its last days. Grand imperial projects for London and colonial capitals only occur in any number after Queen Victoria's golden jubilee in 1887. The earliest is probably Thomas Collcutt's Imperial Institute in South Kensington, apparently inspired by puffy celebratory verses of Tennyson's, then plagued by rising costs and failing funds, turned over to other uses six years after completion and finally demolished in 1946, as good a date for the end of empire as any.

The architect who discovered the right style for the end of Empire, John Belcher, never built overseas. The style he hit upon was a frivolous, witty and inflated variant of Baroque. Its distinguishing marks were a superabundance of features like pediments, domelets, columns, keystones and rustication, all treated decoratively to form a costume which the building wore. As if this weren't enough, across it were draped plentiful festoons of allegorical sculpture for which a multitude of unnecessary perches and hollows were created.

It sounds irrational and it was, the work of people who didn't believe in much but thought they would have a good time doing it. An early critic praised Belcher for reviving 'the cavalier spirit' in architecture, which should not be interpreted strictly as a reference to seventeenth-century aristocratic taste, but rather to a general nonchalance and over-confidence. Belcher's wit is coarse and his last big project, the Ashton Memorial in a municipal park in Lancaster, commemorates a fortune made in linoleum with a grandiose Temple of Fame adorned with depictions of Commerce, History, Science and Art, paved in granite and clad in Portland stone, no linoleum in sight.

Irony is not present, either, around such constructions, unless we import it. Architects like Herbert Baker evidently do not share our sense of unreality in the presence of his great hemicycle of administrative buildings for Pretoria, looking across a canal and perched atop a hill. An unexpected piece of imperial pomp turns up in Britain itself, a new Civic Centre for Cardiff, a colonial capital of a kind, won in competition by the young firm of Lanchester and Rickards in 1898 (illus. 75). It is a design of very high quality, but isn't architectural: at least, the buildings almost disappear under the sculptural frills and many of the forms would be more plausible as soup tureens and table

75 Lanchester,
Stewart and
Rickards, City
Hall, Cardiff,
1901–4.

ornaments. It can be hard to keep the functions straight. Which is the City Hall, and which the Law Courts or the Museum? A formula for public buildings has been evolved which cannot distinguish these various types; all have domes, porticoes and wings.

Public buildings and especially Town Halls were the favourite territory for Baroque designs in Edwardian Britain. The style was never applied as it had been in its Catholic and Continental heyday to churches and palaces, for it had picked up irreligious and suprapersonal connotations. The single ideological excuse for the style which seemed viable in twentieth-century Britain was an idea of public life, essentially of public pomp, which could be satisfied in no other way.

It was a reaction against the serious moral agenda which the Gothic Revival had acquired when it fell into the hands of Pugin and then Ruskin. The practitioners of Edwardian Baroque had had enough of architecture as a form of teaching. The public rituals for which they created settings were more like parties than church services, which would be loomed over by the signs of secular power, such as Aston Webb's Admiralty Arch, flaunting its Baroque concavity yet full of government offices at the same time. These were architects who could see no contradiction in a layout derived from Western Baroque for the new capital of India, or in filling a triumphal arch with spaces for bureaucrats. Such a combination of practicality and incomprehension made them virtually invulnerable in the face of catastrophic events early in the new century.

Perhaps Edwardian neo-Baroque is not a true revival. Certainly when compared with earlier nineteenth-century revivals, including even the pale vernacular echoes of the Arts and Crafts movement, neo-Baroque seems relatively devoid of ideological content. A painter like Sargent is a much more literal throwback than these architects, aiming to transpose seventeenth-century grandeur directly to the present, as if the format and even the palette which suited Rubens and Velásquez is exactly right now. No one has ever suggested that Sargent's pomp is kitsch; who could disbelieve his virtuosity or question his sitters' status?

Unquestionably kitsch are the three palaces built by Ludwig of Bavaria in the 1870s and '80s. Linderhof is a Baroque excursion worthy of Cecil B. De Mille, lacking any of the lightness or refinement which saves Rococo (illus. 76). Here fountains are gilded, variegated plants

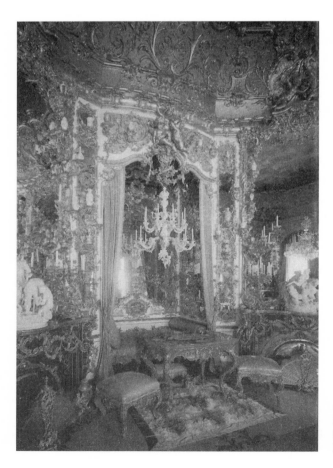

76 Georg Dollmann, Hall of Mirrors, Schloß Linderhof, Bavaria, 1874.

look like Victorian textiles and the sculptural ornament belongs in a French railway station. Kings had been vulgar before, but had they ever produced kitsch before this avid Wagnerite got the building bug?

Inside, Linderhof feels like the Great Exhibition of the Manufactures of All Nations come back to life, the curves of the furniture more curvaceous, the pile of the velvet deeper than the century before, as if intended for those unable to recognize Rococo forms without exaggeration, as if the caricatures of the theatre set have invaded the drawing room.

There is no escape, for if you flee from these claustrophobic interiors you come to the Moorish tent defacing the garden, supported by gilded palm trees and darkened by coloured glass in all its windows. In every direction stretches an alpine landscape of pines and snowy peaks among which Ludwig's cultural fantasies seem completely out of place.

In the world of popular fantasy where Ludwig's castles are at home, Baroque and Rococo have settled into fixed meanings. Porcelain is the eighteenth-century material par excellence, and so porcelain figures of later centuries will almost of necessity be wearing eighteenth-century dress and lounging languidly, singly or in pairs. The men will be effeminate; perhaps they are even playing a particular part like Cherubino or Octavian which is always sung by a woman; or it is less specific, a lazy drifting fantasy of men civilized out of their manhood.

In the nineteenth century Watteau subjects are taken over by academic painters who subject them to various improvements. His characters can be brought inside and multiplied to give a complete catalogue of Rococo costumes which all signify different kinds of idleness – old men read papers, the middle-aged play cards and the young flirt and preen, a strict distribution of roles like the finely graded posts in a modern civil service. Or left outdoors they can be sharpened into recognizable episodes of romance, a couple meeting excitedly on a garden path, or one of them dreaming at a table on a terrace. Unlike Watteau the nineteenth-century version propels you precipitately to the next step: you know what is coming so you hurry to complete the puzzle. Nowadays these paintings have outlived their usefulness except as subjects for jigsaws, as which they are more popular than better paintings, because they make these tugs on the heartstrings.

Hollywood Biblical epics, Miami hotels and American cars of the late 1950s or early '60s are also prime hunting grounds for Baroque in the loosest sense – Baroque reduced to kitsch, consciously crass and

devoid of irony. By now the cars have lost their power to hurt and become lovable holdovers like eccentric aunts who go on dressing in flashy and outmoded style when practically unable to get about (illus. 77). But they began as something more threatening, equipped with snouts and fins like rockets, which was a more serious and mysterious concept in those days. The Cadillacs, DeSotos, Pontiacs and Chryslers – their names often European- or exotic-sounding – were bedecked with a kind of tinsel – chrome – which made them glittery hybrids like Rococo furniture. Of course these cars never deliberately evoked or referred to Baroque or Rococo, but in their unclassical curvaceousness, their cartoon dynamism and their overweening scale, they followed an aesthetic recognizably Baroque. And they are kitsch if not also Baroque in being such blatant objects of fantasy, whose exterior form has nothing to do with their only acknowledged function, transport. It remains a curious fact that car interiors are decidedly less magical.

There are buildings of the same period which embody the same aesthetic, like the TWA terminal in New York, a large fantasy object in curvaceous motion, a building with fins (illus. 78). By the same theory which holds that for a car to be expressive it must not look like a practical appliance, a building must not look like a building but a whole bevy of other things, birds, clouds, or snowslides in the mountains. The designer of the TWA building, Eero Saarinen, would probably be happier with parallels like these than links to the history of architecture, where it is clear that many of his devices for suggesting movement had already been tried in the Baroque.

There is another recent instance of avoiding direct contact with the Baroque out of toughness and fear of contamination. This is the absurd penchant of current theatre directors for changing the period in which operas were located by their composer or librettist. So eighteenth-century operas will be dressed in gangster gear of the 1930s or in Fascist military garb, both particular favourites because crass but also nostalgic. It is partly pure assertion of ego – in certain moments in the history of opera, singers have ruled the roost and even brought their servants on to the stage to perform distracting functions like serving them coffee. Now the time has come for directors to assert *their* priority over the composer, the singers and the text. This phenomenon does not resemble the Elizabethan habit of staging everything in a stylized variant of contemporary dress, which did not call attention to itself but formed a neutral background. Current stage practice, imposed even by the most

77 A 1955 Cadillac
Coupe de Ville, 1955.

78 Eero Saarinen,
TWA terminal,
Kennedy International
Airport, New York,
1956–62.

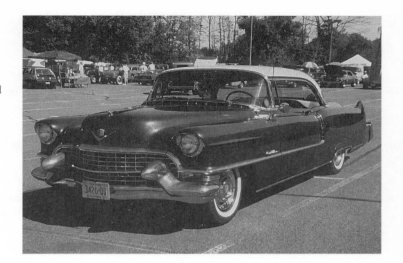

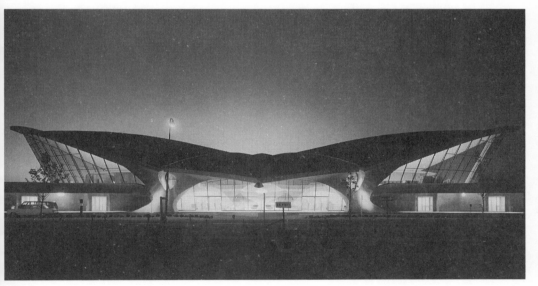

intelligent directors, imagines that it has the power to turn even Mozart
into kitsch, and thus to make the most intimidating works easily avail-
able to all. Such transposition is a joke borrowed from the Surrealists,
who generally knew better than to carry it on for three hours, by which
time the invigorating shock has long passed.

 Surrealist works like Dalí's loaf of bread amalgamated with an
Angelus pen-set and then used as the headdress of an elegant model in
eighteenth-century dress are also the inspiration for Jeff Koons's spoofs.

But the second generation is deprived of the vicious energy which powered the first. The enemy is fatally weakened, so affronts to good taste have almost no force. Some will nonetheless relish the parallel between Baroque conglomerates like the pulpit of the Wieskirche and Koons's concoctions with their flamboyant incongruities of material and context – plastic toys, fake gilt and artificial turf fused together. Like Baroque sculpture these deliberate blunderings into kitsch overstep previous boundaries to enter a new space of metamorphic change.

The earliest purveyor of kitsch in European art is probably Boucher, providing cheap but tired thrills, which only occasionally rise to the frisson of a fur-trimmed gown with plunging neckline for wear in snow and ice. We think Boucher is being silly sending girls out on sleds in outfits like that, but what if these are sly ironies at the spectators' expense like the stripper who looks at her watch in the midst of a supposedly abandoned grind? Boucher's ice-maiden winks at us, if we are paying close enough attention to notice.

Strauss's *Der Rosenkavalier* has struck unsympathetic listeners as Mozart that winks at us. The composer is known to have resisted Hofmannstal's project for an opera based on grisly Greek legend (*Elektra*) to follow one devoted to the most perverse of all Biblical episodes (*Salome*). He had had enough of primitive horrors and wanted to do a Mozart opera next. Hofmannstal's first sketches for what became *Rosenkavalier* were for something more pantomimic, a 'Spieloper' he called it, a toy- or game-like piece. It got deeper as it went on, and probably more Mozartian in combining sweetness and sadness. But this work is not recognizable pastiche such as Tchaikovsky sometimes delightfully wrote. We cannot pick out specifically Mozartian echoes, but feel as if we have been here before. Sometimes this sensation turns up unnervingly in the characters' lines. 'Haven't we felt this before?' Octavian and Sophie ask each other when well into their first meeting. Octavian is a reincarnation of Cherubino and the Marschallin of the Countess from *The Marriage of Figaro*, and Strauss's opera begins with these characters actually doing what they could only fleetingly imagine in *Figaro*, having an affair and waking up in the same bed. *Der Rosenkavalier* sets off on a risqué foot and then retreats, but the tone has been firmly set; we have entered a world governed by desire.

At least one critic has written that this is the last opera which can ever be written, because the civilization which gave birth to and supported

opera ended in 1914. To such a perceiver *Der Rosenkavalier* is the swan-song of a lost Edwardian world of bliss, which has become our Rococo, an irresponsible time of pleasure. The suggestion is that Strauss half-knew this and so expressed in this opera all his attachment to a sort of music he senses is already obsolete, as he feels Schoenberg's hot breath on his back. Nostalgia for eighteenth-century Vienna is confused with nostalgia for a music that began with Mozart and ends here, to which Strauss is saying a languorous goodbye. The Marschallin gives up Octavian and the composer gives up the world he has known.

As it happens, he never wrote another opera as lush and delectable as this and so it is a farewell to something, but not to the possibility of music drama in the future. His later operas may be even more reflexive and ironical than this, but there are lots of them. That does not sound like the later career of someone who regards 1914 as the end of civilization.

What is more, Strauss himself does not see *Der Rosenkavalier* as a tragedy of loss and advises that the Marschallin's relinquishment at the end of Act I should be played with a Viennese grace, 'one eye wet and the other dry'. This grotesque way of putting it admits that getting the mixture right is almost impossible.

From the beginning we are talking of endings: no beginning was ever less like a beginning than *Der Rosenkavalier*'s. We have intruded on people who have histories, but histories we will never learn. Octavian cannot bear to acknowledge that the Marschallin has a past, so she must suppress every memory she might be inclined to preserve. That rings true, yet contributes to the sense of these creatures as somehow evanescent and insubstantial.

When the Marschallin acts as sponsor to the young couple in the final scene, having just declared everything up to now a farce, and the three are resolved into two in a ravishing trio, we are reminded of those Mozart ensembles in which differences are harmonized without being ironed away. Strauss's trio goes them one better. It consists of three female voices, which renders it wonderfully ethereal and consistent. The different identities are hard to tell apart and melt into each other like semi-transparent, exchangeable beings.

But the opera doesn't end there, for the Marschallin leaves the young couple alone and they carry on singing. By this means we have it both ways, and the final consolation for those who are not young is to find that Sophie and Octavian, left to their own devices, are a little dull. The

world is turned over to the young after all, but we will have to wait till they are as old as we are for them to be interesting.

Strauss made a point of insisting that the Marschallin was no older than thirty-two at most, a strange claim matched by his idea that Ochs is only inwardly a bounder. He wants to smooth away ugliness but at the same time to avoid letting characters slip into easily labelled types. So it comes as a surprise to hear that some of the crowd scenes were inspired by Hogarth. In Strauss's hands Hogarth's grossness becomes exotic colour, parrots and little black servants. His eighteenth century even in its lowest reaches has more in common with Beardsley.

To careful historians Strauss's way of mixing up our own preoccupations with his portrayal of the eighteenth century is probably maddening. But exactly this living connection to post-Freudian psychology and cultural flux makes him one of the most stimulating interpreters of the Rococo. Aubrey Beardsley is a more problematic case, powerfully drawn to the period but constrained by the specificity of his private fantasies. He is more explicit in earlier series like the drawings for Oscar Wilde's *Salome* and exhibits the body in a disturbing variety of tormented postures. Moving to *The Rape of the Lock* and the eighteenth century is a retreat from nudity to clothing, and from openly predatory to more guarded relations between the sexes (illus. 79). In Beardsley, especially later on, these relations can occur within a single body: a figure may have male face and female hips, or male torso and female limbs. The eighteenth century functions as a kind of disguising decor which makes these semi-magical hybrids harder to pin down, hence less immediately scandalous.

Like Strauss, Beardsley will have none of the conventional view of the eighteenth century as rational, but he goes much further, albeit down a narrow path. Like his nudity his clothing is suggestive, and asks to be inspected for the lewd innuendo which must be lurking in it. Body parts are not in their right places – vaginas have migrated to pocket openings and penises to tightly stretched corsets which explode in lace at the neck. He was ingenious in making hands inside thick cloaks look mildly lewd or cloth bulge in places where there are no body parts underneath. Perhaps his world is not so remote after all from the Rococo conceived as the realm of tinkling teacups, because these people with the most depraved imaginations are strapped into clothing which prevents activity even while suggesting it. Imprisoned in their clothes, they thread their way among furniture which resembles

79 Aubrey Beardsley,
Illustration for *The Rape
of the Lock*, 1896.

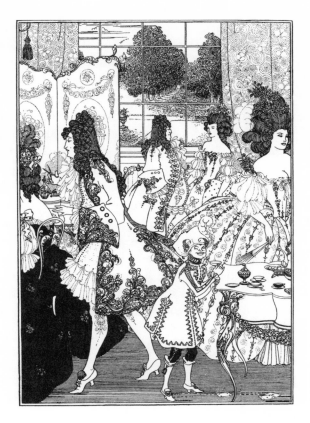

deformed creatures writing with pleasure. Beardsley's favourite eight-eenth-century scene is the toilette, where the subject sits passively, being dusted, tickled and groomed, until finally encased in a costume like a fantastic dumbshow of touching which never occurs.

Hogarth and Beardsley are opposite sides of the coin of exaggera-tion, Beardsley a fantasist not a satirist, his most preposterous joke to show his dreams taking place in society, as if his weird derangements could become social norms. Yet he can be taken seriously as an inter-preter of the eighteenth century, who puts his finger on a link between the hypercivilized and the fetishistic. Many eighteenth-century obses-sives could be collected to lend weight to this association, ranging from de Sade and Fuseli to Beckford and Pope.

As an artist Beardsley could be viewed as a case of not just arrested but reversed development, the radical who becomes effete, which is also the pattern followed by Hector Guimard, one of the leading French practitioners of Art Nouveau. Guimard began as one of those looking,

around the turn of the century, for a way out of the nineteenth-century entrapment in historical imitation. The first widely acclaimed solution to this dilemma has been known as Art Nouveau ever since. It appeared to find inspiration outside culture in the energies of the vegetable world. These sources were interpreted quite narrowly as a new linear vocabulary of sinuous curves. As in Beardsley the narrowness of the range went together with unusual intensity: writhing plant stalks resembled human limbs and often hinted at a fleshly subtext.

And the supposed escape from the cycle of styles was not quite what it seemed. The new mode appeared first in the so-called minor arts, illustration rather than painting, furniture and decor rather than architecture. To some observers it will seem a kind of giveaway that Art Nouveau furniture tends to luxurious coloured woods, to marquetry, even to metal appliqué and inlay, in other words to all the technical sophistications of the last gasp of the Rococo. And then comes Guimard's acknowledged swerve late in his career back to out-and-out imitations, to recognizable neo-Rococo, above all in his own house in Paris at no. 122 avenue Mozart (16ᵉ) where stair rails are miracles of refinement, metal hybrids which combine modern technology with eighteenth-century outlines. The result, like *Rosenkavalier*, is a deft playing at historical flavour.

The saving feature of all these high-art imitations of the Rococo is their unliteralness. It is hard to imagine anyone enjoying them fully without referring to the model, but perhaps this is a learned, even academic response which Strauss, Beardsley and Guimard would not welcome. In our own time historical reconstructions are often more literal and naive: so National Trust restaurants now serve recipes from the period of the country house in which you eat them, and you can order a Baroque meal to match the Baroque setting. Perhaps this is just an irrelevant frill on an essentially scientific carcase of theory, for the National Trust do not favour costumes and living demonstrations which animate historical settings in pantomimic and unpersuasive ways. Instead, their properties are treated as corpses, to be revered and stared at like Lenin in his tomb. This effect is not damaged by photos of the current inhabitants or samples of their reading matter, which interfere no more than the photographs of the deceased in Italian cemeteries. The key fact is that no one is *in* any of the rooms, except National Trust volunteers, who have much the same effect as finding an electrician at work on the wiring. It damages but does not contradict the illusion.

The most complete reconstruction ever attempted of a vanished historical reality was based on eighteenth-century topographical paintings by Bernardo Bellotto, who had recorded the old centre of Warsaw, destroyed in the Second World War, more systematically than anyone who has drawn or photographed the city since (illus. 80). Bellotto matches modern preoccupations in a number of ways – in his comprehensiveness and sense of the relations between parts, as well as in unusually keen focus on detail, which eliminates the blurring effect of distance on vision; beyond a certain threshold of smallness he shows what he knows rather than what he can see. His conception of the View is encyclopedic rather than strictly perceptual, and thus his images could be used by modern technicians as banks or depositories of information.

Needless to say Bellotto could not imagine this use for his paintings, now taken to pieces and enlarged, thus reversing his careful process of composition, in which he collects information and then reduces it. It is hard to guess what he would think of the attempt at exact replication. Previously, cities destroyed by war or other natural or cultural catastrophe had been rebuilt, perhaps on the original plots but never in the original form. Such reconstruction is based on a kind of formalism

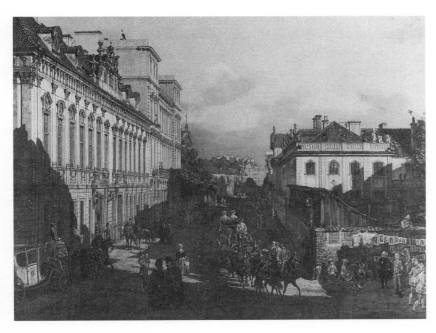

80 Bernardo Bellotto, *Miodowa Street* (Warsaw), 1767–80.

unimaginable before our century, but now widely duplicated at various scales, from entire towns (Williamsburg, Virginia) to single buildings (Art Lover's House, Glasgow). Rather than a religion of history, it often represents a total disregard for chance survivals and an outlandish confidence in the power of technique to overcome an absence of content. It is touching that the Poles could not stand the idea of the missing heart of Warsaw, but it is hard to see how they can feel at home in the Old Town they have built, which is not a reworking of Renaissance and Baroque motifs for modern requirements but a large war memorial looking delusively like a city.

Someday someone will write a piece showing how this is old Warsaw as seen through the eyes of a Baroque view painter, with some of the *raison d'être* of the View necessarily omitted. The edges of Bellotto's Warsaw have not been reproduced, though they could have been, since empty bombed space existed which could have been turned into eighteenth-century outskirts. But this would have called sharper attention to the change of meaning, even the change of place, between eighteenth- and twentieth-century city core. It has proved possible to resurrect Bellotto's parts but not his whole; only the details remain.

Reconstructions by the National Trust or the Polish government are presented as scientific recoveries by specialists, but of course they always fulfil political agendas too. The National Trust is proselytizing, in the most tasteful way, a vision of landowner's Britain, a safer, more wholesome and of course authoritarian place than we live in now. In restoring Warsaw the Communist government of Poland was authenticating itself, putting down local roots to which some observers would have queried its claim.

It is a far cry from these passionate fabrications to the irresponsible or at least loose extensions of the term 'Baroque' in everyday usage, detached from a particular historical location and meaning simply operatic, exaggerated, oversized. Hence Verdi is baroque, as is opera in general. There are baroque personalities, baroque styles of writing, baroque plots and baroque politics, intrigues or modes of dress. Here 'baroque' means lurid and probably untrustworthy. The idea is that these manifestations may be enjoyable to a degree but you should not take them at face value; not always intending to be, they are nonetheless deceptive. Among architects 'baroque' as a term of abuse often bespeaks a Puritanical mistrust of profusion and a wish for bareness. To this mentality deprivation signifies strength. One can do without decoration;

one is tough. It would be silly to complain that the term is debased by such appropriation. Name-calling and polemic are a special department of thought with different rules.

Some of these extensions embody genuine insights. One of the strangest is the application of this art-historical term to natural forms, as if they embodied the sort of intention found in art. Kinds of marble and bloom seem to echo Baroque designs: there are natural structures with curved, twisted, broken or mottled shapes and textures which match Baroque conceptions. There is even an object occurring in nature from which the term Baroque may be derived, a kind of misshapen pearl which had probably been discarded many times before someone recognized its possibilities, after which the so-called Baroque pearl, lumpish and embryonic as if a force moved within this bulging skin, began to figure in elaborate jewels, where it formed the body of an animal, some of whose finer features were more clearly modelled in metal.

The search for the origins of the term has so far been inconclusive but the two best candidates as sponsors of 'Baroque' are this obscure mineral freak, the baroque pearl, and a certain twist or turn in scholastic logic. Both sources identify a distortion of straightforward form as the crux. That seems as far as we will get in trying to learn about Baroque by exploring its linguistic roots. Incidentally, Rococo, another word hard to pin down etymologically, has also been traced to a production of sea creatures, rocaille or shell-work.

If it is hard to track 'Baroque' to its source, it proves equally difficult to keep track of its progeny. Almost every complex artistic development will eventually be credited with a Baroque phase, or so it seems. One of the most unlikely, to a casual glance, is the so-called Japanese Baroque, lavish, short lived and uncharacteristically gaudy. Its appearance is sometimes explained as a nouveau riche backlash against the prevailing austerity of seventeenth-century Japanese architecture. It is sponsored by military strong men, upstarts in competition with the older aristocratic families. In truth its decorative excess and lurid jumbling of materials are startling in the Japanese context and appear to come from nowhere, sudden mushroom growths. The complex eaves familiar in earlier wooden buildings are now embellished with gold foil and bright-hued lacquer, in busy forms representing clouds, sea spray and blossom, close to Bavarian iconography of a century later (illus. 81). The overall effect resembles European Baroque in multiplication and crowding of motifs and in complex luxurious finishes, including lots of

81 Kara-mon (Chinese gate), Tosho-gu, Nikko, Japan, 1634–6.

gold. But whether the route to this result is anything like the European development seems questionable. Thus the term 'Japanese Baroque' will not further our understanding of Japanese architecture unless we use it only to discard it later.

When the art historian Henri Focillon labelled late Gothic architecture 'Gothic Baroque' he was diagnosing an illness. He saw the elaborations of late Gothic as perversions of architecture away from its true intellectual and structural purpose towards painterly and decorative goals (illus. 82). The illogicality and delight in illusion of late medieval buildings fill him with horror, but others find these same qualities in earlier Gothic. For Focillon the history of architecture follows a pattern familiar in the life of most natural organisms – from birth to vigorous youth to maturity to decline, decrepitude and death. But in culture the progress is not neutral, even if it is inevitable, so for Focillon as for Ruskin, it comes loaded with moral import. In his view, as they grow

82 Saint-Vulfran, Abbeville, begun after 1488, detail of the west front.

older, cultures lose their way and succumb to moral degeneracy. Thus the spirit of fantasy which rules in late Gothic reveals a weak grasp on reality and a childish hearkening after flattering falsehoods.

Focillon does not justify his coinage 'Gothic Baroque' in detail. It is a kind of oxymoron or two styles in the place of one. So as well as the

213

idea of relentlessly logical sequence which it contains, there is a whiff of delicious absurdity in the term. At certain points Focillon even talks of Romanesque Baroque, for which the signature motif is twisted colonnettes. 'Baroque' is the marker he throws down when anything is too much for him; in his model every development has a degenerative phase, and Baroque is its name.

But the model is defective and the development from simple, logical and harmonious to over-elaborate, illogical and anguished is not the single recurring pattern in culture that Ruskin, Spengler, Focillon and others would have us believe. A development nearly the reverse of this is probably more common in the careers of individual writers, painters or architects. And in English Gothic, the progression from Decorated to Perpendicular does not match Focillon's model. Even the alternating rhythm between classic and romantic phases, a simpler version of recurrent sequence than Focillon's, often falls foul of the complexity of individual examples. Focillon's analogies with the body are inadvertently revealing: this process of decline or corruption is a subjective projection, throwing inner experience on to large historical process and thereby humanizing and even individualizing it, making it not only graspable but sympathetic, resonating with the vibrations of our emotional life.

In the troubled period of transition from Ming to Ching eccentrics and deviants appeared among Chinese painters, who favoured stronger, more violent composition and a bolder, more fractured technique. The appearance of painters such as Kung Hsien and Chu Ta marks a clear break with tradition, their work more dynamic and impinging than anything previous (illus. 83). It was firmly lodged in my memory that this phase was called Baroque by modern scholars, a memory I can trace to a large exhibition I made a special trip to Cleveland, Ohio to see. But looking at the catalogue again, I cannot find a single mention of Baroque, so the term must have been a private way of understanding this development which was both expansive and hermetic. All revolutions are like each other, and attempts at new directness bring new sophistications in their train – such beliefs underlay my labelling.

Now I would put my Chinese Baroque together with Focillon's Gothic Baroque as aberrations of thought which might cause someone to look again at a familiar phenomenon and to appreciate its oddity more fully, but which do not deserve to become reusable terms. They should appear and disappear like metaphors in poems.

83 Chu Ta, 1625–*c.* 1705, *Mynah Birds and Rocks,* one of a pair of hanging scrolls.

Among all the readings backward or outward of the concept of Baroque to other settings than seventeenth-century Europe, one holds a special place. Although Hellenistic Baroque was not called that in the second century BC, there is a sense in which the Hellenistic phase is precursor, source and model for Borromini, Cortona and the rest.

First of all come a few striking monuments scattered around the edges of the old Greek world at Didyma, Pergamon and Petra, monuments grotesquely large and muscular in their proportions, scenographic in their relation to the spectator, and violent or importunate in their expression, presenting writhing figures on façades or forests of columns to be waded through, so that the exact point or plane at which the building or the sculpture begins becomes difficult to determine (illus. 84).

Individual cases seem very strong, yet the overall narrative is in doubt. Survivals are spotty, dating those survivals is uncertain, and besides, much evidence contradicts the simple three-part model: exuberant Baroque followed by lighter Rococo and then by a sterner classicizing backlash. Contradictory modes exist together, and archaizing revivals complicate the picture at most stages. If no simple historical

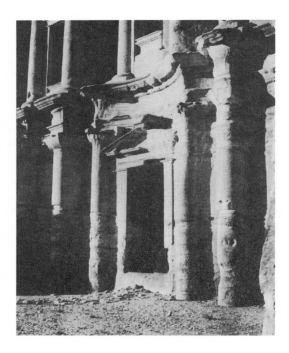

84 Rock-cut tomb of the Deir, Petra, Jordan, early to mid-1st century AD.

pattern is credible, at least we have a few strong instances of Greek sculptors and architects fascinated by and practising the principles we call Baroque, favouring bold chiaroscuro, disorienting asymmetries, exaggerated contrasts, decorative and expressionistic use of formerly structural elements. Like seventeenth-century Baroque their work calls familiar orders in question, replacing them with subjective and perspectival vision. As with later Baroque we are not sure how far to push the implication of an individualist, even relativist viewpoint as the generating force behind these changes. In vastly different social and political settings, separated by two thousand years, we find a sequence in art we recognize as the same. It is unnerving to say the least.

Heinrich Wölfflin meant to include classical Baroque in his *Renaissance and Baroque* of 1888 but left it out at the last minute because it would have made the book 'too weighty'. Wölfflin's book is the first attempt at a systematic account of the Baroque, yet it is a strange and idiosyncratic growth. He was a pioneer in more ways than one and is sometimes cited as the inventor of the detailed visual comparison made possible by simultaneous projection of two slides. This focus on the particular, which arose from his teaching, is a marked feature of his later, more famous *Principles of Art History*, but we see it already in *Renaissance and Baroque*. The most bizarre instance is the Gothic vs. the Renaissance *shoe*, from which Wölfflin derives opposed ways of standing, stepping, moving and being in the world. There are Gothic and Renaissance bodies, physiques, postures, all detectable in these pieces of footwear. He gives beguiling pictures of two world views converted to bodily gesture. But this instance is a caricature of his method. He has read his experience of Gothic naves and Renaissance domes into the shoes of the respective periods, hugely overflowing the measure in arguing the continuity of all manifestations of human culture.

Wölfflin believes that he is at home in the Renaissance and repelled by Baroque, but his book shows otherwise. It begins by saddling itself with various arbitrary constrictions of the field: the only real Baroque is Roman, so no other kind will be considered. He is principally interested in the transition from Renaissance to Baroque, so he will end his account in 1630. Anyone could tell him that in drawing the boundaries this way he has excluded most of the liveliest material, including Bernini and Borromini. Their names creep in from time to time but they never receive his full attention. And, finally, although Wölfflin turns first and most naturally to painting, and though the kinds of meaning he

85 Wölfflin's Baroque:
Façade of Santa
Caterina dei Funari,
Rome.

thrives on are easier to uncover there, his book will concentrate on architecture.

Wölfflin does not greatly like the works he has chosen, church façades by Carlo Maderno and Giacomo Della Porta (illus. 85), and who would? But we can deduce what their fascination is for him. As he reads them, they are architecture striving inappropriately towards the condition of painting, blurring individual elements by superimposition (overlapping pilasters), fudging boundaries by multiplication (double cornices) and generally concentrating on effects of light rather than forms. So they embody an interesting impossibility, quintessentially solid objects trying to disembody themselves.

We have caught him at the trick of the shoes again, reading back into stolid early examples the exuberant excesses of the next generation. As a writer Wölfflin is naturally Baroque, contradictory, lopsided, best in intense moments which are sometimes hard to square with the general theories. Repeatedly he calls Renaissance effects 'happy' and Baroque ones, if not anguished at least strained, in pursuit of the unattainable.

His own project too is inharmonious and doomed to incompletion, founded as it always is on contrasts between incompatible quantities (Renaissance and Baroque) and hence falling often into negative description, a vocabulary of dissatisfaction. Some of his most suggestive remarks are among his most exasperated – Wagner as a recurrence of the Baroque, or Palestrina as producing legitimately the same effects that are suspect in Bernini. In such moments it is a book which escapes from the constricted space in which it has penned itself up.

Later commentators like Wittkower and Blunt never mention Wölfflin because even in his narrowest moments he is too broad for them, or because whatever his uses once, they feel he has been superseded. But in expositions like his brief account of how architecture is corporeal Wölfflin has put it better than anyone since. And again, on the problem of how single instances and large concepts fit together in the history of art, his usefulness is certainly not exhausted.

If we call Wölfflin the first theorist of the Baroque we may find it surprising that he appears at least a hundred years after the end of what he is studying. Earlier commentators who use the word Baroque more or less as we do (Winckelmann one of the first) are uniformly negative in their estimates of the corrupt, diseased, impudent seventeenth century. When German theorists coming after Wölfflin, like Hermann Baur, take a more positive view, they link Baroque with Nietzsche and the irrational, or with Gothic and romanticism, an association which would have astonished Ruskin.

Of course it is an exaggeration to call Wölfflin a Baroque writer. However much he reproduces the blurred, unattainable effects he analyses, however much he immerses his readers in the boundless experience of certain works, he aims to take us with him to his conclusions. He accepts that a book is an attempt at communication. A recent ambitious treatment of the subject does not operate within such conventions. Gilles Deleuze's *The Fold: Leibniz and the Baroque* is a much more profoundly Baroque performance in one of the earliest senses of the word, a codification of the bizarre. It begins more like a fantastic animated film than an argument, evoking strange spaces which take place where? And when? In what was called in science fiction of the 1950s, outer space.

A concept is quickly introduced, the Fold, which will be obsessively reiterated but left doggedly undefined. Is it the single key which will unlock the Baroque? Is it even (this seems a real possibility) all there is to the Baroque? If we think it will be tested by reference to particular

cases, we are wrong. This will happen before the end, but not now. The third chapter called 'What is Baroque?' does not have an answer. That finally comes unheralded when we have given up expecting it, in the last chapter of all.

True, there are occasional proper names or fleeting mentions of recognizable Baroque types – painted ceilings, domes, allegories – but these are tiny glints like exotic fish in an aquarium lit from underneath. Sometimes the reader wonders if the ideas are really as mysterious as they seem. 'The Fold is always between two folds,' we are told towards the unusually mysterious end of Chapter 1. Puzzled out, does that mean any more than 'This phenomenon continues on either side'? Dozens more examples could be produced. 'Baroque perspectivism is not a variation of truth but the truth of a variation,' is one.

It is easy to say that something could be said more clearly, but can one ever be sure? Deleuze certainly believes that losing the reader is productive, and that having no idea where one is can be an illuminating experience. I have not located and I do not know if one can, what the primary subject of this book is. Is the author using art to illuminate science or vice versa, or both at once? Would Deleuze pretend that one can't really tell them apart? Only near the end does he admit that Leibniz's relation to Baroque is problematic. Mallarmé's, on the contrary, isn't. Nor Stockhausen's nor Carl Andre's. These are all great exponents of the Fold and hence, inescapably, of the Baroque.

When he names painters – it is always painters and never architects for some reason – who are Baroque in the standard sense of the word, he generally gets it wrong. El Greco, Tintoretto and Caravaggio – those are his idea of the central Baroque painters. There will be a dazzling or baffling concept – like *inflection* – and when it is specifically applied, the poles are incorrectly aligned: Klee is Baroque, and Kandinsky Cartesian, according to Deleuze. The more specific he is, the more embarrassing – the *law of the cupola* turns this feature into the apex of a cone and then into a model of the world, an example of forcing your cases to fit your concepts.

The Fold reaches a negative fulfilment in the last chapter when Deleuze finally puts his cards on the table and traces *folds* in specific kinds of painting and building. Then we find out that he really means things like folds in clothes, and he seems more and more like a mad person I know who has discovered the key to the universe in car licence plates, from whose randomly grouped letters and numbers he receives messages meant just for him.

Deleuze may have chosen the Baroque because it seems unusually malleable, and its boundlessness lets one read or import foreign material into it. At one point he calls it the abstract art par excellence and smuggles in Dubuffet and some French painters of the mid-twentieth century, 'great modern Baroque painters' whom we are not likely to have heard of. One can say in Deleuze's defence that in some sense Baroque invites this kind of treatment and thus to some degree deserves what it got.

In the history of interpretations of the Baroque, Wölfflin represents the normative or Renaissance stage in which it still remained to make an initial survey of the field and to frame a definition which would clarify a topic relatively unknown. Arriving a hundred years later, Deleuze enters a terrain where Wölfflin's formulations are part of the debris which needs to be cleared. His deflected vision resubjectivizes the material and gives a Baroque twist to interpretation of the Baroque. In part of course he is coopting Baroque concepts to apply them in the present. At the end of the century we occasionally hear that we live in a Baroque age, meaning that rules of taste are impossible to enforce and forms have gone haywire in various arts – but from lack of conviction rather than revolutionary enthusiasm – and that much of culture smacks of theatre. The old name gives the confusion of the present a shape, but a dispiriting one: we have been here before.

BAROQUE IN THE
TWENTIETH CENTURY

AT ONE EXTREME we have Gilles Deleuze, whose eccentric book
on the Baroque mentions more twentieth- than seventeenth-century
figures; at the other extreme, Anthony Blunt, whose strict intellectual
propriety objects to all straying beyond boundaries and denies that
there is any such thing as a Roman Rococo, let alone twentieth-century
versions. For Blunt, adopting such a coinage confuses chronology,
importing later, exotic ideas back to the starting point of the Baroque
and undermining its primacy. Others will like the idea of such reversals
of cultural flow and can cheerfully set off into the deliberate anachronism
of calling later work Baroque.

A strong inhibiting factor in the search for twentieth-century
Baroque is early Modernism's clear-out of superfluous detail which still
inspires in many architects a strong distaste for the Baroque. But the
effort of finding current avatars of the Baroque frees our relation to
the whole structure of history, and so it is worth persisting. Nothing is
ever quite repeated, of course, but odd resemblances in the present can
help us understand what Baroque has been and will yet be, for as the
distance between us and the seventeenth century lengthens or shrinks,
and as we juxtapose Hans Scharoun or the Czech Cubists to the Baroque,
the whole concept grows and changes.

At a crucial moment Picasso was inspired by African sculpture; but
for the Czech Cubists the key source was Central European Baroque.
Picasso sought to extract raw energy from African objects, ignoring
their local meaning and functions. Likewise the Czech Cubists sought
to rescue the dynamism of the Baroque from its local doctrinal content.
There are, it is true, Cubist settings for Baroque street sculpture (illus. 86)
where the relation is explicit – jagged Cubism vs. curvaceous Baroque –

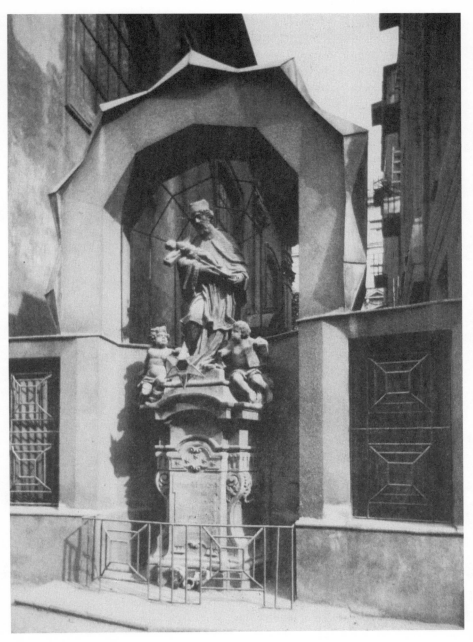

86 A. Pfeiffer, Cubist frame for a Baroque statue, Spálená, Prague, 1912.

but usually the process of abstraction has gone further and the Baroque influence is harder to recognize than African traces in Picasso's work of 1906–7.

The relation between the dynamic effects of the Czech Cubists and the structure of the building does indeed parallel a similar relation in the Baroque. Expression and structure are barely connected, although one is supposed to feel life pulsing through the whole fabric. The Cubists reinterpret Baroque buildings as living material which violates the usual rectangularity of architecture, not for aesthetic ends alone, but in a deeper ideological quest. So their own hard, crystalline forms, so different from the frothy and momentary substance of Bavarian Rococo, have an almost opposite intention from similar-seeming motifs in Le Corbusier or De Stijl. Though stripped bare, the Czech work is imbued with organic mysticism.

To some observers this mysticism sits badly with Cubism's superficiality, shared with the Baroque. They would be happier if Czech Cubist work became more serious or at least more literal in its violations of rectangularity, and made ceilings slope more violently to suggest the alien geometry of eccentric organic compounds. Going that much further, one would still come up against the barrier of usefulness, which inevitably conflicts with expression in architecture at some point, however well one hides the joint. In the seventeenth century this conflict was generally ignored, and in fact, the Modernist wish that there should be no conflict between structure, use and expression can only be satisfied in any period by drastic suppressions.

Czech Cubist architects imagined that they preserved the spirit of Baroque without its timebound trimmings, but to some observers their work looks like parody. Perhaps any reinterpretation will seem parody to literalists, who take offence at any attempt to reimagine the original. The Baroque itself is one of the great ages of parody. Sometimes it almost seems that every Baroque work is a kind of fantasia on an earlier model, produced by a fundamentally irreverent intelligence – irreverent, but still tied to the model, for the fantasia is a free variation on a familiar theme or form, freer than parody to depart from the original which it mocks or nips at the heels of. There's often a hint of childishness about the more aggressive but more constrained parody. Some of the most obvious parodies are brash youthful works, like Tiepolo's version of classical myth as slapstick (illus. 87) or Handel's reinterpretation of ancient history as farce, which can be delicate or gross according to how they are played.

Borromini would not thank you for reading all his works as ironic send-ups of classical forms, as if mockery and destruction were their main components, but Bernini professed to believe that his rival's designs were based on heretical disbelief in the intellectual and moral foundations of architecture. Although Bernini's own architecture and interior decor (for St Peter's and other sacred settings) is much less odd, it also undermines earlier consensus in startling ways, by making spiritual truths too readily available to human senses.

Bernini is one of the first and will not be the last to accuse certain Baroque designers of crossing a dangerous border which can never be uncrossed. Baroque marks the beginning of a long decline in which one slick appeal to human susceptibilities after another is allowed, each more degraded than the last. In the Baroque, artists began to think of creating a sensation, a shift which now seems obvious, but was then an option which had remained unavailable since late classical times.

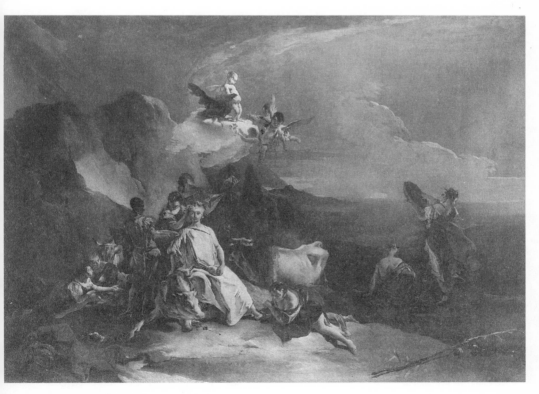

87 Giambattista Tiepolo, *Rape of Europa, c.* 1720.

This attack on Baroque sounds like Ruskin, who preached something similar and tormented himself with categorizing the Baroque façades of Venice according to the failing each particularly excelled in. Without doubting that Ruskin really did hate the Renaissance – and all his worst instances of Renaissance we would call Baroque – one can note his fascination with it. Ruskin's highest flights often take off from contrasting material, as when he comes at St Mark's by describing an English cathedral and then the squalid crowd which clusters round the portals in Venice.

One might say that the English cathedral is Ruskin's past, of which he works himself free in Italy, and that the beggars and shrieking children are his own demons who block his entrance into art, and whom he can sometimes evade for an hour or two. Ruskin is not the only one for whom the Baroque fills this kind of function, representing a disorder both sought after and loathed.

Like any dominant mode, Baroque eventually attracted plenty of insincere practitioners, designers who treated it as a set of conventions and no more. But even in its heyday we will still find those for whom it remains authentically the theatre of private struggle. In the mind of Giovanni Santini all the styles of the past, of which Baroque is only one, seem to have equal status. Not that he unscrupulously picks and chooses among them as Robert Venturi is able to do, but he seems capable of designing either a Baroque building in misleading Gothic dress or a Gothic building whose details are all Renaissance (illus. 88). What he finds difficult or uninteresting is to produce a straight example of any of these types. He is the ultimate practitioner of Baroque as a mode of distortion, where recognizable cultural references are wrenched from their context and recombined in a cartoon or caricature of Gothic or whatever else. This new self-consciousness makes the architect himself the subject of the building, a condition which has grown much more familiar to us since then.

He is nearer to us than the nineteenth century, through his free, ahistorical relation to the past, which makes him closer kin to Eliot's *Waste Land* than the scrupulous Gothic Revival. Like Santini's buildings, set in the history of architecture, Eliot's poem takes place in the history of literature, or in a mind so invaded by that history there is little space left over for any thoughts of its own. The whole idea of 'one's own' has been blown to bits and the poem is the aftermath of the explosion.

When one thinks of 'Baroque' impulses in modern literature one is

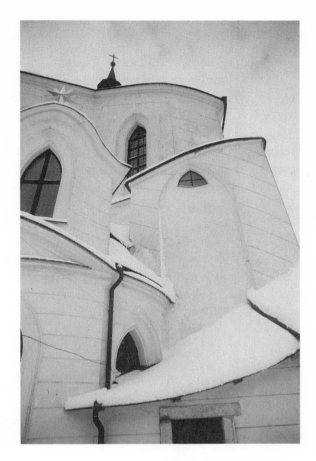

88 Giovanni Santini,
Cemetery chapel, Zdar,
Moravia, 1719–22.

on shakier ground than in architecture, reduced to calling up amusing pranks like John Barth's *Sot Weed Factor* or Thomas Pynchon's *Mason & Dixon*, rather than more adventurous encounters with the past like Eliot's or Joyce's in *Ulysses*. The truth is that the idea of the Baroque is still most at home in the visual arts, so that even writers like Milton are not *exactly* Baroque but *like* Baroque by a kind of metaphorical extension. Thus, in calling seventeenth-century writers Baroque one is already making the leap one makes in calling twentieth-century architecture Baroque.

There are current architects whose work is a kind of rewriting, or collaging of references to previous forms like the quotations in *The Waste Land*. Watching them at work we see the burden of history wrestled with and overcome in a violent rejection which works like a vaccination, introducing poison to provoke vivid resistance. This is architecture as

commentary, which stands to early Modernism as licentious Baroque
did to sober Brunelleschi.

Frank Gehry first came to wide public notice through the strange
transformation which he performed on an ordinary suburban bunga-
low in Santa Monica (illus. 89). Gehry has said that when he first saw
this house, found by his wife, in its unaltered state he knew he couldn't
live in it, and would have to do something to it. What he did has no exact
precedent in modern architecture, though Kurt Schwitters's *Merzbau*,
a tormented insertion in an existing structure (illus. 90), and Gordon
Matta-Clark's surgical attacks on buildings scheduled for demolition
provide suggestive parallels (illus. 91).

Gehry encased the house as found in a strange outer layer which
made it look as if the building was exploding or decomposing. Energy
had been let loose which could not be controlled: steps spilled helter
skelter from the entrance, windows heaved themselves and became
giant cubic solids barging drunkenly through the walls, upper bits
turned to gas, crudely rendered in chain link fence. The result was
violent but also diagrammatic, aggressive yet highly intellectual. The
more one looks the more obvious it becomes that the attack is carefully
calculated: for one thing the violent acts, though made of raffish materials
like raw plywood and corrugated metal sheet, are carried out in pure

89 Frank O. Gehry's house in Santa Monica, California, 1977–8.

 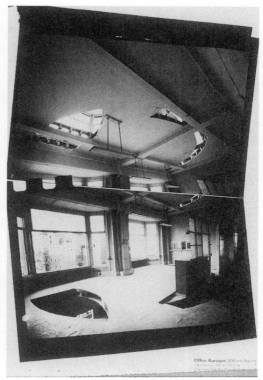

90 Kurt Schwitters, *Merzbau*, Hannover, *c.* 1923–36. 91 Gordon Matta-Clark, *Office Baroque*, 1977.

Modernist geometry. The same paradox creates the excitement of Matta-Clark's work, destructions contrived by the intellect to reveal the maximum amount about the workings of the organism under attack.

Gehry's results do not look Baroque in detail, but his goals are Baroque – to impart movement and through perspectival play to set up spatial illusions, subverting the vocabulary of conventional forms while more or less leaving it in place.

Borromini can also be seen as a destroyer of simple forms, surgically altering the profile of pilasters, creating false impressions of precariousness, or jamming elements as if they have been concertinaed by some hostile compressive force. He often uses materials in alarming ways, treating brick sculpturally in the Oratory or juxtaposing it awkwardly with marble in Sant' Andrea.

Gehry's fascination with incompleteness, which led him to strip existing interior walls or to leave external surfaces unclad like flayed

anatomical models, is a literalized form of Baroque animation, which was formerly realized through sculptural decoration or elliptical spaces which seem non-axial from many perspectives.

Apparently models remain a key part of Gehry's design process from early to late. He made countless little models of the famous kitchen window in his own house, a kind of sub-building within the building, at war with the host. By the time we get to the Guggenheim Museum in Bilbao of 1993–7, the scale and purpose of the project have changed dramatically, but we are told that it too began with rudimentary sketches and a series of models.

Then at some point these constructions are transferred to computer and manipulated on a three-dimensional modelling program which determines dimensions of cladding elements and spacings of the structural frame. At this point the word fractal first appears to describe the odd curves of the external skin. It has been said that you couldn't work out how to build this design without the help of computers, but how can this be so? Isn't it rather that the computer has been given the boring bits? One result of its labours, the largest interior at Bilbao, a gallery 130 metres long, feels more like a conventional Baroque space, where roof forms become clearly ornamental, perhaps because the computer has prescribed a series of them, so that an odd contour appears repeatedly in a way one cannot imagine in early Gehry work. Forms are soft now, but their replication feels heartless.

External volumes search for a personal signature. The large flower or firework in titanium which sprays its giant petals so memorably on to the gritty skyline of Bilbao bears an interesting relation to Claes Oldenburg's send-ups of monuments in the form of enlarged everyday objects. Gehry's surprising superstructure is an abstract rendering of one of these electric fans, matchbooks or popsicles (illus. 92). Its huge expressive shape sits atop a semi-submerged and would-be-invisible base full of necessary spaces, from which it effectively distracts us, like the elaborate Baroque façade which hides a plain box behind. We are meant to think that this gigantic cultural institution can be summed up in a metaphor, a single congealed flutter of excitement. If Borromini is the natural parallel to the earlier Gehry, one of the overpowering silver-clad altarpieces in the Gesù in Rome is the proper mate to the later museum.

In spite of the movement from the subversive to the honorific, certain motives and goals remain the same, impatience with stable and

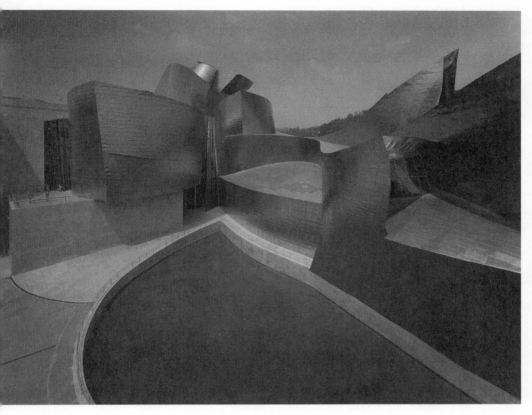

92 Frank O. Gehry & Associates, Guggenheim Museum, Bilbao, 1993–7.

regular forms, and the building as an explosion which transcends the
ordinariness which surrounds it. We have watched these leanings become
conventionalized within the career of a single practitioner, but it is a
familiar observation that the stylistic evolution which formerly took a
generation or two is now condensed in the volatile sequences of one life-
time or even a part. Gehry's open-ended phase lasted only a year or two.
His museum at Bilbao depends on sophisticated illusionistic devices like
anamorphism, in radically foreshortened titanium-clad masses, fun but
arbitrary. The shapes are stranger but the execution more monotonous,
reminding us of Baroque freaks like buildings in the form of giant letters
of the alphabet. The freak is one end of Baroque production, often of a
relatively useless type like the garden pavilion, which is glaringly unlike
any other building. Gehry has gone from buildings unlike other buildings
to insignias unlike other buildings, an easier brief to fill.

Partly through new technologies and partly through the breakdown
of cultural structures it has proved possible in the late twentieth century
to go further in Baroqueness than anyone wanted or dared in the seven-
teenth century. Baroque flirtations with chaos were less literal than
current ones, of which early Gehry is neither the most radical nor
bizarre, though it may be the most authentic.

In the early eighties a practice in Vienna which named itself alarm-
ingly or facetiously Coop Himmelblau, did a number of conversions of
stolid nineteenth-century buildings in the staid capital, inserting violent
Baroque vectors in a sclerotic older fabric. These satisfied a surprising
range of functions – night clubs, artists' studios, lawyers' offices. It was
work which looked even more radical because instead of sweeping
away the moribund nineteenth century it landed on top of it or sliced
through it, among the most pointed instances ever of architecture as
critique (illus. 93).

This degree of open antagonism, performed as on a hastily erected
stage, has no parallel in the Baroque, which raised its temporary erections

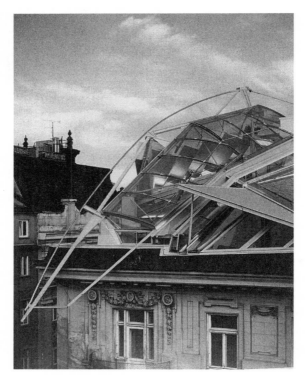

93 Coop Himmelblau,
Rooftop conversion,
Vienna, 1983–8.

but took them down afterwards. In twentieth-century versions, both in revolutionary Russia and unrevolutionary Austria, there seems an optimistic dream afoot that new architecture could really transform the world. Coop Himmelblau began in the Utopian or half-crazed 1960s when fantasies of teenagers taking over the world had a short moment of plausibility. Perhaps their name is meant to conjure up impossible hopes, 'the sky's the limit', as if one could actually live in the never-never land of a Baroque ceiling.

Coop Himmelblau began with large inflatables which filled the sky overhead for a weekend and gave a small or large, but temporary, crowd the illusion of living under a new, much looser dispensation. However laboured some of their later work might seem, there remains a kernel of belief in the metamorphic design which changes lives. A kind of magical transformation is even included in the design process: each project begins with drawings done blindfold or without looking, a method which produces predictably scrambled, unarchitectural results. Then a laborious translation begins, converting the scribble into structural members which make sense without losing the overall feel of nonsense. In one way it is a charmingly elaborate method of keeping intact a Baroque exuberance. Beginning in spontaneity it travels through vast stretches of responsibility with the final intention of enshrining spontaneity for ever. Necessary constraints of production outwit the desired unruliness even at the beginning. 'Naturalness' operates in a small contrived opening, a single injection which sets in motion a more methodical follow-up. The system is as natural as the 'juice drink' which has twelve per cent 'real fruit'. It takes place in the land of Baroque illusion.

If Frank Gehry and Coop Himmelblau are Utopian at certain points in their progress, it is a vision which has detached itself from large social projects and turned into non-partisan dramas of space. Important among Gehry's predecessors were some Russian architects who blossomed briefly in the 1920s and became convinced that new architecture could construct a new life. Much energy was poured into defining new institutions of the Soviet era as new building types, particularly communal housing with shared cooking and laundry facilities, and workers' clubs, the most modest and workable of a series of new monuments to labour.

It seemed obvious to most of these Constructivist architects that the styles and planning formulas of the past should be jettisoned. The most interesting of them, Konstantin Melnikov, therefore converts himself rather abruptly from a Romantic classicist to a hard-edged Modernist.

But even in his most radical period, preliminary sketches for many projects show him playing with swirling symbolic forms he later edits out. These forms constitute a gigantic architectural graphics which recurs in Melnikov's work at all stages, purified of obvious narrative content in his best designs.

In the series of workers' clubs built after his return from the Paris exhibition of 1925 where his stunning exercise in lightweight dynamism had housed the Soviet exhibits, a precarious equilibrium is achieved between Melnikov's Modernism and his hankering after monumentality. His interpretation of the purpose of these buildings leads him to something like Baroque dynamism. The clubs are celebratory structures, but celebrate social upheaval and inversion: formerly the lowest tier, ordinary workers are now given palaces, but palaces inculcating new attitudes and grooming users for new roles.

As in Baroque palaces, grand entrances often introduce the clubs, approached by curving stairs which allow partial perspectives on the structure to come (illus. 94). The purpose of such entrances is not to awe but to energize, giving the climber a taste of activity. Plans of the clubs incorporate pie-shaped segments of circles which suggest, as in Lissitsky's well-known graphics of the time, a piercing thrust rather than formal stasis. The resulting interior spaces are seen jutting out over the street, violating steady vertical walls. Here the anti-classical subversions of the Baroque are combined with a social programme subversive of the old order, extremely rare in the history of responses to the Baroque.

Of the few which exist, the most interesting later convergence of Baroque spatial dynamism and the social responsibilities of architecture occurs in the work of Hans Scharoun, a German whose work received a crucial negative stimulus in the Nazi period, from which it emerged profoundly changed and if anything even more Baroque.

Scharoun's last important work before the Nazi clampdown on modernism was a house for a factory owner named Schminke in Lobau in what became East Germany. Because of its location it has been somewhat out of reach for Western observers and has thus become fixed in old photographs which emphasize open stairs from high terraces to the garden and give a picture of a certain kind of life rather than of an architectural language. Stair and roof are played against each other, and turn in different ways. Inhabitants are encouraged by this movement in their surroundings to follow momentary impulses, changing direction like these routes (illus. 95).

94 Konstantin Melnikov, Sketch of the Svoboda Workers' Club, Moscow, 1927.

95 Hans Scharoun, Schminke House, Lobau, Germany, 1932–3, exterior stair.

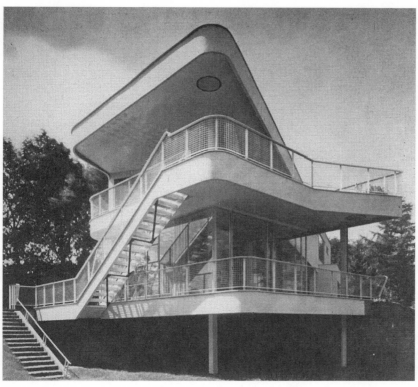

The main dynamic device in the Schminke house is the diagonal, which keeps reappearing, in the main internal stair and also in the end walls, which frame the whole living space but are clearly set against the main axis. Here movement follows clear vectors as if life consists of a specifiable number of moves.

After the Nazis came to power, Scharoun continued to get small domestic commissions in the suburbs of Berlin. Because of Nazi building controls, these houses needed to camouflage themselves with pitched roofs, shutters and coloured render, producing a deceptive effect of Alpine vernacular. Meanwhile inside, the spatial experiments continued, with results more ambiguous, and even labyrinthine, than before.

Such radical interiors in conservative shells remind one of some strange Rococo freaks in English landscape gardens, houses which are Gothic outside and classical within, the first for exciting views, the second for unexciting comfort. Scharoun's camouflage isn't seeking picturesque effect. It is the physical form of an enforced schizophrenia which leads him away from simple Modernism.

After the war he seems less interested in the exterior and gives major public projects surprisingly makeshift envelopes. Abjuring grand gestures is not a Baroque habit, but positively cultivating a lack of match between inside and outside echoes the Baroque love of discontinuities in one's subjective experience of the building.

Discontinuities were deeply lodged in the landscape surrounding Scharoun's biggest post-war project. Although he had ambitious plans for the spaces around the Philharmonie, his large concert hall in Berlin, he must have known that something of the bomb site would cling to this territory for years to come, situated as it was very close to the border of the Eastern zone in one of the most devastated parts of the city. So there would be a shocking contrast between outside, with its reminders of destruction, and inside, his domain.

Features of urban sites are notoriously liable to change and for an architect as responsive to site as Scharoun eventually became, this creates nearly insoluble puzzles. It did not come naturally to him to conceive buildings as jagged fragments like bits of shrapnel littering a ruined cityscape. He would have preferred thinking on a Baroque scale. But like other visionaries hoping that the destruction of the past would make room for new thinking about the city in the present, like Christopher Wren after the Fire of London, Scharoun was able to make virtually no impression on the structure of Berlin.

Because it was designed that way, it is easiest to explain the logic of the Philharmonie from the inside out, though of course this is not the sequence in which it is experienced. Scharoun began by placing the orchestra at the centre and letting the rest exfoliate from there in layers or leaves. He talks about the auditorium as a landscape, a valley rising in vineyard terraces to a sky-canopy. The audience is broken into segments each roughly equal in size to the orchestra and canted at different angles as well as different levels from each other. Scharoun was keen to emphasize the anti-authoritarian nature of the broken-up space. The hall feels surprisingly intimate for its size, and from most perspectives less regular and symmetrical than it really is. To an unusual degree it achieves the relaxed organization of a landscape.

But without Scharoun's prompting would the idea of a valley with cultivated slopes ever occur to us? Could one in fact sketch out a sequence from Bavarian Rococo dripping with nature imagery through Gaudí, with his childish 'naturalism', where entrance halls are like Baroque grottoes and roofs like miniature mountainscapes, to Scharoun whose naturalism hovers just over the edge of visibility?

The concert hall was meant as the culmination of the building, and yet for many the most exciting spaces here are the circulation areas wrapped around and threaded under the hall (illus. 96). These consist of platforms from which stairs arrive and depart in great profusion and

96 Hans Scharoun, Philharmonie, Berlin, 1960–63, interior.

freedom. It feels like an outdoors to the hall's interior, and it includes both cave-like spaces at lower levels and uplands when you go higher, with varied views up and down. This really is a landscape, which makes getting to one's seat an entertainment in itself.

Of course it is not as random and profuse as it feels, and has been *given* all these qualities, which make it only *like* a landscape. So it is the fulfilment of certain Baroque tendencies, now carried further than in any seventeenth-century work, to regard subjective experience as primary. The logic of this project is one thing and the experience is another.

Scharoun's space lacks the imagery which Gaudí would certainly have supplied, an absence which keeps the experience from being an ecstatic release. Baroque ecstasies coerce the user, who feels goaded to rise to the intensity of the building's details. The lack of distinct content in Scharoun's vision grants a kind of freedom to the inhabitant, allowing for more variety of mood than the great Baroque spaces.

97 Ludwig Leo,
Submersion Laboratory,
Technical University,
Berlin, 1975–6.

98 Enric Miralles and Carme Pinós, 'River' at Igualada cemetery, near Barcelona, from above.

Strictly speaking, 'content' in this space is somewhat bland, but not absent altogether. Indeed, the supposed lack of content in modern art and architecture can be a contentious subject. Not infrequently an architect will deny the presence of expressive content which seems obvious to everyone else. Thus the extremely speaking forms of Ludwig Leo's Lifeboat Station and Submersion Laboratory of the 1970s in Berlin are explained by the architect as rational solutions to functional requirements (illus. 97). In this case the designer stands alone in refusing to see the imagery which defines the project for ordinary users. While expressive content by itself does not establish a connection with the Baroque, creatural monstrosities like these two buildings feel like disfigurements of the old Renaissance parallel between human and architectural proportions. And they recall the sort of Baroque bombast which favours magnification not shrinking.

Sometimes content slips in by the back door as in Oldenburg's Ray Guns, where naming alone seems to have the power to make innocent occurrences sinister. Then, too, certain situations are conducive to symbolism, like cemeteries for instance. If one were tracing the re-emergence of symbolic content in Modernist architecture, this would be an obvious place to begin, with Asplund, Lewerentz, Rossi and Scarpa, whose cemeteries all fulfil a wider brief, the creation of architectural landscapes.

Yet another recent cemetery at Igualada north-west of Barcelona is a striking made-landscape, where Enric Miralles and Carme Pinós have colonized one side of a huge abandoned quarry, in which piles of human debris and semi-ruined natural features are hard to tell apart (illus. 98).

Like most of the architects in this chapter, the Spanish pair would probably be surprised to hear that anyone finds the slightest hint of the Baroque in their work. And how can one prove or disprove the existence of something admitted even by its discoverer to be camouflaged? For half the fun at Igualada is noticing symbolism which could be dereliction or 'nature'. Here most routes meander and most constructed elements lean. One could make a catalogue of forms of tilting, ranging from the long incline down into the site to 'doors' which turn into tomb slabs in a series of stages. Unlike a Baroque garden this complex is rugged and informal and made of materials which resist smoothing or civilizing. Yet it is also a kind of new town which culminates in a circular or ovoid public space, after a theatrical approach between leaning façades. Igualada is the Romantic vision of a piece of Baroque planning fallen into decay and now inhabited mainly by ghosts and those who wander in to pay their respects to the past.

The question of the influence Baroque exerts in the present has more than one answer. First come those who explicitly refer to it or claim inspiration from it, cases which can be interesting – Charles and Rae Eames, for example, who made a film about the Bavarian churches – and often test your ingenuity in guessing what the attraction could possibly have been. But more revealing than conscious imitators are those with a deep unspecific accord like Scharoun and Gehry. Establishment figures (like Lutyens, wonderful as he is) seem to be playing within a closely circumscribed field. Rather than the blustery Baroque of Bernini, I prefer to look for parallels to the subversive Baroque of Borromini. Inevitably this means wandering quite far afield, which is after all the Baroque enterprise, to depart so far from the familiar model that some of your audience think you have forgotten it entirely.

NOTES

FOREWORD

page vii Michelangelo's deformations are most evident in spaces attached to San Lorenzo, Florence. In the vestibule of the Laurentian Library, for instance, normal structural and proportional logic is violated and columns appear as if excavated in the walls, while other elements are turned upside down or squeezed uncomfortably by their surroundings.

vii Regional forms of Baroque. For those not treated at length in this book, see G. Kubler and Martin Soria, *Art and Architecture in Spain and Portugal and Their American Dominions, 1500–1800*, Pelican History of Art (Harmondsworth, 1959); Brian Knox, *Architecture in Prague and Bohemia* (London, 1965); Anthony Blunt, *Sicilian Baroque* (London, 1968) – not the latest books on their subjects but relatively easy to find.

vii Neumann's Baroque spaces classicized at Neresheim Abbey in Bavaria and in the balustrades and decor beneath Tiepolo's frescoes in the stair hall at Würzburg.

viii Rococo is well defined by Hans Sedlmayr's short article in the *Encyclopedia of World Art*.

ix *Guarino Guarini and His Architecture* by H. A. Meek (New Haven and London, 1988) is thorough and well illustrated.

ix Author of the longest fiction: Henry J. Darger; see *The Times Literary Supplement*, 30 October 1998. John Ashbery has apparently written a poem based on this novel and its author.

I THE CASE FOR DISRUPTION

1 Bernini's architectural work is fully catalogued in Franco Borsi, *Bernini architetto* (Milan, 1980).

2 Mussolini's various interferences with the historical fabric of Rome usually aimed to bring out links between Fascism and the Imperial past and to suppress the intervening centuries. Like Hitler he took a detailed interest in city-form as a kind of propaganda for the regime. For both men long, unobstructed avenues were physical assertions of political

power. See T. Benton, 'Rome Reclaims Its Empire', in *Art and Power: Europe under the Dictators 1930–45*, Hayward Gallery, London (1995), with further bibliography.

6 Milton in Italy. He saw Galileo in Florence and attended a concert in the Barberini palace in Rome, but according to contemporaries often gave offence by his strict morality and outspoken attacks on popery. He worried that the Roman Jesuits were consequently laying snares for him.

6 Milton's earlier ideas for epic subjects included the Arthurian stories familiar in medieval romances. At that point he thought an English epic should have an English subject.

7 Hawksmoor's City churches often play central off against longitudinal plans. The most striking is St George's Bloomsbury, which has two entrances (one long blocked) and two chancels, corresponding to the two orientations.

8 St Ignatius's letters, autobiography and other personal writings are conveniently assembled with useful commentary by Joseph A. Munitiz and Philip Endean in *St Ignatius: Personal Writings* (Harmondsworth, 1996).

8 Staging of the earliest operas is covered in *The New Monteverdi Companion*, ed. D. Arnold and N. Fortune (London, 1985). *Baroque Music: A Research and Information Guide* by John Baron (New York and London, 1993) is a model reference book and contains detailed analytical critiques of the important sources.

10 Baroque stage design has received much recent attention; *Baroque Art: The Jesuit Contribution*, ed. Rudolf Wittkower and Irma B. Jaffe (New York, 1972), has an interesting piece on how this intersected with liturgy in the Gesù in Rome. See also Baron, *Baroque Music* and *New Grove Dictionary of Opera*, ed. Stanley Sadie, 4 vols (London, 1992), under 'Bibiena'.

10 Bernini's plays. Two of them – *Fontana di Trevi* and *Impresario* – have been published in English translation but are out of print and hard to find.

10 Bird's-eye views had a heyday of a few centuries before the advent of photography, after which pictures taken from balloons made them much less of a conceptual miracle. Photographs cannot single things out as well as drawings and do not invite the same careful study from the viewer. A book on the bird's-eye view would be welcome.

11 Fischer von Erlach's archaeological investigations and the meanings with which he tried to load the Karlskirche are well summarized by Beverly Heisner in the *Macmillan Encyclopedia of Architects*.

12 On centralized plans in the Renaissance see Wolfgang Lotz, *Studies in Italian Renaissance Architecture* (Cambridge, MA and London, 1977), and Robin Evans, *The Projective Cast: Architecture and Its Three Geometries* (Cambridge, MA, 1995).

12 Costanzo Michela. There is a thorough but unsympathetic treatment in the *Macmillan Encyclopedia of Architects*.

15 The Katsura Villa or Detached Palace (begun in 1616) represents a watershed in traditional Japanese architecture, but has possibly exerted an even greater influence on Western modernists for its combination of minimalist geometry, relaxed planning and openness to the landscape.

17 Palermo's development during the Baroque is covered in Cesare De Seta and Leonardo Di Mauro, *Palermo*, in *Le città nella storia d'Italia* (Rome, 1981).

19 Congonhas do Campo. For a plan and full description see the *Footprint Handbook* for Brazil.

20 Sacred Mounts. All lie within a fairly small area of hilly country north and east of Turin. Besides Orta and Varallo (treated in the text), major examples can be seen at Varese, Crea and Oropa. The English Victorian Samuel Butler became obsessed with them and wrote interestingly on the subject in *Ex Voto* (1888; new edn 1928). Much detail about his encounter with these places is given in Elinor Shaffer, *Erewhons of the Eye: Samuel Butler as Painter, Photographer and Art Critic* (London, 1988). Butler is commemorated at Varallo with a bronze portrait plaque.

22 Views on Bernini's St Teresa. See R. Wittkower in *Bernini, Sculptor of the Roman Baroque* (London, 1997), and A. Blunt in *Guide to Baroque Rome* (London, 1982), which is a useful book for details of authorship and building history.

25 Fra Andrea Pozzo published his discoveries extensively with persuasive plates illustrating his perspective methods. See his *Perspectiva pictorum et architectorum* (1693, 1700). Other Pozzo ceilings are found as far afield as Vienna and Mondovi in Piedmont.

27 Franz Anton Maulbertsch, the greatest Austrian Baroque painter by far, is reasonably well represented in the Österreichische Barockgalerie, Vienna.

28 *Tiepolo in Würzburg, der Himmel auf Erden*, ed. Peter O. Krückmann (Munich, 1996), is the catalogue of an extensive exhibition.

29 Country house poems continued to be produced throughout the seventeenth century, but rarely reached the earlier heights. Pope's youthful *Windsor Forest* partly derives from them and his *Epistle to Burlington* may be the last gasp of the genre.

30 Marvell's metaphysics were the subject of some wonderful speculations by William Empson writing about 'The Garden' in *Some Versions of Pastoral* (London, 1935).

II TORMENTED VISION

34 Handel's Italian operas have begun to be performed and recorded more in the last ten years, though experts seem to agree that Handel scholarship languishes far behind Bach or Mozart studies, so that re-examination of basic sources is urgently needed before accurate performances will be possible. Nonetheless the following recordings seem outstanding: *Agrippina* (1709), John Eliot Gardner on Philips; *Flavio* (1723), René Jacobs on Harmonia Mundi; *Giulio Cesare* (1724), René Jacobs on Harmonia Mundi; *Ariodante* (1735), Raymond Leppard on Philips. Unlike the others listed, this last is decidedly not an 'authentic' performance, on which subject see Harry Haskell, *The Early Music Revival: A History* (London, 1988), which follows the tortuous course of the idea that music written before the nineteenth century should not be played on modern instruments.

35 Rubens and the Jesuit church in Antwerp. The project has a whole volume of the *Corpus Rubenianum* devoted to it which assembles all the prints, oil sketches and drawings that give us an idea of the destroyed scheme.

37 Rubens's *Samson*: a melodramatic early painting now in the National Gallery, London.

40 Rubens's letters. A selection translated by Ruth Saunders Magurn (Cambridge, MA, 1955; reprinted 1991) is the best place to sample Rubens the diplomat.

42 Rubens's oil sketches are collected by Julius S. Held in *The Oil Sketches of Peter Paul Rubens* (Princeton, 1980).

43 Juvarra's theatre sketches. Many of the best are in an album at the Victoria & Albert Museum, London. A well-illustrated and comprehensive catalogue of these and others is Mercedes Viale, *Filippo Juvarra, scenografo e architetto teatrale* (Turin, 1970).

44 Gehry and Coop Himmelblau, both called Deconstructivists in a famous exhibition at the Museum of Modern Art, New York, by analogy with Jacques Derrida's disintegrative treatment of literary texts. Their early work is the most interesting, especially Gehry's conversion of an ordinary bungalow in Santa Monica, California, for his own use and Coop Himmelblau's conversions, which look like disruptions, of various nineteenth-century buildings in Vienna.

47 Bernardo Antonio Vittone built a large number of parish churches, many in obscure Piedmontese villages and towns – Vallinotto, Bra (S. Chiara), Turin (S. Maria de' Piazza and S. Chiara), Villanova di Mondovi (S. Croce), Riva di Chieri, Grignasco (Assunta), Borgo d'Ale (S. Michele), Rivarolo Canavese (S. Michele), Corteranzo (S. Luigi, cemetery chapel) and Vercelli (S. Chiara).

48 Ruin enthusiasm. The only systematic book on this important subject I have found treats mainly German cases: Reinhard Zimmerman, *Künstliche Ruinen: Studien zu ihrer Bedeutung und Form* (Wiesbaden, 1989), with many murky illustrations.

51 Santini (often called Santini-Aichel by German writers). His Gothic/Baroque hybrids are not taken seriously by most critics, and the most complete catalogue of his work comes from a small French publisher, Jacques Damase: *Santini, architecte gothico-baroque en Bohême 1677–1723* (Paris, 1989).

52 The literature of the convent. *La Vie de Marianne* by Marivaux, *Castle of Otranto* by Horace Walpole, 'The Earthquake in Chile' and 'St Cecilia' by Heinrich Kleist, 'The Duchesse de Langeais' (from *The History of the Thirteen*) by Balzac and the Father Zossima sections of *Brothers Karamazov* by Dostoevsky.

52 Blessed Ludovica's story is told by Blunt in his *Guide to Baroque Rome*.

53 Descendants of Bernini's *Teresa* in other Roman churches include Francesco Aprile, *Sant' Anastasia* (1685), in the church of Sant' Anastasia, and G. B. Maini or Camillo Pacetti, *Sant' Anna*, in Sant' Andrea delle Fratte.

53 Jesuit reductions in the provinces of Paraguay and Peru, which include present-day Bolivia, are explored by Richard Gott in *Land without Evil* (London, 1993). The wooden churches which survive have recently been restored by a Swiss architect and are now the subject of organized group tours.

53 Favourite Counter-Reformation saints include Ignatius, Francis Xavier, Aloysius Gonzaga, Carlo Borromeo and Philip Neri (Goethe devotes ten pages to the latter in his *Italian Journal*, 4–6 June 1787).

55 Franz Xaver Messerschmidt's work is well reproduced in Maria Pötzl-Malikova's monograph (Vienna, 1982). In *Born under Saturn* Rudolf and Margot Wittkower (London, 1963), record the contemporary report that Messerschmidt produced the expressions enshrined in the heads by pinching himself in an effort to break the power of the envious Spirit of Proportion, who, resenting the sculptor's skill, visited him nightly. The Wittkowers do not accept that Messerschmidt was schizophrenic.

57 For Mrs Radcliffe's pines see *The Mysteries of Udolpho* (1794) and *The Italian* (1797), which were favourite books for some of Jane Austen's young ladies.

58 Sterne and the cult of sensibility are most blatantly displayed in his *Sentimental Journey through France and Italy* (1768).

58 Monk's Cell staffed by a live 'monk' in the landscape gardens at Stourhead. At Selbourne, Hants., Gilbert White's brother Harry, rector of Fyfield, dressed up as a hermit and surprised visitors. Another hermitage with hermit at Painshill, Surrey; Merlin's Cave with a small library, by William Kent for Stephen Duck the thresher-poet at Richmond, Surrey; Druid's Temple with paid Druid at Swinton Park, North Yorkshire.

58 Walpole's 'monastery' at Strawberry Hill survives in part; Beckford's at Fonthill Abbey, Wiltshire, fell down in part, suffered a fire and had its contents sold when Beckford needed money.

58 British travellers in Italy are catalogued in an astonishing publication of 1,070 pages based on material collected over many years by an eccentric twentieth-century dilettante, Brinsley Ford: *A Dictionary of British and Irish Travelers in Italy 1701–1800*, compiled by John Ingamells (New Haven and London, 1997).

III THE VIEW FROM ABOVE

61 Grammichele near Caltagirone in south-eastern Sicily makes an interesting case because it did not really succeed and hence remains fairly intact. Richelieu likewise has not spread much beyond its original confines, perhaps because its powerful projector Cardinal Richelieu died before it was finished. St Petersburg has had an ambiguous history, regularly resented by patriotic Russians including Tolstoy and the Bolsheviks for being cosmopolitan and un-Russian, by contrast with Moscow.

71 Noto has been thoroughly studied by Stephen Tobriner in *The Genesis of Noto* (London, 1982).

71 Blandford Forum is covered by a Royal Commission on Historical Monuments inventory, *Dorset*, vol. 3, *Central* (HMSO, 1970).

74 Adolf Loos has probably exercised an influence out of all proportion to the volume of his architectural work because he is a powerful polemicist and radical theorist whose witty essays like 'Ornament and Crime' and 'Cladding' continue to have widespread effect.

74 Ceauşescu's plans for Bucharest were only part of a thoroughgoing re-organization of the manmade environment and how people live in

it applied to the whole country, perhaps the most megalomaniac architectural project undertaken since ancient times. Many Romanian villages were apparently levelled to be replaced with regional centres of high-rise dwellings. Much of historic Bucharest was bulldozed because it smacked of the bourgeois past, and a series of avenues of enormous width were laid out, converging on the Presidential Palace (now House of the People), a symmetrical classical monster on the scale of a small town.

77 Castrati are most thoroughly treated by John Rosselli in 'The Castrati as a Professional Group and a Social Phenomenon, 1550–1850', in *Acta Musicologica* LX (1988), pp. 143–79. Farinelli, one of the most famous, is the subject of a novel and a film; early sound recordings exist of one of the last castrati, who was not an opera singer; they nonetheless give an idea of the special timbres which can no longer be heard.

IV THE END OF HEROISM

78 Opera seria. Recordings of this despised genre remain few, but one can read about key instances in Manfred Bukofzer, *Music in the Baroque Era* (New York, 1947), and Julie Sadie, *Companion to Baroque Music* (Berkeley and London, 1990).

78 Mozart's early operas do not seem properly appreciated to this day. A very effective video of a performance of *Mitridate* exists, conducted by Nicholas Harnoncourt and designed by Jean-Pierre Ponnelle. There are good recent recordings of all of them: *Mitridate, re di Ponto* (Decca, Rousset); *Ascanio in Alba* (Naxos, Grimbert); *La finta semplice, La finta giardiniera, Lucio Silla, Il re pastore* (all in Philips Complete Mozart Edition); *Zaïde* (Harmonia Mundi, Goodwin); *Idomeneo* (DGG, Gardiner).

80 Early French opera. So far this territory is monopolized by a few conductors, above all William Christie, who has recorded Rameau's *Hippolyte et Aricie, Castor et Pollux, Les Indes galantes* and *Fêtes d'Hébé*, and Charpentier's *Médée, David et Jonathas* and *La Descente d'Orphée aux Enfers*.

82 Shakespeare's *Antony and Cleopatra* is tidied up in Dryden's *All for Love*; the comparison remains one of the most telling demonstrations of seventeenth-century blindness.

V THE WORLD AS SCENERY

102 Pope's crippled body. Dr Johnson in his *Life of Pope* unkindly remarked that the poet's weakness 'made it difficult for him to be clean'.

103 Pope's works have been elaborately edited at least twice, in the nineteenth century by Elwin and Courthope, more recently in the eleven-volume

Twickenham edition by various editors (New Haven and London, 1939–68).

105 Wit as a subject in the eighteenth century was not new, of course, and there are vivid earlier treatments by Shakespeare and Donne among others. 'Wit' is one of Empson's *Complex Words* (London, 1951).

109 For *Architetti teatrali* see *New Grove Dictionary of Opera*. A single complete Bibiena set survives, at Drottningholm Court Theatre, Sweden (*c.* 1774).

113 Prisons in eighteenth-century art, of which the Newgate novel is a tangential strain. Fielding's *Jonathan Wild*, a send-up of the genre, remains better known than any straight version except John Gay's anti-opera *The Beggar's Opera*. Hogarth and Goya both toyed with the subject, as did Fuseli and the Prussian architect Friedrich Gilly.

117 Soane's collection has never been completely catalogued, perhaps because it is so heterogeneous that no single curator feels competent to deal with all its branches, and then of course the overall effect would be more chaotic the more meticulously the atoms were separately described. The collection of models would make a feasible sub-unit, and the drawings are now being catalogued in volumes devoted to Robert Adam, the Italian Renaissance and other conventional categories.

122 Baldassare Longhena was more prolific than one might think, given that he built entirely in the Veneto. But even the four double-column pages devoted to him in the *Macmillan Encyclopedia of Architects* are more than some people want about this ordinarily bombastic architect.

124 Vanbrugh's plays are all collected in a Penguin Classic.

126 Vanbrugh locations: Blenheim, Woodstock, Oxfordshire; Grimsthorpe Castle, south-east of Grantham in Lincolnshire; Castle Howard, North Yorkshire, north-east of York. All three houses are open to the public.

VI BAROQUE NATURE

127 Authentic performance has been a boom area in music and especially in recording over the last twenty years. Several periodicals are devoted to the subject, including *Early Music, Goldberg* and *Early Music Review*. For a book-length treatment which is no longer quite up to date, see Harry Haskell, *The Early Music Revival: A History* (London, 1988). *The Penguin Guide to Compact Discs* (London: 1999) contains plentiful critiques of various 'authentic' performances.

129 The Tiber island is the subject of a fascinating anthropological excursion by Carl Kerenyi in *Asklepios: Archetypal Image of the Physician* (London, 1960).

132 Beich's paintings of all the Bavarian ducal residences are hung at Nymphenburg.

137 For Goethe's comment on Bagheria see the entry for 9 April 1787 in his *Italian Journals*, trans. W. H. Auden and Elizabeth Mayer (Harmondsworth, 1970).

143 The Dutch tulip craze runs all through Anna Pavord's *The Tulip* (London, 1999) and has recently inspired a novel by Deborah Moggach.

144 Spanish still life. A good selection could be found in the National Gallery, London's exhibition of 1995, all illustrated in the catalogue.

147 New drawing techniques: Robin Evans, *The Projective Cast* (Cambridge, MA, 1995).

147 The Accademia dei Lincei and Cassiano dal Pozzo were the subject of a British Museum exhibition and catalogue, *The Paper Museum of Cassiano dal Pozzo* (1993).

150 Lives of seventeenth-century scientists are conveniently collected in *Dictionary of Scientific Biography*, 18 vols (New York, 1970–90).

151 Mozart and bird song. He always kept a caged bird and became particularly attached to a starling on whose death he wrote a sentimental poem. It has recently been claimed that the Musical Joke, K. 522, was written as a requiem for this bird.

152 Rameau. Storms and volcanic eruptions occur in *Les Indes galantes* and *Hippolyte et Aricie*, as well as in *Les Boréades*.

155 Francesco Pianta at the Scuola di San Rocco is a neglected figure. When the *Dizionario Biografico degli Italiani* reaches 'P' (in 1999 it had got as far as 'G') it will be easier to find material on his life. Another of his works, a fantastic clockcase with signs of the zodiac and the four ages of man, can be seen nearby in the *sala capitolare* of the Frari.

157 Hogarth: a good recent biography by Jenny Uglow (London, 1999).

162 Orlando goes mad in Haydn's *Orlando paladino* (1782) and Vivaldi's *Orlando* (1727).

VII COLONIAL BAROQUE

165 Landa and destruction. One can get an idea of the books he destroyed from Gordon Brotherston, *Painted Books from Mexico* (London, 1995).

166 Gaulish coins appear in André Malraux's *Les Voix du silence* (Paris, 1951), reproduced at many times life size, one of the most effective exhibits in his *musée imaginaire*.

174 Persian tombs at Samarkand are illustrated in Sheila S. Blair and Jonathan M. Bloom, *Art and Architecture of Islam 1250–1800*, Pelican History of Art (New Haven and London, 1995).

176 *Estípite* column. Perhaps this strange element has been seized upon too eagerly by historians as the key to Mexican Baroque. Other distinctive oddities have not been granted special names.

178 *Blue Guide: Mexico* by John Collis and David M. Jones (London, 1997), so far the most complete guidebook in its coverage of colonial architecture.

179 Stella Kramrisch, the most original writer on Indian architecture, in *The Hindu Temple* (Delhi, 1946). She was associated with the Philadelphia Museum of Art, which has a surprising collection of Indian art and architecture, including a large Hindu temple interior.

181 Goan Baroque, both Christian and Hindu, is catalogued in José Pereira, *Baroque Goa: The Architecture of Portuguese India* (New Delhi, 1995), and illustrated in Antony Hutt, *Goa: A Traveller's Historical and Architectural Guide* (Buckhurst Hill, Essex, 1988).

183 Francis Xavier's tomb in Old Goa is an astonishing Florentine Baroque work donated by the Grand Duke of Tuscany. It is a many-tiered structure of mixed materials – jasper, marble, bronze, silver – displayed theatrically in a chapel too small for it, so that you walk around to different openings getting partial views of the ungraspable whole.

183 *San Ignacio* on CD, 'a lost opera of the Jesuit missions in Amazonia', Ensemble Elyma, Gabriel Garrido, K. 617, 1996.

184 Early history of opera in Bukofzer, *Music in the Baroque Era*, and *New Grove Dictionary of Opera*.

184 SS Alessio e Bonifacio, on the Aventine in via Santa Sabina, contains the wooden stair St Alessio lived beneath, which is now enclosed in a glass case borne aloft by angels and putti.

185 Provenzale had been seriously neglected until championed recently by the Neapolitan group Cappella de' Turchini under Antonio Florio, who have recorded many of his works, latterly in Opus 111's Tesori di Napoli series, but not (so far) either his opera seria *Stellidaura vindicata* or his comic opera *Lo schiavo di sua moglie*.

187 *Oratorio erotico*, apparently a seventeenth-century term, applied to oratorios on virgin martyr subjects among others, where female virtue is threatened but rises superior to aggressive lust, not before sensuality is given its musical turn. Howard Smither's *A History of the Oratorio* (Chapel Hill, NC, 1979), mentions a number of examples including Vivaldi's *Juditha Triumphans*.

VIII NEO AND PSEUDO BAROQUE

196 Persian 'Rococo' painting was well represented in *Royal Persian Paintings: The Qajar Epoch 1785–1925* at the Brooklyn Museum (1998).

198 John Belcher in A. Stuart Gray, *Edwardian Architecture: A Biographical Dictionary* (London, 1985), which also treats the other Edwardian projects mentioned in the text. Belcher's most flamboyant London building, the Institute of Chartered Accountants in Great Swan Alley off Moorgate, has recently been the subject of a book, *The Alliance of Sculpture and Architecture: John Belcher and the Institute of Chartered Accountants Building*, by Terry Friedman et al. (Leeds, 1993).

201 American cars of the 1950s were lavishly depicted in the brochures which accompanied the arrival of new models every year. Stephen Bayley, *Harley Earl and the Dream Machine* (London, 1983), follows the career of one of the most successful designers of these high points of popular culture.

203 Jeff Koons. This millionaire artist's 'archive' demands prohibitive fees to reproduce his work, so none are illustrated here.

209 Bellotto's twenty-four views of Warsaw and its surroundings are all reproduced in the catalogue of a loan exhibition from the National Museum, Warsaw, to Palazzo Grassi, Venice (1955).

210 Colonial Williamsburg Inc. was the brainchild of the rector of Bruton Parish Church, who persuaded John D. Rockefeller to fund the project. C. R. Mackintosh's famous *Haus eines Kunstfreundes* was entered in a Viennese competition in 1900, arrived too late to win, but went on to exert immense influence in its published form. The replica of this project recently erected in Bellahouston Park in Glasgow derives from these prints and reveals the hazards of depending on such sketchy sources. Mackintosh would probably not have been satisfied with some of the shapes and textures which have been extrapolated from his imprecise but suggestive perspectives.

216 Hellenistic Baroque is surveyed in Margaret Lyttelton, *Baroque Architecture in Classical Antiquity* (London, 1974), with results which are disappointing because too literal-minded. These buildings on the fringes of empire represent a more violent deviation from classical norms than the author acknowledges.

IX BAROQUE IN THE TWENTIETH CENTURY

222 For Blunt's objection to Roman Rococo see the bibliographical note to his *Guide to Baroque Rome*, which is the most personal part of this work and gives a vivid impression of the scholar among his books.

222 Czech Cubists as theorists and historians: an impressive account of their ideas in Ákos Moravánszky, *Competing Visions: Aesthetic Invention and Social Imagination in Central European Architecture 1867–1918* (Cambridge, MA, 1998).

226 Ruskin on Baroque in *The Stones of Venice*. He relaxed his longstanding hostility to Renaissance painting when bowled over by Tintoretto but never gave way on architecture. His catalogue of important Venetian buildings contains much amusing vituperation of Baroque churches and palaces.

228 Matta-Clark, the son of a Chilean painter-father and an American mother, trained as an architect but went on to produce powerful attacks on architecture which include a complicated piercing and slicing through the floors and walls of a condemned office building called *Office Baroque*. His work is surveyed in a Spanish exhibition catalogue, *Gordon Matta-Clark* (Valencia, 1992).

ACKNOWLEDGEMENTS

The author wishes to thank the University of North London and the Head of the School of Architecture and Interior Design, Helen Mallinson, for their generous support of this project. Among the many who were helpful or hospitable are Letitia Verna in Agliè, Francesco Battuello in Turin, John, Patricia and Matthew Holmes in Tepotzotlán and Christopher Ridgeway at Castle Howard. Special thanks to Philip Trevelyan, who provided the desk where the writing was done. Among those who made interesting suggestions at various points along the way were Colin Davies, David Grandorge, Brian Hatton and Gordon MacLaren, but there are others as well. Michael Leaman has been an ideal publisher from my point of vantage, never interfering but never disappearing for long. Everyone else at Reaktion Books has been consistently helpful. Howard Davies is responsible for many improvements in the text. As usual, I owe most to Esther Whitby, the book's best reader and the author's best friend.

PHOTOGRAPHIC
ACKNOWLEDGEMENTS

The author and publishers wish to express their thanks to the following sources of illustrative material and/or permission to reproduce it (excluding sources credited in full in the captions):

Architectural Association Photo Library, London/Peter Cook: 97; the author: 1, 9, 18, 19, 23, 25, 29, 32, 39, 43, 44, 47–52, 63–5, 67, 69, 70, 88, 98; Barnaby's Picture Library/Sol Feinstein: 77; Bayerische Verwaltung der Staatlichen Schlösser, Gärten und Seen, Munich: 46; Bernisches Historisches Museum (inv. no. MK 1913.610.71): 74; Peter Blundell Jones, 96; Osvaldo Böhm: 42, 59, 87; British Architectural Library, London (photo A. C. Cooper): 36; British Library, London: 45; The Codrington Library, All Souls College, Oxford (photo courtesy of the Warden and Fellows of All Souls College): 21; Courtauld Gallery (photo © Samuel Courtauld Trust, Courtauld Gallery, Courtauld Institute, London): 14; Sue Cunningham/SCP: 27; Diözesan-museum Freising: 31; Fitzwilliam Museum, Cambridge (photo © Fitzwilliam Museum): 17; Fotostudio Otto: 13, 20, 62; Galleria dell' Accademia, Venice: 87; Gemäldegalerie, Berlin: 34; Guggenheim Bilbao Museoa (© FMGB Guggenheim Bilbao Museoa, 2000, photographer Erika Barahone Ede, all rights reserved, partial or total reproduction prohibited): 92; G. Headley: 57; Musée du Louvre, Paris (photo RMN): 24; National Gallery, London: 2, 15; National Monuments Record, Swindon: 26; Nelson-Atkins Museum of Art (Kansas City, MO): 83; Österreichische Galerie im Belvedere (Barock-museum), Vienna: 13, 20, 62; private collections: 15, 53; Stefan Rebsamen: 74; Royal Castle, Warsaw: 80; Royal Commission on the Ancient and Historical Monuments of Wales (photo Crown copyright): 75; Royal Library, Windsor Castle (photos The Royal Collection, © 2000, Her Majesty Queen Elizabeth II): 54 (RL 28738), 55 (RL 194338), 56 (RL 19358); Schloß Charlottenburg, Berlin: 35; Schloß Nymphenburg, Munich: 46; Staatliche Museen zu Berlin – Preußischer Kulturbesitz/Jörg P. Anders: 34, 35; Tate Gallery, London: 60; Trans World Airlines, Inc.: 78; Victoria & Albert Museum, London (photo V&A Picture Library): 16; Wallace Collection, London (photos © and reproduced by kind permission of the Trustees of the Wallace Collection: 40, 41; Witt Library, Courtauld Institute of Art, London: 37, 38.

INDEX

Figures in *italics* are illustration numbers.

Abbeville, Saint-Vulfran *82*
Abstract Expressionism 65–6
Acatepec, Mexico, San Francisco *65*, 173–4
Accademia dei Lincei 147–50, 251
Actors of the Comédie Française (Watteau) *34*,
 97–8
Admiralty Arch, London (Webb) 199
Agliè, Italy, Santa Marta (Michela) *4*, 12–13
Aleijadinho [António Francisco Lisboa] *8*,
 19–20
All Souls, Oxford (Hawksmoor) 126
Amalienburg (Cuvilliés) *47*, 134
American 1950s cars *77*, 201–2, 253
anamorphic painting 4
Andre, Carl 220
anti-Catholic feeling 30–32
Antichità Romane (Piranesi) *45*
architetti teatrali 109–13, 253
Arrival in Marseilles (Rubens) *24*, 65–6
Art Lover's House, Glasgow (Mackintosh),
 reconstruction of 210, 253
Art Nouveau 207–8
Arts and Crafts movement 200
Asam, Egid Quirin and Cosmas Damian 13,
 28–31, 86–91
Ascanio in Alba (Mozart) 79
Ashton Memorial, Lancaster (Belcher) 198
Asplund, Gunnar 239
Austen, Jane 103, 138, 248

Baker, Herbert 198
Balzac, Honoré de 52
Banqueting House, Whitehall, London
 (Rubens ceiling) *15*, 40–42
Baroque
 Chinese *83*, 214
 Edwardian *75*, 168, 198–200, 253
 Goan *69*, 181, 252
 Hellenistic *84*, 216–17, 253
 Japanese *81*, 211–12
 Latin American 192
 pearls 211
 Romanesque 214
 Russian *71*, *72*, 192–5

 Sicilian *32–3*, *49*, 61–4, 71–2, 91–6, 136–8
 Turkish *73*, 168, 195–6
 Ukrainian 193, 194
 origin of term 211
Barth, John 227
Bastard, John and William *26*, 71
Baur, Hermann 219
Beardsley, Aubrey *79*, 206–8
Beckford, William 58, 207, 248
Beethoven, Ludwig van 83
Beggar's Opera (Gay) 162
Beich, Franz Joachim *46*, 132–3, 250
Belcher, John 198, 253
Bellotto, Bernardo *80*, 209–10, 253
Berlioz, Hector 153
Bernini, Gianlorenzo 1–3, 8, 10, *10*, 12, 21–4,
 27, 31, 38, 52–4, 57, 86, 89, 91, 112, 114–15,
 118, 127, 128, 191, 217, 219, 225, 240, 243,
 244, 247
Bibiena family *36*, 109–13, 250
Bilbao (Guggenheim Museum) *92*, 230
bird's-eye perspective 10
Bishop-Saint, A (Maulbertsch) *13*, 33–35
Blake, William 160, 178
Blandford Forum, Dorset *26*, 71–2, 248
Blenheim Palace, Woodstock (Vanbrugh and
 Hawksmoor) *25*, 68–9, 125, 126
Blessed Ludovica (Bernini) 52, 247
Blunt, Anthony 23, 219, 222, 253
Boréades, Les (Rameau) 153
Borgonio, Gian Tommaso 6
Borromini, Francesco *1*, 2–4, 13, *19*, 50–51,
 112, 127, 166, 193, 216, 217, 225, 229, 240
Bosch, Hieronymus 105, 154
Boucher, François 100, 204
British Empire 198–9
Brothers Karamazov (Dostoevsky) 52
Bruegel, Pieter 160
Brunelleschi, Filippo 12, 166, 228
Butler, Samuel 245
Byzantine architecture 193, 195

Caltagirone, Sicily 62–3
Canaletto [Giovanni Antonio Canal] *40*, 119–22

Caravaggio [Michelangelo Merisi] 220
Carceri d'invenzione (Piranesi) *37*, 113–15
Cardiff, Civic Centre (Lanchester, Stewart
 and Rickards) *75*, 198–9
Caserta, garden at 64
Cassiano dal Pozzo *54–6*, 149–50, 251
 Paper Museum 54–6, 149–50
Castle Howard, Yorkshire (Vanbrugh) 125, 126
castrati 76–7, 249
Ceaușescu, Nikolae *27*, 74, 248–9
ceilings, painted *12*, 24–9, 220
central-plan buildings 7,12, 47–8, 245
Cesi, Federico 147–50
Cézanne, Paul 28
Charpentier, Marc-Antoine 80, 249
Chaurasi, Orissa, Varahi temple *68*, 179–81
Cherubino (in *Marriage of Figaro*) 201, 204
Christening (Hogarth) 159–60
Chu Ta *83*, 214
Çinili Köşk, Istanbul 195
Clemenza di Tito, La (Mozart) 78, 79, 80,
 112–13
Clérisseau, Charles-Louis *17*, 44
Collcutt, Thomas 198
Collegio di Propaganda Fide, Rome
 (Borromini) *1*, 3–4
colonial expansion 70, 151, 164–91, 192
Congonhas do Campo, Brazil *8*, 19, 245
Congreve, William 82, 102, 106–9, 122
Constructivists *94*, 112, 233–4
 stage design by 112
convents 51–2, 165, 247
Coop Himmelblau 44, *93*, 232–3, 246
Cornaro chapel, Santa Maria della Vittoria,
 Rome (Bernini) *10*, 23–4
Corso, Rome 15
Cortona, Pietro da 216
Così fan tutte (Mozart) 80, 84–5, 86
Counter-Reformation 37, 155, 186, 247
country house poems 245
Cowper, William 160
Crashaw, Richard 31–2, 57
Cubists (Czech) *86*, 222–4, 254

Dalí, Salvador 203
Dante Alighieri 5
Darger, Henry J. 243
De Mille, Cecil B. 187–8, 200
De Stijl 224
Debussy, Claude 80–81, 153
Defoe, Daniel 70
Deleuze, Gilles 24, 219–21, 222
Della Porta, Giacomo *85*, 218
Derrida, Jacques 246
Didyma, Turkey 216
Disneyland 20

Divine Comedy (Dante) 5
Don Giovanni (Mozart) 80, 84, 85
Dreiser, Theodore 167
Dryden, John 67–8
Dubrovitsy, near Moscow, Church of the
 Virgin of the Sign *71*, 193–4
Dubuffet, Jean 221
Duccio di Buoninsegna 37
Dunciad, The (Pope) 104–6

Eames, Charles and Rae 240
Earthquake in Chile (Kleist) 52
Eisenstein, Sergei 79
El Greco 220
Election, The (Hogarth) 160
Elective Affinities (Goethe) 137
Elektra (Strauss) 204
Eliot, T. S. 226–7
Elizabethan prodigy houses 166
Embarkation for Cythera (Watteau) 24, 96, 100
Empson, William 246, 250
encyclopaedia 147
English landscape gardens 132, 138, 195–6, 236
Epistle to Burlington (Pope) 29, 245
Esther before Ahasuerus (Rubens) *14*, 35–6
estípite columns *67*, 176, 252
Ettal, Bavaria, pilgrimage church 141–3
Eugen of Savoy (prince) 69

Feichtmayr, Johann Michael *51*, 140–41
Fellini, Federico 105
Fili, near Moscow, Church of the Virgin of
 the Intercession *72*, 194
Finta giardiniera, La (Mozart) 83–4
Fischer von Erlach, Johann Bernhard *3*, *11*,
 11–12, 24, 73–4, 166, 244
Five Orders of Periwigs (Hogarth) 159
Focillon, Henri 212–14
Fold: Leibniz and the Baroque, The (Deleuze)
 219–21
Forest Lawn Cemetery, Los Angeles 95
fountains 17, 24, *73*, 195
Fragonard, Jean-Honoré 48, 100
Francisco Miguel [native designer of
 Ocotlán] *63*, 170
Franklin, Benjamin 151
Franz Joseph (emperor) 74
Freising, cathedral, Asam redecoration of *31*,
 90–91
Freudian effects 23, 168
Fuseli, Henry 207

Galileo 148, 244
gardens 128–39, 240
Gardiner, John Eliot 80
Gaudí, Antonio 13, 237, 238

Gehry, Frank O. 44, *89*, *92*, 228–32, 240, 246
Gersaint's Shopsign (Watteau) *35*, 100–101
Il Gesù, Rome 69, 89, 230, 244
Giardino Buonacorsi 130–31
Goethe, Johann Wolfgang von 137–8, 251
Gothic
 Baroque 82, 212–14
 late 13
 novel 118–19
 Revival 199, 226
Goya, Francisco de 163
Grammichele, Sicily 61, 248
graveyards 48, 137–8, 239–40
Grimsthorpe Castle, Lincolnshire
 (Vanbrugh) *43*, 125–6
Guanajuato, Mexico, La Valenciana, retables
 191
Guardi, Francesco *41*, 121–2
Guarini, Guarino 13, 48, 50, 243
Guggenheim Museum, Bilbao (Gehry) *92*,
 230–31
Guimard, Hector 207–8

Haci Mehmet Emin Agha fountain, Istanbul
 73, 195
Hagia Sophia, Constantinople 195
Hameau, Versailles 76, 82, 134
Hamlet (Shakespeare) 34, 85
Handel, George Frideric 10, 34–5, 67, 76–7,
 89, 162–3, 246
Hawksmoor, Nicholas 7, *25*, 50, 68, 124, 125,
 126, 244
Haydn, Joseph 163, 251
Heads of Six of Hogarth's Servants (Hogarth) *60*,
 158–9
Herbert, George 19
Hildebrandt, Johann Lukas von 12
Hind and the Panther, The (Dryden) 67–8
Hindu temples *68*, 179–81
Hofburg, Vienna (Semper enlargements)
 74
Hofmannstal, Hugo von 204
Hogarth, William *60–61*, 153, 157–61, 206,
 207, 251
Hollar, Wenceslaus 115–16
Homeric parallels 76, 103
House of the People, Bucharest *27*, 74, 132,
 248–9
Hymn on the Morning of Christ's Nativity
 (Milton) 7

Idomeneo (Mozart) 80–82
Igualada cemetery, Spain (Miralles, Pinós) *98*,
 240
Imitation of Christ (Thomas à Kempis) 54
Imperial Institute, London (Collcutt) 198

India
 layout of new capital derived from
 European Baroque 199
Isola Bella, Lago Maggiore *44*, 128–30
Ivan the Terrible (Eisenstein) 79

James, Henry 119
Japan, medieval 73
Jesuit church, Antwerp (Rubens ceiling) *14*,
 35–7
Jesuit reductions in Bolivia and Paraguay 53,
 183, 247
Jesuits 25–6, 53, 58, 89, 95, 244, 246
 worldwide/overseas 69–70, 128
 in America 89
 see also St Ignatius
Jolalpan, Mexico, Santa María *66*, 174–6
Jonson, Ben 107, 108
Joyce, James 227
Juan Diego [Indian visionary] 169–71
Judd, Donald 64, 65
Juvarra, Filippo *5*, *16*, 14–17, 42–4, 48, 64–5,
 113, 246

Kandinsky, Wassily 28, 220
Karlskirche, Vienna (Fischer von Erlach) *3*,
 11–12
Katsura Villa, Kyoto 15, 245
Kent, William 113
King Lear (Shakespeare) 85
kitsch 200–204
Klee, Paul 220
Koons, Jeff 203–4
Kramrisch, Stella 179, 252
Kubler, George 165–6, 173
Kung Hsien 214

Lanchester, Stewart and Rickards *75*, 198–9
Landa, Diego de 165, 251
Landi, Stefano 185
Laurentian Library, Florence (Michelangelo)
 243
Le Corbusier 224
Leo, Ludwig *97*, 239
Leonardi, Vincenzo *54–6*
Lewerentz, Sigurd 239
Lewis, Matthew 'Monk' 118
Life of Marie de' Medici (Rubens) *24*, 65–6
Linderhof, Bavaria *76*, 200–201
Longhena, Baldassare *42*, 122–4, 250
Loos, Adolf 74, 248
Louis XIV 131
Louvre (Napoleon III enlargements) 74
Love for Love (Congreve) 106–9
Lucio Silla (Mozart) 79
Ludwig II of Bavaria 200–201

Lully, Jean-Baptiste 97
Lutyens, Edwin 240

Mackintosh, C. R. 210, 253
Maderno, Carlo 218
madness and 'madness' in art 162–3, 251
Maestà (Duccio) 37
Mallarmé, Stéphane 220
Mannerism 50, 153, 154, 174
Marie Antoinette 76, 82, 100
Marivaux (*La Vie de Marianne*) 52, 101
Marlborough, John, Duke of 68–9
 see also Blenheim
Marriage à la Mode, subscription ticket
 (Hogarth) *61*, 159
Marriage of Figaro, The (Mozart) 80, 81, 84, 109
Marschallin, the (in *Rosenkavalier*) 204–6
Marvell, Andrew 18, 29–32, 246
Mason & Dixon (Pynchon) 227
Matta-Clark, Gordon *91*, 228–9, 254
Maulbertsch, Franz Anton *13*, 27–8, 33–5, 245
Melnikov, Konstantin *94*, 233–4
Merzbau (Schwitters) *90*, 228
Messerschmidt, Franz Xaver *20*, 55, *62*,
 160–63, 247
Metastasio, Pietro 79, 112
Mexico
 colonial 51–2, 164–91, 192–3
 pre-Conquest forms in 165–6, 172, 187,
 188
 tile-covered façades in *65*, 172–4
Mexico City, Sagrario *67*, 176–8
Miami, Florida, hotels 201
Michela, Costanzo *4*, 12–13, 245
Michelangelo Buonarotti 37, 50, 95, 166, 243
Milton, John 5–7, 66–8, 76, 103, 227, 244
Milton Keynes 64
Mitridate, re di Ponto (Mozart) 78
Modernism 222, 224, 228–9, 233, 234, 236,
 237
Modica, Sicily 62–3
Monet, Claude 4
Monteverdi, Claudio 8–10, 80, 82, 244
Mozart, Wolfgang Amadeus 78–86, 107, 110,
 112, 136, 168, 203, 204–5, 249, 251
music, authentic performance of 127, 250
Mussolini, via della Conciliazione 2, 243–4

Nancy, Lorraine 74
Naples 17, 24, 74
Naryshkin, Lev Kirillovitch (prince) 194
National Trust reconstructions 208, 210
Neumann, Balthasar vii, 243
New World 69–71, 89
 Spanish models in 165–6
Nikko, Toshu-gu, Kara-mon [Chinese gate] *81*

Noto, Sicily 62, 71–2, 248
Nymphenburg, Munich 132–4

Ocotlán, Tlaxcala, Mexico, sanctuary *63–4*,
 168–72
Octavian (in *Rosenkavalier*) 201, 204–6
Office Baroque (Matta-Clark) *91*
Oldenburg, Claes 230, 239
opera 8–10, 34–5, 67, 75, 76–7, 78–86, 89, 97,
 112–13, 136, 157, 183–7, 202–3, 204–6,
 210, 244, 252
opera buffa 82
opera seria 78–9, 86, 249
orange 145–7
oratorio erotico 186–7, 252
Oratory of the Filippini, Rome (Borromini)
 13, 229
Orlando (Handel) 162–3
Orta, Italy, Sacred Mount *9*, 20, 38–40, 245
oval plans 1–3, *3*, 10–12, 191

Paestum, Doric temples 115
Painswick, Gloucestershire, graveyard *50*, 138
Palermo 17, 61, 63–4, 92–4, 245
Palestrina, Giovanni Pierluigi da 219
Palladio, Andrea 100, 110
Pantheon, Rome 1
Paradise Lost (Milton) 5–7, 8, 66–8
Pelléas et Mélisande (Debussy) 80
Pergamon, Turkey 216
Peru, colonial 51–2
Peruzzi, Baldassare 166
Peterskirche, Vienna (Hildebrandt) 12
Petra, Jordan *84*, 216
Philharmonie, Berlin (Scharoun) *96*, 236–9
Pianta, Francesco the Younger *59*, 155–7, 251
Piaristenkirche, Vienna (Maulbertsch ceiling)
 27–8
Piazza Navona (Bernini) 24
Piazza Sant' Ignazio, Rome (Raguzzini) *22*,
 61–2
Picasso
 and African sculpture 222–3
pineapple *54*, *57*, 145, 151–2
Piranesi, Giambattista *37–8*, 44, *45*, 113–16,
 118, 122
plague column, Graben, Vienna *11*, 24
planning, Baroque 60–64
plans, importance of 10–12, 14–17
 see also oval plan
Pollock, Jackson 65–6
Ponce, Antonio *53*
Pope, Alexander 29, 76, *79*, 102–6, 107–9, 147,
 159, 160, 207, 245, 249
porcelain 76, 95, 136, 201
Poussin, Nicolas 146, 149

Pozzo, Fra Andrea *12*, 25–7, 118, 245
Pretoria, South Africa, proposed
 administrative complex (Baker) 198
Principles of Art History (Wölfflin) 217
Protestantism 30–32, 53, 58–9, 67, 118, 157
Proust, Marcel 101
Provenzale, Francesco 185–6, 252
Pugin, A. W. N. 199
Puritans 108–9, 210–11
Pynchon, Thomas 227

Querétaro, Mexico 70–71, *70*, 174, 191

Radcliffe, Mrs Ann 57, 118–19, 120, 248
Ragusa, Sicily *23*, 62
Rameau, Jean-Philippe 80, 83, 99, 151–3, 249,
 251
Rape of the Lock (Pope) 76, *79*, 103–4, 108,
 206
Regensburg, St Emmeran (Asam brothers)
 88, 90
Renaissance
 in England 194–5
Renaissance and Baroque (Wölfflin) *85*, 217–19
Reni, Guido 146
retablos
 in Mexico *67*, *70*, 176, 178, 188–91
Return of Ulysses, The (Monteverdi) 9–10
Richardson, Samuel 157
Richelieu (planned town) 61, 248
Rigaud, Hyacinth 74
Rivoli, Castello di (Juvarra) 16
Robinson Crusoe (Defoe) 70
Rococo 18, 28, 48, 55, 58, 77, 78, 82, 83, 86,
 90, 102, 113, 115, 117, 118, 121, 128, 138,
 139, 143, 163, 168, 195, 196, 200–201, 202,
 206, 208, 222, 243
 in Bavaria 17, 127, 190, 192, 224, 237
 in Persia *74*, 196–7, 253
 origin of term 211
Rodríguez, Lorenzo *67*, 176, 179
Rohr abbey (Asam brothers) *28*, 86–7
Romanticism 1, 35, 80, 107, 118, 160, 167, 240
Rosenkavalier, Der (Strauss) 77, 168, 204–6
Rossi, Aldo 239
Rothko, Mark 65–6
Rubens, Peter Paul *14*, *15*, *24*, 35–7, 40–42,
 65–6, 200, 246
ruins *17*, *38*, *45*, 48, 247
Ruskin, John 119, 124, 199, 214, 219, 226, 254

Saarinen, Eero *78*, 202
Sacred Heart of Jesus 54–5, 56
Sacred Mounts, Piedmont *9*, 20–21, 37–40, 245
Sade, Marquis de 207
Sagrario, Mexico City (Rodríguez) 67, 176–81

St Francis
 life of, at Orta *9*, 20, 38–40, 65
St Francis Xavier 53, 181–4, 252
St Ignatius 8, 20–22, 27, 39, 52, 54, 183–4, 244
St John Nepomuk, Munich (Asam brothers)
 29, 86–7, 90
St Mark's, Venice 226
St Peter's, Rome 6, 225
 Piazza (Bernini) 1–2
 Sacristy (Juvarra) 64–5
St Petersburg 61, 74
St Teresa (Bernini) 8, *10*, 22–24, 31, 52, 57, 245
St Teresa: The Flaming Heart (Crashaw) 31
sainthood 38–40, 53–4, 247
saints in ecstasy 24, 52
Salamanca, Mexico, San Agustin, retables
 190–91
Salome (Strauss) 186, 204
Salomé (Wilde) 206
Samarkand, Persian tiled tombs 174, 252
San Cristóbal de las Casas, Chiapas, Mexico
 167, 174
San Giovanni Battista (Stradella) 186–7
San Ignacio (Jesuit opera) 183–4, 252
Sant' Alessio (Landi) 184–5, 252
Sant' Andrea al Quirinale, Rome (Bernini)
 10–11
Sant' Andrea delle Fratte, Rome (Borromini)
 229
Sant' Ignazio, Rome (Pozzo ceiling) *12*, 27, 69
Sant' Ivo (Borromini) *19*, 50, 193
Santa Maria della Salute, Venice (Longhena)
 40–42, 122–4
Santa Rosalia, or The Wounded Dove
 (Provenzale) 185–6
Santini, Giovanni (Santini-Aichel) 50–51, *88*,
 226, 247
Sargent, John Singer 200
Sassetta, Stefano di Giovanni 20
Savannah, Georgia 70–71
Scamozzi, Vincenzo 110
Scarpa, Carlo 239
Scharoun, Hans *95*, *96*, 222, 234–9, 240
Schminke house, Lobau (Scharoun) *95*, 234–6
Schoenberg, Arnold 205
Schönbrunn palace, Vienna (Fischer von
 Erlach) 73–4
Schwitters, Kurt *90*, 228
scientists, seventeenth-century 150, 161–2, 251
Scuola San Rocco, Venice (Pianta carvings)
 59, 155–7
Semper, Gottfried 74
sensibility, cult of 58
Serpotta, Giacomo *32*, *33*, 92–6
Shakespeare, William 10, 75, 82, 84, 107, 119
shopping malls 64

Sistine Chapel, Vatican (Michelangelo ceiling) 95
sketch, idea of 40–44, 50
Soane, Sir John (London house) *39*, 44, 116–19, 124, 149, 250
Solimena, Francesco 48
Sot Weed Factor (Barth) 227
Soviet pavilion, Paris,1925 (Melnikov) 234
Spada, Palazzo, dwarf passage (Borromini) 2
Spengler, Oswald 214
Spiritual Exercises (St Ignatius) 8, 20–22
SS Sergius and Bacchus, Constantinople 195
stage
 designers 10, 16, 109–13
 scenery *16*, 17, 43, 109–13, 244
stairhalls 17–18
Steinhausen (Zimmermann) 12
Steinhauser, Pontian *52*
Sterne, Laurence *7*, 18–19, 46–7, 50, 58, 248
still lifes with tulips, Spanish *53*, 144, 251
Stockhausen, Karlheinz 220
storms 152–3
Stradella, Alessandro 186-7
Straubing, Ursuline convent (Asam brothers) 88
Strauss, Richard 77, 168, 186, 204–6, 208
stuccatori, Sicilian *32–3*, 91–6
Stupinigi, hunting lodge (Juvarra) *5*, 14–15, 65
Submersion Laboratory, Berlin (Leo) *97*, 239
Summerson, John 68
Superga, Basilica di (Juvarra) 16–17, 44
Surrealism 203

Tchaikovsky, Pyotr Ilyich 204
Teatro Olimpico, Vicenza (Palladio) 100, 110
Tepotzotlán, Mexico, St Martin 188–9
Tiber Island (Piranesi) *45*, 129, 250
Tiepolo, Giambattista 17, 28–30, 43, *87*, 92, 150
Tintoretto, Jacopo 92, 155, 156, 220, 254
Tlaxcalancingo, Mexico, San Bernardino 173
To Penshurst (Jonson) 29
Topkapi palace, Istanbul 195–6
Tower of Babel (Bruegel) 160
Tristram Shandy (Sterne) *7*, 18–19, 46–7
tulip craze, Dutch 143–5, 251
Turin *6*, 13, 15–17, 61, 72–3, 74
TWA terminal, New York (Saarinen) *78*, 202

Ulysses (Joyce) 227
Upon Appleton House (Marvell) 18, 29–32

Vanbrugh, Sir John *25*, *43*, 68–9, 124–6, 250
Varallo, Sacred Mount 38–9, 245
 see also Orta
Vedute di Roma (Piranesi) *38*, 115–16
Veitshöchheim, Franconia *48*, 134–6
Velásquez, Diego 42, 200
Venaria Reale, Castello di (Juvarra) 15, 73
Venice
 scuole 92
 as scenery *40–42*, 119–24
Venturi, Robert 226
Verdi, Giuseppe 210
Versailles 64, 69, 73, 74, 82, 121, 131–2, 138
via del Po, Turin *6*, 15–17
Vierzehnheiligen, Franconia, pilgrimage church (Neumann) *51*, 139–41
Villa Palagonia, Bagheria, Sicily *49*, 136–8, 251
Virgin's dressing room, Ocotlán and Tepotzotlán, Mexico *64*, 171–2
Vittone, Bernardo Antonio 13, *18*, 47–8, 51, 247
Vivaldi, Antonio 163, 251, 252

Wagner, Richard 153, 201, 219
Waldsassen Abbey, library *58*, 153–5, 156
Walpole, Horace 58, 118, 248
Warsaw, Old Town (reconstructed from Baroque views) *80*, 209–10
Washington, DC 74
Waste Land, The (Eliot) 226–7
Watteau, Antoine 24, 29, *34–5*, 50, 76, 82, 96–101, 102, 154, 196, 201
Webb, Aston 199
Wedding at Cana (Preti) 2, 4–5
Weltenburg abbey (Asam brothers) *30*, 86–90
Whitman, Walt 167
Wieskirche, Bavaria (Zimmermann) *52*, 139, 141–3, 204
Williamsburg, Virginia 210, 253
Winckelmann, Johann Joachim 219
wit 105–6, 250
Wittkower, Rudolf 23, 52, 219
Wölfflin, Heinrich *85*, 217–19, 221
workers' clubs, Moscow (Melnikov) *94*, 234
Wren, Christopher 7, 12, *21*, 60, 236
Würzburg, Bishop's Palace (Tiepolo ceiling) 28–9

Yucatán, rural churches 168

Zócalo, Mexico City 187–8